A WINTERHOUSE EDITION
PRINCETON ARCHITECTURAL PRESS
NEW YORK

SIRI HUSTVEDT

Essays on Painting

Mysteries
of the
Rectangle

Published by
PRINCETON ARCHITECTURAL PRESS
37 East Seventh Street
New York, New York 10003
Web site: www.papress.com

Produced by
WINTERHOUSE EDITIONS
PO Box 159
Falls Village, Connecticut 06031
For a free catalog: 860.824.5040
Web site: www.winterhouse.com

© 2005 Princeton Architectural Press
First paperback edition, 2006
All rights reserved. Printed in China.
18 17 16 15 7 6 5 4

No part of this book may be used or reproduced in any manner without
written permission from the publisher, except in the context of reviews.
Every reasonable attempt has been made to identify owners of copyright.
Errors or omissions will be corrected in subsequent editions.

Editor: Scott Tennent
Designers: Winterhouse Studio — William Drenttel & Don Whelan

Special thanks to: Nettie Aljian, Nicola Bednarek, Janet Behning, Megan Carey,
Penny (Yuen Pik) Chu, Russell Fernandez, Jan Haux, Clare Jacobson, John King,
Mark Lamster, Nancy Eklund Later, Linda Lee, John McGill, Katharine Myers,
Jane Sheinman, Jennifer Thompson, Joseph Weston, and Deb Wood of
Princeton Architectural Press — Kevin C. Lippert, Publisher.

Front cover: Francisco José de Lucientes y Goya, *Capricho with Five Heads*, 1820–21.
Collection of Stanley Moss.

ISBN-13: 978-1-56898-618-0
ISBN-10: 1-56898-618-1

The Library of Congress has cataloged the hardcover edition of this book as:
Hustvedt, Siri.
 Mysteries of the rectangle : essays on painting / Siri Hustvedt.—A Winterhouse ed.
 XXI, 179 P. : ILL. (some col.) ; 24 CM.
 Includes bibliographical references.
 ISBN 1-56898-518-5 (alk. paper)
 1. Painting—Themes, motives. 2. Painting—Appreciation. I. Title.
 ND1145.H845 2005
 759—DC22 2004029909

FOR KAREN WRIGHT

CONTENTS

ix LIST OF ILLUSTRATIONS

xii ACKNOWLEDGMENTS

xv INTRODUCTION

1 THE PLEASURES OF BEWILDERMENT

11 VERMEER'S ANNUNCIATION

27 THE MAN WITH THE RED CRAYON

43 GHOSTS AT THE TABLE

61 NARRATIVES IN THE BODY: GOYA'S *LOS CAPRICHOS*

93 MORE GOYA: "THERE ARE NO RULES IN PAINTING"

121 GIORGIO MORANDI: NOT JUST BOTTLES

135 JOAN MITCHELL: REMEMBERING IN COLOR

149 GERHARD RICHTER: WHY PAINT?

169 NOTES

175 ILLUSTRATION CREDITS

LIST OF ILLUSTRATIONS

THE PLEASURES OF BEWILDERMENT

3 Giorgione, *The Tempest*. c. 1503–1504.

VERMEER'S ANNUNCIATION

13 Vermeer, Jan (Johannes), *Woman with a Pearl Necklace*. c. 1662–65.

20 Duccio (di Buoninsegna), *Annunciation of the Death of the Virgin*. c. 1308–11.

22 Petrus Christus, *The Annunciation*. c. 1450.

THE MAN WITH THE RED CRAYON

34 Chardin, Jean-Baptiste-Siméon, *A Glass of Water and a Coffee-pot*. c. 1760.

37 Chardin, *Young Student Drawing*. c. 1733–34.

40 Chardin, *Self-Portrait with pince-nez*. 1776.

GHOSTS AT THE TABLE

47 Cotán, Juan Sánchez, *Quince, Cabbage, Melon and Cucumber*. 1602.

50 Claesz, Willem, *Vanitas*. 1628.

52 Soutine, Chaim, *Carcass of Beef*. 1925.

53 Cézanne, Paul, *Still Life with Pitcher and Aubergines*. 1893–94.

56 Guston, Philip, *Painter's Forms*. 1972.

NARRATIVES IN THE BODY: GOYA'S *LOS CAPRICHOS*

64 Goya y Lucientes, Francisco José de, "Francisco Goya y Lucientes, Painter,"
plate 1 of *Los Caprichos*. 1799.

66 Goya, preliminary drawing for plate 43 of *Los Caprichos*. 1799.

66 Goya, "The sleep of reason produces monsters," plate 43 of *Los Caprichos*. 1799.

69 Goya, "They say 'yes' and give their hand to the first comer," plate 2 of
Los Caprichos. 1799.

72 Goya, "Young Woman Holding up her Dying Lover," preliminary drawing
for plate 10 of *Los Caprichos*. 1799.

72 Goya, "Love and death," plate 10 of *Los Caprichos*. 1799.

76 Goya, "All will fall," plate 19 of *Los Caprichos*. 1799.

76 Goya, "There they go, plucked," plate 20 of *Los Caprichos*. 1799.

76 Goya, "How they pluck her!," plate 21 of *Los Caprichos*. 1799.

78 Goya, *Self-Portrait*. 1795–1800.

82 Goya, "He puts her down as a hermaphrodite." preliminary drawing for plate 57
of *Los Caprichos*. 1796–97.

82 Goya, "Masquerade of Caricatures," preliminary drawing for plate 57
of *Los Caprichos*. 1799.

82 Goya, "The Lineage," preliminary drawing for plate 57 of *Los Caprichos*. 1799.

82 Goya, "The Filiation," plate 57 of *Los Caprichos*. 1799.

86 Goya, "Blow," plate 69 of *Los Caprichos*. 1799.

88 Goya, "Blasts of wind," plate 48 of *Los Caprichos*. 1799.

89 Goya, "The devout profession," plate 70 of *Los Caprichos*. 1799.

90 Goya, "Bon voyage," plate 64 of *Los Caprichos*. 1799.

MORE GOYA: "THERE ARE NO RULES IN PAINTING"

95 Goya y Lucientes, Francisco José de, *Execution of the Defenders of Madrid, 3rd May,
1808*. 1814.

98 David, Jacques-Louis, *Jean Paul Marat, politician and publicist, dead in his bathtub,
assassinated by Charlotte Corday in 1793*. 1793.

108 Goya, *Execution of the Defenders of Madrid, 3rd May, 1808*. 1814. DETAIL.

110 Goya, *Self-Portrait with Dr. Arrieta*. 1820.

114 Goya, *The Procession of San Isidro*. 1820–23.

117 Goya, *Capricho with Five Heads*. 1820–21.

GIORGIO MORANDI: NOT JUST BOTTLES

124 Morandi, Giorgio, *Still Life*. c. 1916.

124 Morandi, *Still Life*. c. 1952.

129 Morandi, *Still Life with Yellow Cloth*. 1952.

JOAN MITCHELL: REMEMBERING IN COLOR

142 Mitchell, Joan, *Calvi*. 1964.

142 Mitchell, *Mooring*. 1971.

144 Mitchell, *Clearing*. 1973.

146 Mitchell, *Untitled*. 1992.

GERHARD RICHTER: WHY PAINT?

152 Richter, Gerhard, *Uncle Rudi*. 1965.

159 Richter, *Confrontation 2 (Gegenüberstellung 2)*. 1988.

159 Richter, *Confrontation 3 (Gegenüberstellung 3)*. 1988.

159 Richter, *Hanged (Erhängte)*. 1988.

161 Richter, *Youth Portrait (Jugendbildnis)*. 1988.

162 Richter, *Dead (Tote) 1*. 1988.

163 Richter, *Dead (Tote) 2*. 1988.

163 Richter, *Dead (Tote) 3*. 1988.

164 Richter, *January (Januar)*. 1989.

167 Richter, *Reading (Lesende)*. 1994.

ACKNOWLEDGMENTS

Eight years ago, I would have been surprised if someone had told me that I would publish this book. Although I have always loved paintings and have included painting and painters in my fiction, had it not been for Karen Wright, the editor of *Modern Painters*, who after reading my first novel asked me to try my hand at writing about art, I might never have written the pieces in this book. I send her my warmest thanks, not only for her faith in and kindness to me, but because the adventure of writing about painting has given me real happiness.

I must also express my gratitude to Stanley Moss, whose extensive knowledge of painting and his intimacy with the works of Goya in particular have been very helpful to me. Not only did he generously open his house to me and show me the two Goyas in his collection, one of which appears on the cover of this book, he has also helped me better understand the world of museums and collecting, the complex business of provenance, and the even more arcane and controversial issue of attribution. After I had finished my two meditations on Goya and written about the obscure but nevertheless visible self-portrait of the painter in *The Third of May*, it was Stanley Moss who, through a friend, directed me to a paper by the art historian Albert Boime called "Oscuridad al Meliodía: La Junta de Filipinas," which was delivered

at a conference on Goya at the Prado in 2001. Boime also found a figure "not discernable at first sight" in a shadowy portion of the *Session of the Company of the Philippines* that he identified as Goya.

Manuela Mena, a curator at the Prado Museum, also deserves my thanks for kindly consenting in October of 2004 to allow me to show her the hidden face in *The Third of May* and for acknowledging that there is indeed a face floating there below the cloaked women in the left-hand corner of the canvas. Before we parted, Ms. Mena agreed to have the canvas X-rayed, a way to confirm that the image is original to the painting. Ms. Mena speculated that the face was added later. I am not in a position to guess about this. It is certainly possible that a mischievous restorer or unknown person added an image to the picture, and only technology can prove whether Goya is the author of that face or not. As of now, the mystery remains unsolved.

I am indebted to my editor at Princeton Architectural Press, Scott Tennent, for suggesting that I revisit a couple of the essays in this collection. They benefited greatly from that second look. My thanks go to William Drenttel, who is not only the designer of this book but my coconspirator in the entire venture. Without his superb eye, formal insight, and spirited resistance to visual clichés, this volume would be only a gray shadow of itself. I want Robert Hughes to know that his lively mind and muscular prose, as well as his encouragement, were important to me; and finally, I want to tell Paul Auster that his enduring enthusiasm for my verbal wanderings into works of art and his unflagging faith in me have left their marks on every page.

INTRODUCTION

Painting is there all at once. When I read a book, listen to music, or go to a movie, I experience these works over time. A novel, a symphony, a film are meaningful only as a sequence of words, notes, and frames. Hours may pass but a painting will not gain or lose any part of itself. It has no beginning, no middle, and no end. I love painting because in its immutable stillness it seems to exist outside time in a way no other art can. The longer I live the more I would like to put the world in suspension and grip the present before it's eaten by the next second and becomes the past. A painting creates an illusion of an eternal present, a place where my eyes can rest as if the clock has magically stopped ticking.

The history of painting is, by and large, the story of a thing as flat as a tabletop. In representational works, this means that a thing or figure one recognizes from our world—a world that includes fictional beings, monsters and fairies—has been translated into a visual sign that is two-dimensional rather than three. In abstract works, it means playing with that same recognition or abandoning it altogether for its flat truth. Unlike sculpture, paintings and drawings have no meaningful behind or back view. You don't walk around a canvas. You stand in front of what is most often a rectangle and gaze at what's inside its edges.

Because it determines boundary and scale, the frame is vital to understanding the image inside it. Are we looking at a miniature world or a gigantic one? Are the figures in the painting as large as I am or are they reduced? A tiny painting affects me differently from a huge one. The frame also circumscribes my vision in a way that is unlike ordinary looking. Walking down the street, I never see everything. My vision is filtered by necessity: I ignore some images and take in others, and what I see is in constant flux, only one part of a drift of stimuli, in which the visual can't be easily extricated from what is bombarding my other senses. A man in a gray T-shirt and blue pants crosses the street in front of me; an unseen dog barks; the odor of garbage mingles with the smell of baking bread. A painting allows my eyes to focus on a space delimited by an absolute perimeter and ponder a still, silent, and odorless image. This is a highly restricted, contemplative form of looking that is in many ways much easier than absorbing the myriad sights of daily life.

Despite the truth that a painting's elements don't change and aren't sequential, my own experience with a picture can't mirror that simultaneity. My engagement with a painting takes place in time, and I have rarely been able to assimilate the various aspects of an image all at once. Occasionally, I'll run across a canvas or a group of canvases in a gallery that I call "one liners," pieces that rely on a simple juxtaposition or moment of surprise, and then, having expended themselves in the joke, they promptly die as objects of interest. Once the punch line is known, no further glance is needed. The paintings and etchings discussed in this book, on the other hand, have withstood hours of my looking at them and could hold up under many more. Examining every part of an image requires long viewing sessions and then periods of rest, during which an image settles in the mind; and even then, the best works of art continually escape definition.

Seeing anything is immensely complex. In order to absorb an image, we must isolate and assign value to whatever we're looking at. In a figurative painting, I will notice the woman who stands at the center of the canvas before the man who stands far to the left. But I will probably see him before I notice the ring on the woman's finger or the thin line of lace at the hem of her dress. In an abstract painting of many colors and shapes, I will see red before ochre, the large heavy shape before the wisps of paint near it. Although we take these discriminations for granted, the ability to make them is rooted in the physiology of experience. Blind people who suddenly recover their sight

cannot see what we who have had sight from birth see. Their vision is unorganized, and it can take years before they make sense of the shifting blur before them. Many never manage it at all. Elizabeth Bates, director for research in language at the University of California at San Diego, has concluded that "the experience of language helps create the shape and structure of the mature brain."[1] Because we know that an infant's brain is structurally different from a grown-up's brain, it makes sense that the blind open their eyes to an inchoate visual world. They have not gained the internal visual representations and associations that are created over time as a sighted person develops, a process that includes the acquisition of language and its dissection of the visual field.

We perceive the "out there" through language and the whole symbolic level of human experience it brings with it—long-established cultural hierarchies and pictorial codes that shape expectation, recognition, and memory of what is seen. People who suffer from a strange affliction called blindsight all have damage to the visual cortex of their occipital lobes. Although these patients can still process visual information in the uninjured part of their brains, they have lost all awareness that they see. As Mark Solms and Oliver Turnbull write in their book *The Brain and the Inner World*, those with blindsight have brains that "compute visually, but they do not possess visual consciousness."[2] Without this consciousness, they are effectively blind, despite the fact that when asked to "guess" about visual information in front of them, their guesses are correct at a far higher level than chance would allow. All of us have a blind spot in each eye at the place where the optic nerve enters the retina, but we don't experience that gap in our vision because we fill it in with what we expect to see. Expectation, born of experience, closes the gap. What do these stories tell us about looking at art? They confirm that the visual capacity of the brain isn't mechanistic. We do not possess little cameras in our heads that record a naked reality, and our memories are not computer files where an identical copy of what we once saw can be retrieved at will. Rather, perception is a hugely complicated neuronal process that relies on a dynamic, not fixed, memory that allows us to make sense of what we see.

To see a work of art and instantly forget it would be as bad as being blind. Art we care about must endure in memory or it's useless. But for people with normal vision, even hours of scrutiny won't guarantee a perfect mind copy of a painting that may be consulted as true. Most people lose details, blur backgrounds, or alter colors in memory. I lost an entire figure in Giorgione's

The Tempest between viewings, and there are only three people represented in the canvas. Nevertheless, as I explain in my essay on that remarkable picture, the male figure went missing for a reason. Sometimes a perceptual error can unlock a painting's internal logic. Whether we know it or not, seeing is always interpretive, and the distortions of memory may reveal far more than a mere subjective gaffe. They can uncover an aspect of the work that had hitherto gone unseen or was "seen" unconsciously.

Like every human trait, visual ability varies from person to person. Aleksander Luria, the famous Russian neurologist, had a patient who apparently could recall everything he had seen. He could produce a permanent scroll of unchanging images as if his mind really were like a camera.[3] Temple Grandin, who wrote about her work as an animal scientist and her autism, also has a photographic memory, which she compares to playing a video.[4] While her savant vision has the advantage of moving forward and backward without gaps, it also attaches no degree of emotional importance to the inner pictures. To relate a more ordinary story of differences in perception, I understood that my daughter had an idiosyncratic way of looking at things when she was five, and her kindergarten teacher reported to me that in her twenty years of teaching, Sophie was the first child ever to draw a person from behind. I have a strong visual memory that is nevertheless subject to editing and lapses, but I've come to the conclusion that when I look at a picture, my apprehension of it is more "all over" than that of other people. When I read about works of art in books, I'm continually surprised by the fact that an aspect of a painting I found compelling or even critical to its meaning isn't even mentioned. There are a few possible explanations for this. I'm extremely nearsighted and without corrective lenses the world is a blur. This has made me less tolerant of visual ambiguity than many people. The dim, darkened rooms my husband finds pleasurable inevitably frustrate me. I also suffer from migraines and the auras that accompany them. My experiences of flickering lights, floating black shapes, and tiny sparkling holes in my vision, as well as a single episode of something called a Lilliputian hallucination—I saw two small pink figures on the floor of my bedroom—has perhaps made me more dubious about what I'm looking at than people who have never suffered from visual disturbances. Doubt is a catalyst for close attention.

By looking long and hard and at every part of a picture, I've discovered elements that have never been discussed by art historians or critics before:

an egg detail on the window frame of Vermeer's *Woman with a Pearl Necklace*, an important piece of the overall puzzle because I'm convinced the work as a whole refers to the Annunciation. I also found several hidden self-portraits in Goya's *Los Caprichos* and one in *The Third of May*. These revelations have led me to conclude that those who analyze works of art for a living are not exempt from blind spots. Because few people anticipate that they will find anything new in a very old or very famous painting, they don't. Expectation prevents discovery. Nevertheless, such moments happen. David Hockney's theory that mirrors were common tools among Renaissance painters created a furor of debate and resistance among art historians.[5] Whether one accepts Hockney's argument or not, it is undeniable that his insight was born of his scrupulous investigation of individual canvases made possible by his long experience as a working artist. What is remarkable is not so much the controversy that surrounded his idea, but the fact that nobody, it seems, had entertained the possibility before him.

Visual art exists only to be seen. It is the silent encounter between the viewer, "I," and the object, "it." That "it," however, is the material trace of another human consciousness. The artist, who is missing from the scene, has nevertheless left us a work, an act of pure will, which has no practical purpose. The painting carries within it the residue of an "I" or a "you." In art, the meeting between viewer and thing implies intersubjectivity. Despite the fact that I would run in terror if a painting actually talked to me, I am alert to the human presence that is part of the object. Common parlance makes it clear that most people feel this about art. "That really *spoke* to me" has become a gallery cliché.

The intersubjectivity inherent in looking at art means that it is a personal, not impersonal, act. I have often thought of paintings as ghosts, the specters of a living body, because in them we feel and see not only the rigors of thought, but the marks left by a person's physical gestures—strokes, dabs, smudges. In effect, painting is the still memory of that human motion, and our individual responses to it depend on who we are, on our character, which underlines the simple truth that no person leaves himself behind in order to look at a painting. A person's experience of a canvas by Joan Mitchell, for example, might be influenced by a distaste for the romantic character of Abstract Expressionism, a long-standing attraction to the color orange connected to a childhood experience, a feminist ideology, or even a nagging stomachache.

When I write about art, I never pretend that I have disappeared from my own sentences or that my memories, emotions, and peculiarities haven't shaped my response to a painting. In any written work, someone is always doing the telling, and the elimination of the narrating "I" has begun to feel false to me. It's as if the speaking somebody is hiding behind a mask of nobody meant to represent an objective or unprejudiced tone. Although art critics often feel free to hurl either spleen or adoration on artists, they do so under the guise of their expertise, of their superior knowingness, and art historians are often loathe even to set foot in the world of emotional responses to art. Indeed, it was so neglected as a topic in art scholarship that David Freedberg devoted a book to the subject. In his introduction to *The Power of Images*, he writes, "I was concerned, above all, by the failure of art history to deal with the extraordinarily abundant evidence for the ways in which people of all classes and cultures have responded to images."[6] Art has had its great theorists, people like Panofsky, Adorno, and Gombrich. It continues to have, for better or worse, a host of theory-influenced art writers both inside and outside universities. It also has legions of scholars who toil to verify a painting's provenance, who test the age of its pigments for authenticity or X-ray it for underpainting, and others who research a painter's biography and historical period—people who, despite the undeniable value of their research, don't give a jot about what a person feels while looking at a picture. There are a few notable exceptions. Meyer Shapiro, Fred Licht, Robert Hughes, and Dave Hickey have all written eloquently about their responses to images. What interests me is this: Why do some works of art, even very old ones, continue to seduce viewers who know nothing or little about art theory, a work's provenance, or its cultural history? In museums, I have repeatedly seen men and women transfixed by a painting, and I presume not all of them were professional art critics. In my reading of writers as diverse as Diderot, Van Gogh, Proust, and Baudelaire, I've discovered a remarkable uniformity of emotional response to painters such as Vermeer, Chardin, and Goya. Some pictures elicit similar emotions in many viewers.

Recalling the way a work of art made me feel is often more durable than other kinds of memory. I can often remember how I felt when I read a novel, for example, without having a good recollection of its plot. What remains after looking at a painting is not an exact imprint of the image in my mind, but rather the feeling it gave me, a feeling that I sometimes must struggle to name because emotions as experienced in the body are often cruder than

the words we assign to them. Visceral responses to an image, however, are inevitably avenues to meaning. It isn't always clear why a picture affects us the way it does, but for me, pursuing that mystery is the single most fruitful way to discovery. As Henry James once wrote, "In the arts, feeling is meaning."[7] And yet the world of museums has produced a cult of expertise and mythos of greatness that weight the ordinary pleasure of looking at art and responding to it with an alarm about ignorance. Catalogues with page after page of sometimes abstruse and often dull "explanations," earphones that may be purchased to guide the visitor from one work to another, and long textual notes below every picture in an exhibition are all reminders to the viewer that he goes it alone at his own peril, that seeing is not enough, and perhaps worst of all, that without coaching, the art hanging on the walls will be unintelligible to the onlooker. Catalogues, guides, and information of all sorts have an important place in the art world, but I think they are best consulted once the looking is over, just as I believe that the idea of genius, of the masterpiece, of the greatest and the best usually interferes with seeing the thing before us. In the worst cases, the poor beleaguered painting drowns in its own fame. Works like Michelangelo's Sistine ceiling, Van Gogh's *Sunflowers*, Munch's *The Scream*, and more recently, Vermeer's *Girl with a Pearl Earring* have become object celebrities whose names alone serve as commodities of exchange in the popular market, generating everything from postcards to shower curtains. Through the lowering fog of a received idea, some art has faded from view.

I think of this book as a collection of mental peregrinations into the unknown. Sometimes it's a stroll through the bewildering terrain of a single picture, other times through the landscape of an entire exhibition. I've never been interested in writing about work I can grasp immediately, only about those pictures whose allure isn't easily understood or articulated. I have no desire to propose textual solutions to images or to squeeze a complex painting into a preconceived theoretical framework. What fascinate me are the journeys that begin with looking and only looking. For this, no special gnosis is required, only an understanding that the perception of an artwork is a visual adventure in an imaginary space. These are my own stories of traveling in that illusory, strange, and motionless world, and I have written them for anyone who likes the solitary experience of pausing in front of a painting and then waiting for a while to see what happens.

The Pleasures
of Bewilderment

My story with Giorgione's painting *The Tempest* is now twenty-six years old. I saw it for the first time when I was nineteen—not the canvas itself, but a slide projection on a wall in an art history course. I had never heard of the artist and knew little about Italian Renaissance painting, but for some reason the picture caused a physical response in me—a genuine tremor of amazement. I fell in love with it then and there, in the forty seconds before the professor clicked to the next slide. But why? What happened to me? I am not alone in feeling an almost electrical connection to a painting. I know any number of people who travel great distances to see a picture they have longed to see, who stand before a flat rectangular canvas covered with paint and have what they deem "an important experience."

It's possible that to understand a moment like mine with *The Tempest*, we would have to know more about vision and the brain. It's also possible that I would have to understand my own psychology better. It's notable that although I didn't retain a word the professor said about the painting, I remembered the painting itself. In fact, the image seemed to burn itself into my memory with an almost disturbing clarity. As a child, I drew obsessively and tried my hand at watercolors and oils. I also looked at paintings that I found in books here and there, but my interest was haphazard. I could recognize works that had entered the popular consciousness—Renoirs, Van Goghs, Matisses, and Picassos. I liked looking at paintings, but I had never had a truly "transcendent" moment until I saw that reproduction of *The Tempest* in my college class in Minnesota.

There is a mystique that surrounds art in our culture that we all recognize, but which is a phenomenon separate from my experience with Giorgione's image. Two years ago, my daughter and I stood in line for an hour to get into the Louvre. In that museum, it's nearly impossible to catch a glimpse of *The Mona Lisa*. First of all, it's covered by thick glass, and second, a crowd blocks your view. I saw people snapping pictures of the painting, or having photos taken of them beside it. As everyone knows, Leonardo's portrait of Mrs. Giaconda is a painting few people can actually *see* anymore. For reasons obscure to me, the painting has become not so much a *thing* of greatness as a *sign* of it. Like an image of Garbo or Monroe, Leonardo's picture has been turned into cultural currency and is now a circulating icon of superlatives—the greatest, the most mysterious, the most valuable painting in the world. This cultural weight has doomed the lady to her twentieth-century mustaches.

GIORGIONE
The Tempest
c. 1503–04

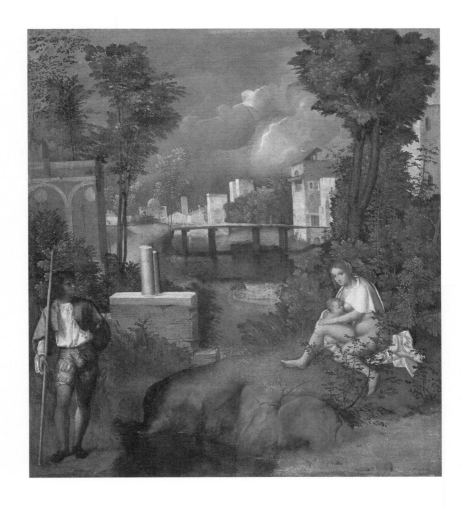

It could have happened to *The Tempest*. The painting has been confounding art historians for hundreds of years, but for some reason it was spared that fate.

Every painting is still. It doesn't move. It is usually a rectangle that mimics the architecture of a window. Its very existence implies a spectator, just as a book implies a reader or a piece of music implies a listener. It is a dead thing animated by the presence of a living person who enters into some kind of relation with it. I once noticed a letter in *The New York Times* from a woman who was writing about seeing Michelangelo's *David* in Florence. She wrote, "What a thrill it was to stand there and soak in its beauty and power. But how long I had to wait in the gallery for things to quiet down so that I could concentrate on it."[1] Two things interest me about her statement. First, that she experiences the *David* as if it were active and she were passive—she "soaks" in the statue—and second, that she needs quiet for this saturation to take place. Her view of looking at the statue is a common one. The stone *David* radiates something in her direction and she prefers to have no distractions during those emanations. We rarely experience other inanimate things in this way. Think of a fork, for example, or a chair. Art is made to be seen. It is activated both by a cultural mythos that has decidedly religious undertones and by a real, even transforming, relation between the viewer and the thing viewed.

The Tempest is a small picture. This is crucial. When I first saw the reproduction, I had no idea of its size, and when I first visited the Accademia in Venice, I was startled by how little it was. Small canvases are inevitably more intimate than large ones. If you move too far back from a diminutive painting, you can't see its details anymore. Its size forces the viewer to remain close. The work, painted in 1503 or 1504, shows a man with a staff standing in the foreground. He is turned toward a woman who is seated on a hillock nursing an infant. A stream runs between them. She is naked except for a white cloth, which is draped over her shoulders and is spread out underneath her where she sits on the ground. Some curious ruins and a deserted city lie behind the figures. Above them is blue-green sky with a frail stroke of lightning and a clouded moon. Nobody knows what the painting is about.

Marcantonio Michiel, a Venetian nobleman and antiquary, kept a notebook between 1525 and 1543 in which he refers to the picture as Giorgione's rendering of a soldier and a gypsy. In the eighteenth century, the painting was called *The Family of Giorgione*, out of a mistaken idea that it depicted the artist, his wife, and child. (The latter two never existed.) Salvatore Settis,

an Italian art historian, argues that the painting is a veiled account of the Eden myth, that the two adult figures are Adam and Eve and that there's a snake in the picture.[2] As far as I know, no one has ever seen this snake but Settis. A more convincing argument detailed by Jaynie Anderson in her thorough monograph on Giorgione is that the canvas is a pictorial version of the *Hypnerotomachia Poliphili*, a romance about Poliphilo, who in his search for antiquity comes across Venus feeding Cupid—but that's only a guess.[3] There are also scholars who believe the painting is about nothing, that's it's an example of a painting without a subject. Whatever it is, *The Tempest* is unusual for its time, because it has no easily recognizable allegory or reference.

Between my first viewing of the slide and a visit to the Accademia, where I saw the real painting for the first time four years later, I made a startling discovery. The image I had carried in my mind was very accurate, with one exception: I had left out the man. My memory of the painting was of the woman, the child, the landscape, the ruins, the city, the sky, the lightning—but no man. I gave this extraordinary gaffe to the heroine of my first novel, *The Blindfold*, who also remembers the canvas perfectly but has no memory of the figure in the foreground. My obliteration of this man is a commentary on the painting, on me, and on the odd business of looking at paintings in general.

I have looked closely at *The Tempest* in the Accademia only three times. Each time is a repetition of my first rapture in front of that projected image in the classroom. I now know there is a man in the picture and that he serves as the vehicle of my entry into an image I don't fully understand, but understand enough to be fascinated. The staff he holds suggests that he is on a journey, that he has been walking. Now in repose, he looks over at the undressed woman calmly nursing her baby in a storm. He looks at her, but she is not looking back at him. She gazes outward toward the viewer, as though she has just lifted her eyes in the knowledge that somebody is spying on her. By recognizing me, the spectator, her eyes draw me into the space of the canvas, where I imaginatively become the man's double. In a painting, everything occurs simultaneously, and I find myself trapped in this triangular seduction of looking, the direction of her gaze at me coupled with the direction of his at her is what triggered my amnesia of him, the wandering male spectator. I forgot him because I had become him.

The man and I occupy a similar space in that neither he nor I will ever get across the stream to speak to the woman or touch her. Nearly every

analysis of the painting I have read acknowledges the chasm between the figures. An earlier version of the painting, however, revealed by X-ray and then by infrared reflectogram, shows an unfinished female figure on the same side of the river as the man. Much has been made of this shadowy form, but it is impossible to know whether she is a second woman or the same woman who ended up somewhere else as the picture evolved. This lady underneath *The Tempest* is the force behind the argument that the picture is not an allegory, but what Kenneth Clark called in 1949 "a free fantasy."[4] I can't help thinking that this reasoning is unsound. It seems entirely possible to have a particular story in mind while painting and then shift the characters around as the canvas develops. The depiction of classical and biblical narratives wasn't so conventionalized that painters had no freedom in their visual telling. If there were initially two women, and not one, then the Adam and Eve narrative seems impossible, but not *every* story. The only thing the phantom woman proves with any certainty is that Giorgione changed his mind, and since the painting was finished, the viewer must assume that it turned out as he wished. The two figures he ended up with feel as if they will never approach each other.

Interestingly enough, however, there is a bridge. Our hero wouldn't have to wade or swim through that stream. He could use the bridge, but he never will. Why? Although the two figures are not very far apart, they appear to exist in separate realms. For one thing, the man is dressed in contemporary clothing. Anderson suggests that this identifies him as a member of the Confraternity of the Sock, a group of young, unmarried noblemen who were engaged in amateur theater productions.[5] The woman, however, is nude, a signification of timelessness in that enchanted landscape, where a curious bit of wall is topped by two cylinders and where classical buildings coexist with houses that resemble those in rural areas outside Venice. The woman's face is illuminated by a light from a mysterious source. Every one of her features is perfectly visible, while the young man's face is shadowed. The rest of him is easier make out. He is obviously young and his jaunty pose and elegant clothing exude confidence. His body is fully inside the frame of the picture, but not by much. He seems to have just stepped in from another world.

The Tempest's ambiguity has baffled its viewers for hundreds of years because it defies preexisting conventions for understanding paintings of the period. We are always reading art through known codes and precedents,

even when those codes are unconscious. Nothing can take place between viewer and image without them. Most people have had the experience of seeing a work of art that is simply unintelligible to them. It doesn't mean that the work can't be comprehended. It means that the viewer's entry is blocked by a lack of orientation. The image can't come into view because it defies expectation, and expectation determines to an enormous degree what we actually see. I remember walking into a large hotel lobby of some architectural complexity and looking down a corridor at a person standing at its far end. I didn't recognize the person for a couple of seconds, and then, with a sudden shock, I realized that I was looking at a reflected image of myself. I needed to know that the wall was a mirror before I could see myself in it.

Very good and very bad paintings are often confused. A very good work may defy codes to a degree that renders it not only nonsensical but irritating to those who see it, and because of this viewers summarily pronounce it bad. Innumerable despised works have gone on to command prices in the art market that take one's breath away. And yet, although sophistication in a viewer may help orient him, it may also bar understanding. After all, those who have been most spectacularly wrong about works of art were usually people who wrote about art for a living. Rigid expectation is blinding. *The Tempest* is a painting that seems to wriggle out of the best-laid art historical interpretations, but just because we can't name the characters in the painting or place them inside a known narrative doesn't mean that the work defies recognition or that it's meaningless.

If the painting is an allegory, it was probably, as Settis argues, an intentionally obscure one, a secret, known to the painter, his young patron, and perhaps a few other cognoscenti.[6] *The Tempest* was privately owned, by the same man who owned *La Vecchia*, Giorgione's great portrait of an old woman that hangs beside *The Tempest* in the Accademia. *La Vecchia* once had a painted cover that could be opened like a cabinet. The cover, now lost, was a portrait of a man in a fur coat. But the secrecy and seduction involved in opening up one painting to reveal another demonstrate the refined pleasures of looking that were at work in painting at the time. *The Tempest*, it seems to me, is about voyeurism itself, and it isn't static, but reveals a game of glances in an imaginary place. Bewildered, the spectator, who is always "I," is drawn into the mysterious otherness of the nude woman. She has caught my eye. She appears to see me, but her body is turned in the direction of the young stranger in the

foreground, who is also looking at her. But has she seen him? There is nothing in her relaxed posture or her gaze to suggest that she knows he is there observing her. And she is not alone. She has a child at her breast, a fact that distances her further from the two spectators, "me and that other guy"—one outside and one inside the painting. The lovely woman is not a reclining odalisque. Her erotic presence is defined by the fact that in this moment of nursing motherhood she is more unattainable than if she had no child beside her.

A lot has been written on the male gaze in painting. Much of it is true. In many paintings with an erotic theme, the spectator is generally acknowledged from inside the painting itself to be a man. What has been discussed less is that women hop very easily into a man's shoes when looking at such a painting. And if it is true, and I think it is, that we all partake of both the male and the female in our heads, then the sexual mobility we have when we look at a painting or read a book is more liberating than constraining.

The drama of looking depicted in *The Tempest* is a reflective one. I, as spectator, am made conscious of my status as voyeur, which in turn binds me to the man in the foreground. His presence destabilizes my position as someone securely outside the canvas, and the teetering effect it has on me creates an awareness of painting as the illusory projection of an artist. Whenever we look at a canvas, we occupy the position once held by the painter, who has now disappeared—that hidden body or ghostly presence behind every canvas. Even self-portraiture has this effect—the image that remains of a living face and body, now immobilized in paint. Giorgione's picture coaxes us into a scene that announces itself as a dream or an inner vision. Just as when we examine the backgrounds in a Leonardo painting, we know that we are looking at an emotional landscape, we know that the countryside of *The Tempest* is not a representation of a real place. The weather is bad, but nobody seems to notice. If there is a wind, the trees are not much disturbed by it. We have stepped into the mirroring realm of the imaginary. If Anderson is right, and the young man with the shadowed face is wearing the colors of a group of young patrician players, what could be more appropriate to this painting than an allusion to theater and art, a world that enchants us through our eyes? In that case, the youth would become a human image of artifice which, by extrapolation, would announce the presence of the painter himself.

Giorgione died when he was only thirty-two years old. Legend has it that he caught the plague from his mistress. He was always young. And it seems

to me that the young man in the foreground doesn't look very different from the self-portrait Giorgione painted of himself as David. It's just a thought. The features of the wanderer are perhaps too blurry to be identified with any certainty. But even if, by some miracle, a scholar discovered a letter written by Giorgione in which he explained all the references in this strange canvas, it would not *solve* the painting. One can't *understand* an image by placing a narrative beside it.

I do know that I have never loved a painting I can master completely. My love requires a sense that something has escaped me. This quality of cryptic excess may be responsible for the language people use to talk about seeing art, as if an inanimate thing were endowed with an elusive, almost sacred power. In a culture flooded by facile images that race past us on a screen, peek out at us from magazines, or loom over us in a city street—pictures so heavily coded, so easily read that they ask nothing of us but our money—looking long and hard at a painting may allow us entry into the enigma of seeing itself, because we must struggle to make sense of the image in front of us. *The Tempest* resides in Room Ten in the Accademia in Venice. I think it will always resist my understanding, and that is why I will keep going back to look at it.

Vermeer's
Annunciation

Every painting is always two paintings: the one you see and the one you re-member, which is also to say that every painting worth talking about reveals itself over time and takes on its own story inside the viewer. With Vermeer's work that story probably lasts as long as the person who sees it. This is my own unfinished story of looking at one of his paintings. Before I walked through the doors of the National Gallery of Art in Washington to look at its historic gathering of twenty-one of Vermeer's works,[1] I was paging through the cata-logue and turned to *Woman with a Pearl Necklace*. I had never seen the original, although I had admired it in reproduction many times, but suddenly, for rea-sons I didn't fully understand, this painting of a woman holding up a necklace in the light of a window jumped out at me, and I walked into the museum already in its grip.

I spent four hours in the gallery, two of which were spent solely in front of *Woman with a Pearl Necklace*. I looked at it from close up. I looked at it from several feet away. I looked at it from either side. I counted drops of light and scribbled down the numbers. I recorded the painting's elements, working to decipher the murky folds of the large cloth in the foreground. I noted the woman's hands, her orange ribbon, her earring, the yellow of her ermine-trimmed jacket, the mirror frame, the light. I never touched the painting, of course, but once I was reprimanded by a guard. Perhaps my nose came too close to the paint or perhaps my obsessive focus on one painting struck him as slightly deranged. He waved me off, and I made an attempt to look less awed and more professional. There was a bench in that room, and after my dance of distances, I sat down on it and looked at the canvas for a long time. The more I looked at it, the more it overwhelmed me with a feeling of fullness and mys-tery. I knew what I was looking at, and yet I didn't know. I had to ask myself what I was seeing and why it had become an experience so powerful I felt I couldn't have lasted another hour without crying. It seemed to me that both because of and despite its particularity, *Woman with a Pearl Necklace* was some-thing other than what it appeared to be. This is an odd statement to make about a painting, which is literally "appearance," and yet I couldn't help feel-ing that the mystery of the painting was pulling me beyond that room and its solitary woman.

Every viewing of a painting is private, an experience between the spec-tator and the image, and yet I would wager that the feelings evoked by this painting are remarkably similar for most people, especially for those who

JAN (JOHANNES) VERMEER
Woman with a Pearl Necklace
c. 1662–65

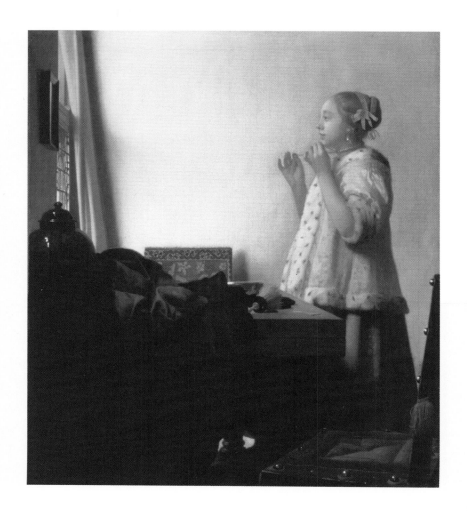

aren't burdened with historical interpretations and the problem of puzzling out Vermeer's intentions. Even the most cursory glance at Vermeer scholarship suggests that there is much disagreement. But I am not an art historian, and those disputes won't come into the story until later. My intention that day was simply to look at this painting, to study it with fresh eyes and to let the painting and only the painting direct my thoughts. In that gallery in the museum I looked at the profile of a young woman who is apparently looking at herself in a small mirror. The mirror is only slightly larger than her face and is represented by its frame only. In fact, the viewer assumes there is glass in the frame because of the way the woman stands and gazes toward it. But what we imagine she is seeing—her own face—is not part of the painting. The window is so close to the mirror, and its light is so clear and dominant on the canvas, that whether she is transfixed by the mirror or by the window isn't entirely clear. My first impression of the painting was that she was looking at the window, although the longer I looked at it, the less sure I became. The woman's gaze is not dreamy but active, the focus of her eyes direct, and although her feet cannot be seen under the shadowed folds of her skirt, they seem to be firmly planted on the floor. Her soft lips aren't smiling, but there is the barest upward tilt at the visible corner of her mouth. And yet there is no feeling that she is about to smile or that her expression will change any time soon. Her hands aren't moving either. She isn't tying the necklace. She has stopped in midgesture and is standing motionless. One look at *The Lacemaker*, a painting in which a girl's fingers are caught in action, confirmed for me that the hands of the woman with the pearls are frozen. In fact, the painting is stillness itself—a woman alone and motionless in a room. I am looking in at her solitude, and she cannot see me.

In a number of Vermeer's paintings, the spectator is seen. *Girl with a Red Hat* and *Girl with a Pearl Earring* are paintings in which the spectator and the subject exchange looks, and although neither of these paintings is large, each depicts a partial rather than a whole body. We see only the upper body of the girl with the hat, and only the head and shoulder of the girl with the earring. This focus on faces creates intimate access into the painting for the viewer— two faces meet for what becomes an eternal moment. On the other hand, the woman with the necklace doesn't acknowledge the presence of any onlookers, and the viewer is barred from entrance to the room on two counts. First, the small size of the painting, which holds her entire body, exists in another

scale from that of the onlooker; my dimensions are radically different from hers. And second, the entire foreground of the painting—a large chair and a table draped with dark cloth and topped with a gleaming black covered jar would have to be shoved aside before anyone from the viewer's position could even imagine stepping into the luminous space she occupies.

So what's happening in this room? The woman trying on her necklace is young, pretty, and beautifully dressed, but she is not preening in front of her reflection. Nothing about her expression or posture suggests vanity. On the table, it is possible to see part of a bowl and a powder brush, but these objects, even if she has recently used them, are forgotten things. They are pulled into the shadow of the dark foreground, which forbids entrance and makes the empty space of light between the woman and mirror more dramatic. While I was looking at the painting, I realized that I had picked it because of its empty center, a quality that distinguished it from other related works. The painting was hanging in a room with three other great Vermeer paintings of women alone: *Woman in Blue Reading a Letter*, *Young Woman with a Water Pitcher*, and *Woman Holding a Balance*. In all of these paintings women occupy a space that is illuminated by a far window on the left as you face the canvas (although the window in *Woman in Blue* is implied rather than depicted by the source of light that illuminates her page). In the three other paintings there is a map or painting somewhere on the wall in the room. In *Woman with a Pearl Necklace*, there is nothing but light.

It turns out that Vermeer changed his mind. In Arthur Wheelock's short essay on the painting in the catalogue, which I read fitfully while I was in the museum, he writes that neutron autoradiography of the canvas shows that there was once a map on that shining wall, and moreover, a musical instrument, probably a lute, sitting on the chair.[2] The great folds of cloth in the foreground also covered considerably less of the tile floor. By simplifying the painting, by allowing fewer elements to remain, Vermeer altered the work's effect and meaning forever. The map, which can be seen in the neutron autoradiograph reproduced in the catalogue, was located behind the woman's upper body, and even in the small and foggy picture in the catalogue, the map draws the viewer back to the wall and gives that surface greater dimension and flatness. By eliminating the map, Vermeer got rid of an object that would have made a geometric cut between the woman's eyes and the window. The map would have interrupted the line of her gaze and disturbed its directness.

And, had it remained, it would inevitably have called to mind a geography beyond that room, the possibility of travel—of the outside. In its final form, the outside is represented only by light. The instrument would have evoked music, and even the suggestion of sound would have changed the painting, distracting the viewer from its profound hush. By increasing the size of the cloth in the foreground, Vermeer further protected the woman from intrusion. This technology of looking through a painting and exposing it like a palimpsest gives a rare glimpse into art as a movement toward something that is not always known at the outset. As he worked, Vermeer's idea about what he was doing was transformed by what he himself saw, and what he saw during the process and came to paint was something simpler and more sacred than what he had imagined at first.

But the question remains: Why is this woman so endlessly fascinating, and how does the painting work its magic on the viewer? That many people feel this is clear, but each one explains it differently. In his book *Éloge du quotidien*, Tzvetan Todorov both includes and exempts Vermeer from his subject: daily life in Dutch painting of the period. He argues that by being the highest example of this genre, Vermeer transcends it, that by taking the everyday to another level, it ceases to be everyday.[3] Notably, Todorov tells his reader to look "again and again" at *Woman with a Pearl Necklace*. The ordinary act of trying on a necklace in front of a mirror doesn't seem ordinary at all. Vermeer, he says, uses genre themes but doesn't submit to them. I would take this further and say that while *Woman with a Pearl Necklace* uses the Vanitas theme as a point of departure, linking it to other paintings of the period showing women at their toilet, Vermeer subverts the theme. This subversion creates ambiguity, and ambiguity creates fascination. Ambiguity in Vermeer, however, is strangely untroubling. This isn't the uneasy ambiguity of Henry James, for example, where conflicting desires hang in precarious balance or secret motives are buried in appearances. And it isn't the moral ambiguity that Todorov writes about in paintings of the same period in which moments of ethical indecision are depicted.[4] Vermeer presents the viewer with a painting that resembles other paintings about vanity, and since he lived inside the world of painting and painters, this is clearly intentional, but to assume that the painting must be about vanity because it evokes that tradition is to miss the point. In fact, the longer I looked at the painting, the less its trappings mattered and the more I felt that I was looking at the enigmatic but unalterable fact of another

person's life in a moment of sublime quiet and satisfaction. The mirror suggests Narcissus only to make it clear that he has no place here. The woman's gaze doesn't convey desire, but the end of desire: fulfillment.

In Edward Snow's *A Study of Vermeer*, an ambitious exploration of looking at the master, the author reiterates throughout his essay that Vermeer's great paintings aren't moral but ontological. When I read his treatment of *The Procuress*, I was struck by how his reading corresponded to what I've always felt about that painting but had found hard to reconcile with its title. Snow argues that despite its vulgar subject, the painting, which has a woman as its radiant focus, conveys the peace of an erotic relationship so natural, so happy, it defies moral analysis.[5] In short, the woman of *The Procuress* isn't bad. All anyone has to do is look at her for a while to know that badness and goodness are not at issue here.

If every painting, particularly those of private life, makes the onlooker a voyeur, most of Vermeer's women undercut erotic voyeurism with their autonomy, very much in the way that the woman in *The Procuress* defies the leering onlooker in the painting itself, not by recognizing his leer but simply through the power of her being. It isn't that Vermeer's women are without eroticism—their physicality is undeniable—but rather that they resist definition as erotic objects. This fact is all the more marvelous in a painting where a man has got his hand on a woman's breast. Even when his women glance back at the viewer or look directly out of the painting, even when his subject is breathtakingly young and beautiful—as is the case in *Girl with a Pearl Earring*—she appears to be in full command of a separate and whole desire that is hers, not the spectator's. And although the subject of *Woman with a Pearl Necklace* invites voyeurism, it deflects it completely. Because she appears to be the object of her own gaze, what she is seeing repeats what the viewer of the painting sees, although from another angle. The mirror then would seem to be the narcissistic *end* of all this looking: "I love what I see." This is exactly what happens in the Frans van Mieris painting *Young Woman before a Mirror*, where the dark frame of the mirror becomes the imaginary focus (because the woman's reflection isn't seen) of sensual desire for the self. But it doesn't happen in Vermeer's painting. And it doesn't happen because we know from the woman's face that what is being reflected there isn't self-love, and more importantly because the entire far side of the canvas is opened up by the astonishing light that comes through the window.

While I was sitting on the bench in front of the painting, a word popped into my head. I didn't search for it. It just came. *Annunciation*. That bench was about six feet away from the painting, and from that distance the light of the pearls disappeared. They are softly illuminated with the most delicate dabs of paint, and I could see them very well when I was standing close to the picture, but from my bench I didn't see their light anymore, only the woman's hands raised in that quiet, mysterious gesture, and the radiance of the window light, a light that no reproduction can adequately show. When I turned my head, almost as if to shake out the thought, I saw one of the exhibition's curators, Arthur Wheelock, standing right beside me, so I stood up and boldly asked: "Has anyone ever thought of this painting in terms of an Annunciation?" He looked a little funny at first. Then he shook his head, and said, "No, but that's very interesting. I had thought of it as a Eucharistic gesture." And then, at the same time, we both lifted our hands as if to imitate the gesture of the woman with the pearls, which is itself an echo of the gesture from early Renaissance paintings in which Mary raises her hands toward the angel who comes to tell her that she is pregnant with God's son. Mr. Wheelock then thanked me a couple of times, which was very nice of him, and the simple fact that he didn't consider this idea an outrage gave me the confidence I needed to think it through. This thought, or maybe little epiphany, didn't leave me. I knew there were "Annunciations" buried in my brain that had been triggered by this Vermeer painting. Later, when I was reading through the catalogue more carefully, I discovered that among the few things known about Vermeer's life is that he was summoned to the Hague in 1672 as an expert on Italian paintings.

It is impossible to know what art Vermeer saw or what places he visited in Italy—if indeed he went to Italy at all. He converted to Catholicism before his marriage, and the painting of St. Praxedis shows that at least once he dealt with a specifically Catholic subject, but no one knows whether it was a commissioned work or not. Nevertheless, Catholicism, with its many female saints and the central position of the Madonna, emphasizes women far more than Protestantism does, and Vermeer's art suggests that, at the very least, this feminine side of his new faith must have appealed to him. Wheelock mentions the Eucharist in his catalogue essay.[6] Snow writes, "The woman appears not to be so much admiring the pearls in the mirror as selflessly, even reverently, offering them up to the light: it is as if we were present at a marriage."[7]

Two sacraments. Both thoughts are similar ways of explaining an experience of looking at something that feels holy. For Todorov, Vermeer's ascension is into art.[8] The artist leaps beyond realism into the enchanted space of art itself, a leap that anticipates a much later aesthetic. All these readings are ways of explaining the magic—the secret that announces itself in the painting and doesn't go away. It may be that Vermeer's ambiguity allows all these readings, that this *is* what the painting *means*, and that like all great art it opens a space of possibility larger than what is circumscribed in lesser works.

Nevertheless, I am going to push my intuition further and suggest that the painting is also rife with allusions to the Annunciation. After I had left Washington and returned to New York, I began mulling over the Annunciation problem and understood that the resemblance I had seen was not only gestural, but spatial. On a hunch, I turned first to Fra Angelico, who painted several Annunciations, and in his work among the San Marco frescoes in Florence, I found an image as motionless as Vermeer's *Woman with a Pearl Necklace*. Intended for monastic meditation, the picture is stripped of all ornament and architectural detail. The event takes place in a bare gray cell. As was conventional, the Virgin is on the right as you face the painting, the Angel on the left, but in this work, there is nothing between them. The space is filled by a soft light that comes from the left, illuminating the back of the angel and the front of the Virgin. But it is also filled by Mary's gaze. Her eyes, turned toward Gabriel, are the hypnotic focus of the work, and although her posture doesn't resemble Vermeer's woman, it must have been her eyes that my ruminations on *Woman with a Pearl Necklace* had called forth.

And yet, there was a particular painting I had in mind, although its details had been lost to me, and in it was a Virgin with uplifted hands. I became convinced that I had seen the work in Siena almost seventeen years ago and knew that I would recognize it if I came across it—and I did. It was a work by Duccio in the Museo dell'Opera del Duomo in Siena. That it was by Duccio isn't strange. His madonnas in the same museum are among my favorite paintings in the world, and when I was there I spent a long time with them. Because Duccio inhabits that borderland between the icon and the human face of the Renaissance, I have always found his figures achingly beautiful. In Vermeer, I have seen something similar. The threshold is a later one, but in Vermeer the sacred and the human are also joined, and the memory of the icon lives in allegory—the form of allusion in Dutch painting of the time.

DUCCIO (DI BUONINSEGNA)
Annunciation of the Death of the Virgin
c. 1308–11

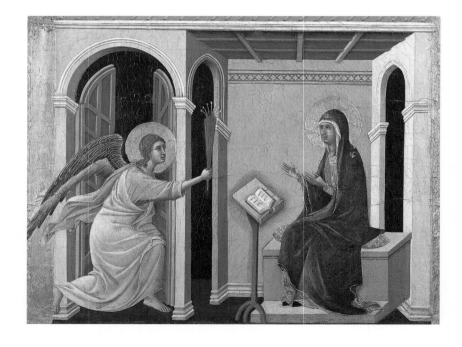

But the Annunciation I remembered by Duccio when I saw it reproduced was *Annunciation of the Death of the Virgin*. So surely, if Vermeer knew his Italian art, he would be making no specific reference to this work. After digging more, I discovered that the Virgin is shown with raised hands in a number of Annunciation paintings, that this posture does belong to the iconography of gesture in both Italian and Flemish paintings of the period. Two examples to turn to are one by Giusto de' Menabuoi from 1367 and one by Dieric Bouts painted a hundred years later. [9]

At the recommendation of a friend, I turned to a book by Michael Baxandall, *Painting and Experience in Fifteenth Century Italy*. Among other things, the author discusses physical gesture in paintings of the period, noting that "the painter was a professional visualizer of holy stories" for a public that through spiritual exercises was well versed in a similar task—seeing in their minds events from the lives of Christ and Mary. He cites a sermon by Fra Roberto Caracciolo da Lecce on the Annunciation as an example of popular preaching on the Immaculate Conception. In the sermon, Fra Roberto first discusses the "Angelic Mission." One of its categories is *time*: the Annunciation took place on Friday, March 25, either in the morning or at midday, during the spring when the earth was blooming after winter, an idea only broadly relevant to the Vermeer painting, in that it is obviously midday light that pours through the window. The "Angelic Colloquoy," also discussed in the sermon, is a dissection into five stages of the biblical passage in Luke. Baxandall points to the Colloquoy as a guide to understanding the Virgin's gestures in paintings that depict the Annunciation at its various moments from the first stage, *Conturbatio* (Disquiet), to the last, *Meritatio* (Merit). [10] What Baxandall's discussion clarified for me was that although pictures of the Virgin were heavily coded, they weren't dictated by the Church. Within that code there was significant range for the painter's own vision of how the Virgin's body would express Disquiet, for example. The painted images are a combination of convention, spiritual teaching, and imagination.

But it was the second stage of the Colloquoy that grabbed my attention: *Cogitatio*, or Reflection. The Virgin receives the salutation of the angel and reflects on it. Knowing this places the mirror in *Woman with a Pearl Necklace* in a whole new context. Isn't that mirror, contiguous to the radiant window, a buried allusion to the Annunciation, and very likely to this second stage—Reflection?

PETRUS CHRISTUS
The Annunciation
c. 1450

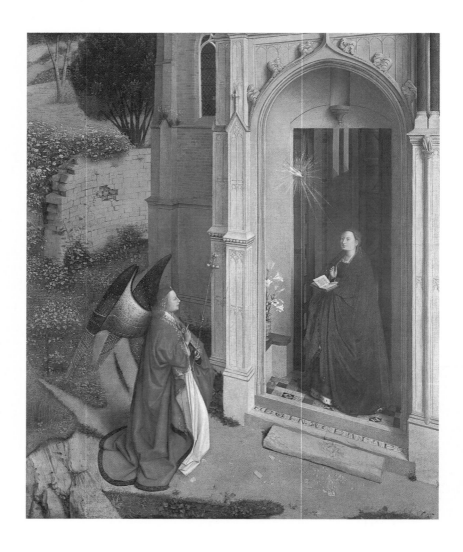

Because I wanted to see more Annunciation paintings, I took a tour of the Metropolitan Museum, looking for them at random. I turned a corner and ran straight into the Petrus Christus painting of the event (a work that has also been attributed to Jan Van Eyck) and was stopped in my tracks. I had seen it before but had never registered it deeply in my private catalogue of remembered paintings. Although the Virgin's gesture is not like that of the woman with the pearls (she has one hand near her neck, clasping the folds of her cloak, while the other holds a book), I had discovered a Virgin whose posture is as erect and whose gaze is as clear and unflinching as Vermeer's woman. Between the Virgin and Gabriel is the Holy Spirit, depicted as a bird that gives off painted rays of light. The Virgin stands at the threshold of a door dividing the painting between inside and outside, placing the angel beyond the domestic interior. Looking at this painting, it became even more apparent that my insight about the Annunciation—half-unconscious as it was—rose out of not one, but many diffuse references in Vermeer's painting—that not only the woman's hands suggest the Annunciation, but the light from the window, her gaze, her posture, and that it is this accumulation of detail that produces the painting's feeling of quiet sanctity.

There is one further thing in *Woman with a Pearl Necklace* that confounded me from the instant I noticed it in the gallery. Above the window frame near the folds of the curtain is a small egg-shaped detail. The truth is that when I first looked at it, I thought: What's that egg doing there? That "egg" is probably part of the window's architecture, and yet it appears to be almost distinct from it. In the museum, I went right up to it, but the closer I came, the harder it was to decipher. It appears as light and shadow itself, or perhaps paint as light and shadow itself. But what's it doing there? We know that Vermeer changed the world he painted as he saw fit. Although he was interested in creating a feeling of realism, he changed objects, colors, shadows, even perspective at will to make what he wanted to make. Surely, he wanted that oval "thing" on his window or he would have eliminated it. I started looking for that shape on other opened and shut windows in Vermeer's work but couldn't find it. This round architectural detail contrasts with the linearity of the rest of the window. It echoes the shine of the woman's earring, the subtle gleam of her pearls, the roundness of the dark covered jar, and the bowl, and the roundness of her own form—the flesh of her face and arms—all the while looking decidedly egglike. No wonder scholars have gone crazy interpreting Vermeer.

There is allegorical allusion in his paintings, signs that can be read, but which are also hidden inside ordinary rooms and in the faces of "real" people, and necessarily so, because these paintings are neither one thing nor the other. They are both.

Conception and pregnancy—that's what the Annunciation is about, after all—an explanation of the divine presence inside a human being. Natural pregnancy and its role in Dutch painting is an old dispute, and it pops up again with Vermeer, although not in regard to the woman with the pearls. Albert Blankert writes that Van Gogh was the first person to suggest that the *Woman in Blue Reading a Letter* is pregnant and points out that the belly of Vermeer's virgin goddess Diana "looks thoroughly bulbous to twentieth century eyes" as well.[11] My personal response to this is that Diana doesn't look nearly as pregnant as the woman in blue who appears to be on the brink of giving birth. No doubt the fashion of the day promoted the big belly as a sign of beauty, but this protruding belly must have been regarded as beautiful for the very reason that it mimicked pregnancy. When he died at forty-two, Vermeer left ten minor children. Obviously, pregnancies came and went at a rapid clip in his own household, and he must have had intimate knowledge of pregnancy in all its stages. Vermeer's attention to the physical details of domestic life and to the women who inhabit it would necessarily have included the changing shape of women themselves. How could it not?

Neither her body nor her clothes tell us whether the woman with the necklace is pregnant. The hint of her pregnancy is in the painting's relation to the Annunciation, to a miraculous beginning. It is in her gaze and in the luster of the pearls which signify, among other things, purity and virginity. It is in her unmoving fingers that call to mind the nearly uncanny quiet of physical gesture in early Renaissance paintings—where the human body speaks not only for itself but also articulates the codes of religious experience. The truth is, however, that the whole painting conveys enclosure and privacy. The room with its closed window and single egg-shaped detail, the rotund covered jar in the foreground that blends with the vast piece of cloth, are all lit by the enchanted light that comes from beyond it. We are allowed to look at a world sufficient unto itself, a world that is lit by the holiness of an everyday miracle—pregnancy and birth—perceived in the painting as a gift from God, shining in God's light, which is also real light, the light of day. The magic here is of being itself, never more fully experienced than in pregnancy—two

people in one body. Isn't this why the woman communicates no desire—only completeness—and why the light seems to hold her as much as the mirror?

Nevertheless, I want to emphasize that my reading is not meant to reduce the painting to an Annunciation either. Vermeer brought the miraculous into a room just like the rooms he knew, and he endowed the features of an ordinary woman with spiritual greatness. *Woman with a Pearl Necklace* is a painting that makes no distinction between the physical and the spiritual world. Here they are inseparable. Each merges within the other to form a totality. In Vermeer, the gulf between the symbol and the real is closed. *Woman with a Pearl Necklace* is a work of reflection at its most sublime. The viewer reflects on the woman who also reflects and is reflected, and through this mirroring of wonder, Vermeer elevates not only his creature—the woman in the painting—but all of us who look at her, because looking at her and the memory of looking at her become nothing less than an affirmation of the strangeness and beauty of simply being alive.

The Man with
the Red Crayon

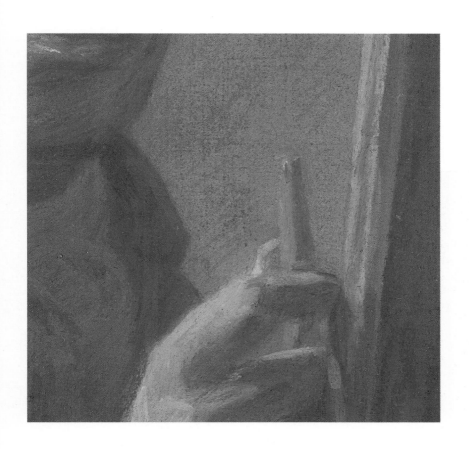

Jean-Baptiste-Siméon Chardin's biography is a collection of fragments, a life cobbled together from official documents, observations and stories told by friends, and contemporary critiques of his work. As far as I know, there are no extant letters by Chardin, no journal, no intimate record of any kind. The bones of his life are interesting anyway, as much for what is missing as for what is known. The artist was born in 1699 in Paris, a city he never left. His father was a craftsman who specialized in the design and construction of billiard tables. Chardin was not trained at the Royal Academy of Painting but at the less prestigious Academy of Saint Luke. Nevertheless, in 1728, he gained admission to the Royal Academy as "a painter skilled in animals and fruit." He married the twenty-two-year-old Marguerite Saintard at Saint Sulpice in January of 1731, and ten months later they baptized their son, Jean Pierre. Two years after that, their daughter, Marguerite Agnes, was born. In 1735, Chardin's twenty-six-year-old wife died, and then, either in 1736 or 1737, his small daughter died as well. Chardin exhibited regularly at the Salons, and in November of 1740 was presented to Louis XV at Versailles and gave him two pictures—Saying Grace and The Diligent Mother. In 1744, he married a widow of comfortable circumstances, Françoise Marguerite Pouget. By 1754, Chardin had received his first royal pension and his son had won the Academy's Grand Prix competition. Biographers underscore that Chardin hoped Jean Pierre would become a history painter and surpass him by taking on what was considered a far loftier genre than either still life or the domestic scenes he worked in himself. Chardin became the treasurer of the Academy, and his son received a stipend to attend the Royal Academy at Rome.

In 1757, father and son become embroiled in a dispute over the son's inheritance from Chardin's first wife. That same year, the painter was granted living quarters in the Louvre and, in 1761, he became officially responsible for hanging paintings at the Salon exhibitions, something he had done unofficially in the past. In his critical pieces on the shows, Denis Diderot made much of Chardin's cleverness when it came to these arrangements, noting that the astute artist hid bad paintings and displayed good ones or hung a terrible work beside a great one to bring out the latter's merit.[1] While returning from Rome the following year, Jean Pierre was kidnapped by pirates. In 1767, he reappeared in Venice, where he is believed to have committed suicide sometime during the next two years. Chardin continued to exhibit paintings at the Salons and his royal pension was increased. In October of 1779, he was too sick

to go to an Academy meeting, and in November the artist died in his quarters at the Louvre. He was eighty years old.

These pieces of a life suggest that the artist was reasonably successful, that despite his work in lowly genres, he was honored as a gifted painter while he was alive. He must have suffered, must have mourned his first wife and daughter, and must have had at best a complicated relation with his son. But Chardin's art is separate from the story of his life, and in his case all that can be argued is that whoever he was, his paintings are works of great feeling, feeling that inevitably transcends their subject matter. That is the real mystery of this artist, one articulated first by Diderot, who was overcome by the painter's canvases and called the artist "a great magician." [2] Years later, Proust, who loved Chardin's work, articulated the same mystery. In his essay on the painter, he escorts an imaginary young man around the Louvre, pauses in front of the Chardins, and says to his fictional companion,

> You're happy aren't you? But really you have seen nothing more than a well-to-do tradesman's wife telling her daughter that she had made mistakes in her wool work, a woman with an armful of loaves, … and even worse, table and kitchen ware, not just Dresden chocolate pots and pretty things of that sort, but such as you consider ugliest, like raw fish lying about on a table, and sights that turn your stomach….[3]

But Proust was no more able to explain how looking at dead rabbits and strawberries and glasses of water and raw fish can elicit happiness in the viewer than Diderot was. I have always felt deeply moved in front of paintings by Chardin, have always felt that the canvases invoke a strong human presence even when they show nothing more than a few pieces of fruit and a cooking pot. I also know that although still life is domestic in character, many still lifes, even great ones, are not particularly emotional works. By the time I walked into the exhibition in Paris at le Grande Palais in October of 1999, I had already decided that I would try to uncover what it is about these canvases that has so moved the people who look at them.

The show in Paris was curated by Pierre Rosenberg, the director of the Louvre, who had also curated a comprehensive exhibition of Chardin twenty years before on the bicentennial of the painter's death. The first two rooms of the 1999 exhibition were mostly still lifes. I decided to begin my own looking by examining two of the early paintings that clinched Chardin's admission

to the Academy in 1728: *The Ray Fish* and *The Buffet*. These two paintings have several striking features. They are both considerably larger than many of Chardin's other paintings, and they have many more things in them. Their backgrounds, both walls, are more detailed than in the mature work, and they include living animals, a cat in *The Ray Fish* and a dog in *The Buffet*. Both are impressive and technically brilliant, but they are not yet what I have come to recognize as quintessential Chardin. They are busier works, and standing before them, there was something about the two animals that bothered me. There were several cats early in the show, and I had the same response to them. It was as if the living creatures intruded on *my* Chardin, and it is true that for the most part the artist stopped painting them. There was one notable exception to this rule in the show: the little dog in the foreground of *The Diligent Mother* which, unlike the earlier animals, belongs securely to the painting and its composition. He is lying down, very quietly, and looking out at the viewers beyond the canvas, and here he is paired with people, not only objects or dead game. Some critics have suggested that Chardin abandoned animals because he didn't want to compete with Oudry, who specialized in them. And while there may be some truth in this, it was surely a secondary consideration for an artist like Chardin, whose work suggests that he quickly established an aesthetic position, the result of both the way he liked to work and a profound understanding of the nature of painting itself.

Animals won't sit still, a fact that must have deterred Chardin from a continuing interest in them. On the other hand, dead game are as conducive to placement as any object, and Chardin's paintings of dead rabbits and birds (of which there were many in the exhibition's second room) are almost unbearably poignant, and ironically, more suggestive of life than the living creatures. A painting of a dead hare with gunpowder and game bag presented on a shallow shelf against a stone wall is a case in point. As I looked at this painting, I sketched its outlines quickly—the hare's head hanging over the ledge, a paw near its chin, its opened legs stiffened in rigor mortis, the cord that hangs between them and down the side of its long body. I moved close to the painting, then farther away from it. It is true that there is pathos in the composition itself, in the way the animal is posed, the nearness of its paw to its obscured face, the brutality of the hunt suggested by the cord, and the fact that the background suggests emptiness, the simple void of a wall, nuanced with color. On close inspection of the canvas, I began to notice Chardin's use

of red—the recurring red-brown in the animal's fur, but also a truer red, and a red that verges on pink, which repeats itself throughout the animal's carcass—the touch of red in its lower ear, in its paw, and near its genitals. The clarity of this red from up close and its overtly painted quality is far more hidden in reproductions than in the actual painting—but the fact that the viewer can see it affects the painting's meaning. The inanimate subject matter, a dead hare, and its medium, the paint, create a balance between the convention of illusion—"I am looking at a dead hare"—and the truth announced by canvas hanging on the wall—"I am looking at a painting." This balance is crucial to Chardin. It is what distinguishes his paintings from many of the Dutch who preceded him (Vermeer and Rembrandt are exceptions). Both Dutch still life and its genre scenes are as a whole much smoother than Chardin's. The use of color is far less free, and even when you get very close to a work, the illusionary quality of the canvas persists.

Chardin's choice of motionless subjects is essential to maintaining this balance between illusion and painterliness. It is possible to argue that all of Chardin's mature paintings are still lifes, although they are not all *natures mortes*. Whether his subjects are animate or inanimate, they are depicted as unmoving. A battle scene by Géricault or a canvas by Jackson Pollack both suggest violent motion, but the truth is they too are still. The sword will never fall. The paint is no longer dripping. Chardin chose subject matter that would mimic the frozen, silent character of the canvas itself. Pictures of objects, food, dead animals are obvious choices, but as has often been noted by Rosenberg and others, Chardin's people don't move either.[4] The woman with her spoon in her teacup is stopped in reverie. The little girl with the shuttlecocks is not playing the game. She is staring into space as one of her hands rests on a chair. A little boy watches a top, absorbed and silent. A governess is leaning forward in a listening posture. The child has been telling her something, but he appears to have taken a breath between sentences. The laundress has paused during her work. The woman returning from the market leans against the cupboard after laying down her bread. Even Chardin's young bubble blower seems to have blown until the bubble has reached a good size and is now fixedly admiring his work while another, smaller child looks on.

Taken as a whole, the human figures (almost all of them women and children) share this quality of pause, and as I studied the portraits and the figures in the genre scenes, I saw that in that moment of distraction

or thoughtfulness their facial expressions are very similar. Although not identical, the range of expression among Chardin's subjects is tiny, from sober inwardness to the barest hint of a smile. Only on the face of Chardin's friend, Charles Théodore Godefroy, is there a true smile, and it's a slight one at that. Again I thought of the Dutch, of Jan Steen, for example, whose people laugh and talk as well as think. As I walked very slowly from one room to another, I wanted to block out the people who were looking at the paintings with me. Because I was slow and sketching, I was jostled and pushed and elbowed. When I moved out of the way for a man and a woman who had stopped for a moment in front of *The Laundress*, I found myself looking at them rather than at the painting. Their expressions resembled each other's, and they resembled the characters in the paintings—attentive, relaxed, a slight upward turn at the corners of their mouths. Later that same evening, I noticed that this is not the expression people wear on the Métro. Travelers look duller, unengaged, absent. Although I doubt that Chardin consciously painted figures whose expressions would mirror those of the viewers who looked at his canvases, contemplation of a painting also constitutes a pause from daily life. It is both an external experience and an internal one. The viewer absorbs the effect of the picture and responds quietly, inwardly. Through images of deliberate stillness, Chardin's canvases enhance rather than interrupt the continuum between viewer and painting, and this stasis makes the effect of his brush strokes and colors more emphatic.

Again I noticed the recurrence of reds in the genre scenes. The woman takes her tea on a red table with an open drawer. The red reappears in the thinnest stripes of her silk dress and more notably in her cheeks, lips, ear, and hand. There is a rusty tone to the olive background that is muted and mottled. The repetition of color and the relation of one color to another, red to green to brown, offset by blue and the bluish steam from the tea, is not mimicking "nature" or "truth," as Chardin's contemporaries liked to think. The repetitions of color in the composition are an insistence on visual harmonies that aren't natural so much as part of an ideal vision, one that creates tangible, painted repetitions that connect one thing to another. When painted by Chardin, human beings and objects are joined together in a grand scheme in which separation is downplayed in favor of wholeness.

By the time I had finished looking at the genre paintings—works Chardin took up and then abandoned for a return to still life—I was going

from one painting to another with two words in my head: *red* and *repetition*. The words, as is often the case with me, preceded any fully articulated thoughts, but they suggested two essential and related ideas. Later, when I returned home to New York and read the catalogue, I saw that Katie Scott had written an essay called "Chardin Multiplied," which treats the works of other artists based on or inspired by Chardin, as well as the painter's reproductions of his own canvases.[5] Chardin copied himself. Scott points out that although Chardin's reproductions may well have been lucrative, money alone doesn't explain why he painted some of his works more than once. She argues that the pictures he copied don't betray his subject matter but rather recreate it, because these are paintings about repetition: saying grace, for example, or returning from the market.[6] They embody the idea of routine, sameness, of repeated action. The insight is valuable and may be taken further. Similarity and repetition lie at the heart of Chardin's work. The very act of painting a painting again confirms his investment in stillness. His subject has already been caught. The fidgety model is left behind, and what matters now is the painting itself. After all, a painting is another object, and reproducing that thingness seems perfectly consistent with the artist's temperament.

But I think that it was in still life that Chardin's insistence on repetition became most fully and subtly expressed—and essential to what one might call the philosophy of the paintings and their almost uncanny emotional resonance. Considering its status at the time, Chardin must have returned to still life out of desire. Many of the objects he painted again and again belonged to his own household, and I imagine him picking up the copper pot or the silver goblet and placing it on a table near a couple of other things to prepare another still life, moving it in one direction or another, in and out of the light, remembering it as it was in another work, an object familiar to him now not only as a thing in his house but as a thing transformed by his art, as part of his private vocabulary of images.

Repetition lies at the heart of meaning. Any vocabulary, whether written or visual, relies on recurrence to establish comprehension. Recognition is repetition. Chardin was working inside a well-established language of painting. Viewers had looked at paintings like his before, especially from the Dutch painters whose works were widely seen in Paris at the time, but they had never seen canvases quite like these. The very familiarity of the images, both in terms of painting and in terms of cultural references outside of art—

JEAN-BAPTISTE-SIMÉON CHARDIN

A Glass of Water and a Coffee-pot
c. 1760

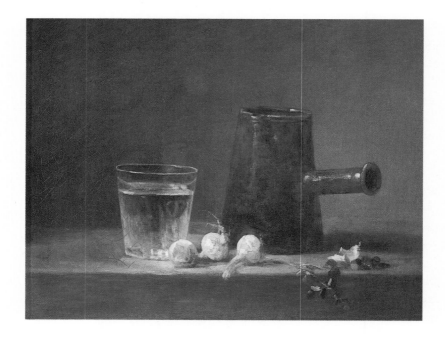

the rendering of a copper pot, for example, that was a staple in all kitchens, high and low—permitted Chardin a greater freedom in their depiction. He used recognition as a catalyst for innovation in his technique.

One painting, to my mind the greatest painting in the exhibition, a painting I have admired for a long time, speaks directly to the "happiness" Proust mentioned in his essay written a little more than a hundred years ago. It is *A Glass of Water and a Coffee-pot*. What the viewer sees is in fact a glass of water, a coffeepot, three cloves of garlic, a few of their fragile leaves, and what is called a branch of fennel by the Goncourt brothers but which doesn't look like what I call fennel, but a delicate sprig of some other plant.[7] The truth is that when I look at this painting, even in reproduction, even in a black-and-white reproduction, it inspires in me an almost inexpressible tenderness that is close to pain, and although my response may be extreme, I have read enough critical writing on Chardin to know that I am not alone. Once ensnared, the painter's admirers gush praise. They feel what I feel—if not for this particular painting, then for another. But again, why do I feel like weeping over a glass of water standing near a coffeepot? A real pot and glass of water would never have this effect on me, unless perhaps these objects had belonged to a beloved person who had died.

It is an austere painting. Rosenberg notes in the catalogue that radiography reveals that initially a bowl of strawberries stood in place of the coffeepot.[8] Chardin changed the painting by simplifying it. The pot is bolder and quieter than the fruit. The arrangement is triangular, and the scale of the canvas is neither very small nor very large. Its size preserves a feeling of closeness without miniaturism. The color scheme is restrained—rust red and brown, white, and olive green touched with black shades in subtle, complex variation. A close look reveals that the brown of the coffeepot is touched by red at its rim to evoke light, a red that recurs on its handle, in blotches of color on its base, and along the edge of the table itself, most notably near the herb and in the garlic stems. But a deeper version of this redness reappears also beyond the pot on the olive-colored wall and near the darkened edge of the canvas itself. And then there is white, the white of the garlic and its detached leaves, the whiteness of the water's transparency and the small touches of white on the pot that indicate light, and the strip of white beneath where the garlic lies, and at the edge of the table, which blends into a smoke of near nothing in the background. The brush strokes are visible even from some distance, and an

impression of dabs, touches, and pricks is fundamental to the effect of the canvas. The stiff peels of garlic so clearly seen from a distance are just strokes of paint when you move close to the work—the clear traces of the painter's hand. Chardin's body has left its mark on the canvas, and even though for many viewers that imprint may be subliminal, it is felt—the simpler the subject matter, the more opulent the human presence. Chardin's brush is like breath on the canvas, and its rhythms embody the omnipresent idea of unity through color, which repeats itself in everything he gives us to see, the invisible harmonies that Chardin thrusts into appearance. The coffeepot, the garlic, and the shimmering glass of water produce recognition in the viewer that goes far beyond the objects themselves, something that happens only in the act of giving those things names. "That's garlic; that's a coffeepot; that's a glass of water." In Chardin these objects are imaginatively reinvented as essences of human dignity. They represent objects but are at the same time not the objects we know. We recognize not only the worth of the painter's labor in the rectangle that hangs in front of us, but we see in the paint the presence of a man who worked with both intelligence and love. I don't think that to mention love in Chardin's work is either mystical or unscientific. Touch lies at the heart of all human life. It is our first experience of another person, and the physicality of Chardin's stroke is evocative of both caresses and touches of reassurance. I am certain that these strokes made by a paintbrush lie at the bottom of Proust's comment that in Chardin one feels the affection a tablecloth has for a table. [9]

Proust's anthropomorphism unearths what we are seeing because the objects we recognize by name as familiar, ordinary things in the world have somehow lost their deadness, their alienation, their separateness when they appear as signs on a Chardin canvas. He has used the visual language of still life in order to change its meanings, and therefore, no matter what some critics may argue, I think that Chardin sheds entirely the moral allegories of his predecessors. His still lifes don't suggest that all is vanity, that domestic comfort is marred by the cruel fact of perdition. These are works that celebrate the ordinary present in relation to the fact of mortality. But there is no horror of death, no hint of the skull, which figures so prominently in other still life. Chardin's genre works are not didactic or pious either, and they evade sentimentality, something Greuze, for example, wasn't always able to do. They are located in a recurring present of domestic life, the world of

CHARDIN
Young Student Drawing
c. 1733–34

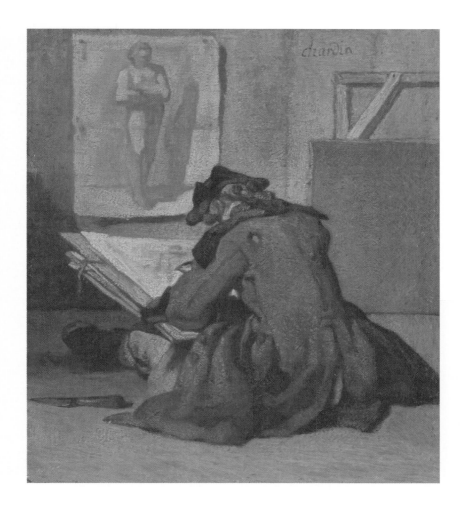

habit, but are free of ethical judgments and promote an aesthetic idea that resists moral lessons.

One of Chardin's contemporaries, Abbé Raynal, wrote about the artist, "His method of painting is singular. He applies his colors one by one, almost without blending them, so that his pictures look somewhat like mosaics, or like pieces built of many parts, like tapestry needlepoint done in cross-stitch."[10] For anyone who has seen Seurat, Raynal's comment may sound rash, but it invites us to reorient our vision, to read backwards and see again the unique quality of Chardin's stroke, a stroke that would have a deep influence on both Cézanne and Manet, and which would lead Vincent Van Gogh to write in a letter to his brother Theo, "I am more convinced than ever that the true painters do not finish their things in the way that is used only too often, namely correct when one scrutinizes it closely. The best pictures ... are but patches of color side by side, and only make an effect at a certain distance"[11] Raynal and Van Gogh saw the presence of the brush. Proust addressed its effect on the viewer. The happiness, the affection is in *the visible touch* of the brush. Chardin's cups and goblets, his plums, peaches, and dead game are reanimated through the pathos inherent in his own gestures.

One of the few quotations from Chardin, one that has been reprinted innumerable times, comes from Charles-Nicolai Cochin in his *Essay on the Life of M. Chardin*:

> One day an artist was going on at length about all he did to purify and perfect his colors. M. Chardin, annoyed at hearing such talk from a man whom he knew to be no more than a cold and careful technician, said to him: 'But who told you that painting was done with color?' 'What is it done with, then?' the other artist asked in surprise. 'Colors are employed,' said M. Chardin, 'but painting is done with emotions.'[12]

In the last room of the exhibition in Paris, I came face-to-face with the painter, or rather with Chardin's own self-image. The pastels, which end the show, were done late in Chardin's life (three of himself and one of his second wife). Although I knew the pastels intimately before I entered the exhibition, I felt rewarded when I arrived at them, because I had never seen so many of the artist's works together, and it was as if the hidden man whose hand I had been admiring from room to room had revealed himself to me at last. The pastels also returned me to a tiny painting much earlier in the show of an art

student viewed from behind. This work is notable because unlike all the other images of people, this young man *is in the act of doing something*—drawing, sketching an Academy study in red chalk. The student's motion reflects the action of the painter himself, as if in this instance Chardin has allowed himself to depict movement because the student's hand mirrors his own. My subject draws, and I paint him doing it. The smallness of the canvas enhances the diffident character of its human subject, and the unusually free brush strokes of the little painting repeat the act of drawing—open, quick, and fluid. The student has a hole in his coat, through which another garment can be seen—a red one—which also sticks out from under his brown coat where he sits and appears through the tear in his coat from behind. The hole is touching, almost narrative in feeling, but it is also more evidence of Chardin's insistence on composing a painting as a thing of connective tissue, as if the space of the canvas is a single body. Reds dominate the image. There are also two canvases in the little picture—one blank and another turned to the wall—which convey the idea of ongoing labor.

The very last self-portrait in the exhibition shows Chardin holding a red pastel crayon in his hand. He is decked out in some crazy headgear tied up with a blue ribbon as he peers out at me from behind his spectacles. The back of his canvas, its content hidden, juts into the space of the picture. I felt as if the young student in the tiny painting several rooms ago had suddenly turned around, that now he was no longer a student but an artist who had worked for years and grown old, and he was still holding the red chalk in his hand. Chardin gave up using oils for health reasons, and the change in medium seems to have initiated a change of subject matter, not at all strange, considering Chardin's intimate reliance on the brush and its motion. The flicks and touches and spots had to be abandoned. He took on his mirror image and the image of his wife's face, which, as anyone who has been married a long time knows, has a reflective quality—the answering face you see when you look up. Chardin was seventy years old when he drew himself with the red crayon in his hand. More strikingly even than in the oil paintings, the pastels create a pattern of undisguised color and its repetitions. The red of the drawing instrument is repeated in the artist's bottom lip, his hand, forehead, and cheek, as lines or rubbed lines. Illusion is subordinated to gesture. The painter's hand is sketched with particular boldness, and the energy of the strokes is seen clearly in the dark lines between the knuckles, in the startling

CHARDIN
Self-Portrait with pince-nez
c. 1779

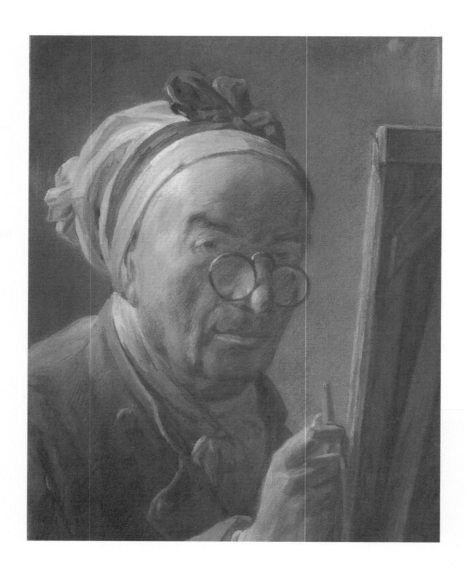

contrasts with which the face is shaded—the whiteness that illuminates the man's forehead.

In the pastels, Chardin seems to announce himself as his own figment. His vigorous line interprets his own face, and like everything else he invented on a canvas, these self-portraits are a combination of sympathy and distance. True to form, Chardin doesn't dress himself up. He wears the relaxed and modest costume of an artist at home. In each, his neck is wrapped up in a scarf. But the simple, even comic attire (the picture of himself with an eyeshade borders on the laughable) is belied by the man's shrewd, concentrated gaze, and the firm set of his jaw and mouth. He looks out at the viewer in all three and meets our eyes. He announces himself as we imagine he saw himself, and he sees himself kindly, respectfully, with the compassion for the self that time brings to the mirror—the awareness of the self as a series of others changing in time. The man's humble clothes, the nonchalance of his posture bear not a trace of vanity, but the hand that has made the homely face is confident, strong, and vigorous. If there is arrogance about himself, it lies in what Chardin has made of his reflected image. The master has used his old trick on himself—a lowly subject elevated by its prodigious form—and together they create complex strains of emotion in the spectator.

When I finally left the exhibition and walked outside into the brilliant sunshine of a cold, clear Paris, I carried the image of the painter's face with me, the face of a man who has been dead for two hundred and twenty years. I realized then that in the last self-portrait, Chardin reveals his secret to the viewer. The red crayon is not only a trope for a life's work, but a vibrant sign of the self-conscious spirit of that labor. With it Chardin shows explicitly that which is implicit in all his art. This portrait is a thing wrought out of blankness by a man's living hand. It is an object, which in its stillness, dead-ness, and silence will outlive the person whose image you see before you. But the picture you see bears the marks of a life and remains in an eternal, immediate present. I am here, an old man, ill and dying, looking out at you. Move closer and you will see that I am these strokes, these blotches of color, this still powerful hand.

Ghosts at the Table

Traditional still life is easy to recognize. It is the painting of things. The objects are usually small and most often set out on a table. The things are not outdoors but inside a house, and the represented space is not deep but shallow, which makes the spectator feel close to them. Still life does not include people. It implies human presence but doesn't show the living human form. Painting the inanimate world is different from painting people or nature for the simple reason that paintings, like things, are *still*. Landscapes may depict storms at sea or a gentle breeze blowing across a meadow, but the paint is motionless. Portraits may imply the movement of a hand, the beginning of a smile, but the human beings on the canvas are stopped in that instant forever. Like all mimetic painting, traditional still life is in the business of illusion. Only a mad person would reach out to take a grape from a Chardin canvas in order to eat it, and yet the fact is that the painting of a table laid for dinner, flat as it is, bears a resemblance to the reality of the things it refers to by virtue of its deadness. The French *nature morte* bears this aspect of still life in its name. The genre as a whole exists within the human relation to things — essentially a relation between what is living and what is dead.

The idea of things and only things as a suitable subject for painting dates back to antiquity, and since then the genre has struggled under the weight of its insignificance. Painting a pear or a dish was never as important as painting a person. The still life has always been lowest on the rung of art's hierarchy. The depicted subject was crucial in determining the significance of the work. Nevertheless, things have always played a role in art, and the problem at hand is to sort out the differences. A Byzantine icon may contain an object, but the depicted thing was not meant to look real. It was filled with the magic of otherness — the rendering of the sacred was itself sacred. And even with the growing humanism of the Renaissance, things in paintings carried symbolic and mythical value. It is the Dutch who are credited with the rise of still life, who moved the detail of a canvas to its center and made it a full-fledged genre, but even then, no matter how mimetic the images, ethical and religious ideas inhabited the objects seen in the painting. The very marginality of still life would make it attractive to modern artists and give it a subversive edge. They could play with the old hierarchies but refuse to give in to them.

And yet the rise of the humble object as a suitable subject for painting cannot be separated from the sense that the ordinary might hold a viewer's interest — that a simple thing could be charged with power. It is true that

without the striving, growing merchant class and its accumulation of material wealth in seventeenth-century Holland, the sparkling glasses, dishes, pipes, fruits, meats, and animal carcasses could not have been elevated to the status of a painting's sole subject. The still life embodied a new emphasis on the significance of the everyday. And this vision of the pedestrian as something interesting, as something worthy of interest, has never left the genre.

When I was in Chicago last summer, I went to the Art Institute, and among the paintings I saw was Chardin's last painting. It is the picture of a table with a simple white cloth. On the table are a sausage, a loaf of bread, a glass, and a knife. It is an image so simple, so without drama that it is difficult to describe its effect. When I looked at it, I was overwhelmed by its pathos. I felt as if I were looking at a scene of a dying child and not a table with sausage on it. I cannot fully explain this emotion, but reading Diderot I discovered that he felt something similar about Chardin. He regarded the work as magical.[1] Norman Bryson, in his book *Looking at the Overlooked*, notes that Chardin avoided arrangements that looked arranged and that the blurring of paint near his frames allows the spectator an illusory entrance into the room.[2] Chardin creates an intimate, familiar domestic space that has a strong relation to human gestures. But more than this, his painting evokes for me what is not there. The man or woman who was eating has left the table, but the food, the utensil, the glass are still charged by an unseen human presence. And because the missing person cannot be reduced to a particular sex, to a unique face and body, the spectator who peers into the space and the one who has left it share the table more completely. The fact is I do not imagine the absent person as a painted image, but as a living being.

In Israel, I had a similar experience with real things at the Israel Museum. Found with the Dead Sea Scrolls were a few objects, among them a basket and a plate. The basket, mostly intact, was identical to one you could buy today in any market in the Mediterranean. The plate was a pale green glass with a simple geometric design around its edge. It could have been made yesterday. Two thousand years stood between me and those objects, and yet in their familiarity and constancy, time vanished. A nameless woman used the plate the way I use my plates. She carried food in her basket the way I carry groceries in mine. Were I to come face-to-face with her by some enchantment, the cultural distances between us would be vast, but through these objects we are linked. It is Chardin's simplest still lifes—the late ones, such as *A Glass of*

Water and a Coffee-pot—that stir me most deeply. Like the basket and plate behind glass in the museum, Chardin's paintings make me feel reverence for what it means to be human. We breathe. We eat. Then one day we die.

Our eyes continually roam over the world of things, and we notice things more when we are alone. A human face will always draw our attention away from objects, but in solitude objects are the company we keep. Chardin's canvas is as silent and the things he represents in it are as motionless as they are in life. But the canvas itself is also a thing, an object that like many objects outlasts human beings, and its survival is written into the idea of the painting itself. Real bread goes stale, real sausage decays. The table, the glass, the utensils, however, might remain for generations. But we are not looking at bread or sausage or wood or metal, but paint, as Magritte's famous pipe joke would later openly announce. We are peeking into a framed space of illusion, but it is an illusion Chardin makes convincingly. Chardin's still lifes are not allegorical as were the ones by the Dutch and Flemish painters. Their grand theme of Vanitas becomes in Chardin the simple truth of mortality. We are all ghosts at Chardin's table.

A hundred years before Chardin, Juan Sánchez Cotán painted still lifes that inhabit a radically different universe. His luminous fruits and vegetables have an uncanny clarity that jolts the spectator. It is not a problem of recognition. I recognize each food in *Quince, Cabbage, Melon and Cucumber*, and yet these fruits and vegetables do not remind me of those in my own kitchen as Chardin's do. It is as if these foods are too visible. The melon reveals a surgical slash made by a knife's incision. The suspended cabbage and quince, the resting melon and cucumber are immaculate, discrete entities. The painting's effect relies on the absolute separation of one thing from another. In this work no food touches the other. As Bryson points out, Cotán's still lifes are rooted in the monastic life he lived as a lay brother of the Carthusian order, an order that emphasized solitude. Bryson links Cotán's painting to the imaginative use of the senses in St. Ignatius of Loyola's Spiritual Exercises,[3] and in Cotán's work the sense of vision is heightened and sharpened to a degree that feels almost painfully exquisite.

When I look at this food I am awed, and I would guess this is exactly the feeling I am supposed to have. In the real world food becomes part of the body. It enters us, is used, and the excess is expelled as waste. Consumption and digestion blur the boundary between the eater and the eaten. In Chardin,

JUAN SÁNCHEZ COTÁN
Quince, Cabbage, Melon and Cucumber
1602

I feel a comfortable relation between the absent bodies and the food that is meant to enter them. In Cotán, we know we are looking at food, and we know that food is meant to be eaten, but the body is weirdly absent from the equation. In *Quince, Cabbage, Melon and Cucumber*, an opened melon sits on the ledge of what may be a pantry. Beside it is another piece of the same fruit. At a glance, the viewer understands that the two pieces don't make a whole; another part of the melon must have already been consumed. The missing piece implies the person who ate it, and yet, as Bryson points out, "the objects take on a value that has nothing to do with their role as nourishment."[4] In Cotán, the very idea of food is suppressed in the name of a larger order of things, an order that relies on highly refined separations—among them a clean cut between the body and the outside world. The fasting and sexual abstinence practiced by the Carthusians as acts of purification may be seen as attempts to seal off the body from the material world. This is not an impulse limited to religious orders; modern anorexics are driven by a similar desire for purity and cleanliness. Bryson evokes the Spiritual Exercises to illuminate the role of vision in approaching the sacred, but the Exercises also present us with a formal schedule of classification and discipline, by which means daily life may be perfectly ordered. In his book *Sade/Fourier/Loyola,* Roland Barthes notes that the Exercises propose a system to cover the day completely, so that no moment is free.[5] This absolute coverage takes pictorial form in these perfectly rendered and neatly distinguished fruits and vegetables. (I can't help thinking of the six-year-old who has a horror of his peas sliding into his mashed potatoes.) Behind the illuminated food and shelf is a black, rectangular void. This space can't be seen as a reference to any actual space. It is intentionally unreal and abstract, and it suggests not a solid wall but infinity. This is food as sacred gift shining inside a system of precise relations ordained by God. When I look at the painting I don't feel the presence of the brother who ate a piece of the melon. I don't even feel the presence of the painter. I am alone staring into something alien and incomprehensible. Like a monk, I am alone with God.

Chardin and Cotán may be said to occupy the psychological poles of still life. Chardin eases every separation, between the viewer and what he views, but also among the objects he paints. There is no strain in looking at his food and objects. It is their very ordinariness that enchants them. Cotán is all strain, discipline, and withholding—qualities so rigorous that the ordinary becomes extraordinary.

Most of Dutch still life painting resides somewhere between these two poles. Willem Claesz's painting *Vanitas* serves as a good example of the middle ground. In it we see smoking paraphernalia, a plate, a knife, a bowl of fruit, a strangely tilted glass vase, and a skull. It is a somber image. The silver bowl is opulent but dimly illuminated; a subtle gleam of light appears on its base, a gleam echoed on the vase, which then reappears more dimly on the skull. Without the skull, the painting would be different, but it would remain a sobering picture. The objects on the table are not in perfect order, but the scene isn't slovenly either. It is true that the plate hangs slightly over the table's edge, as does one of the pipes, but it isn't in danger of falling. The truly precarious object is the glass that tips dangerously to the right, as if it's about to shatter. Looking at it, I feel a dramatic tension between the left and right sides of the canvas. My eye is pulled from the upright form of the bowl to the leaning vase and tipped skull, a movement from relative order to disorder, one that is then somewhat stabilized by the vertical candleholder that sits on a box above the skull. This is an image of fragility and borders, one in which the tipping glass has moved very close to the skull but hasn't yet touched it. I can't help thinking of a falling body when I examine the glass and its strange proximity to the skull. Claesz's skull carries the message of universal mortality far more pointedly and harshly than anything in Chardin because the skull is where the spectator and the object meet. The onlooking *I* will inevitably become *it*. In death, all living creatures are turned into things. The skull is convenient as an allegorical image that fits neatly on a table, and it's important to note no other human bone could have the visual power of a skull. Because the skull retains the broad outlines of a human face without any of the particularities of a living countenance, it reminds us better than any other object that death is democratic. When I look into the ravaged holes of the skull in *Vanitas*, I am intensely aware of my own life as a material body that exists in time and which must end. Through the leaning position of the glass, the dead things in Claesz's painting create a narrative that moves from the pleasures of eating and smoking to the corpse that can consume nothing. The painter has laid the empty cranium on the table in such a way that its eroded jaw gapes like a ravenous mouth.

The skull remains a marker of still life into the twentieth century. Max Beckmann's 1945 *Still Life with Three Skulls* uses the old image to new and terrifying effect. Claesz is reminding us of mortality. Beckmann's table with

WILLEM CLAESZ
Vanitas
1628

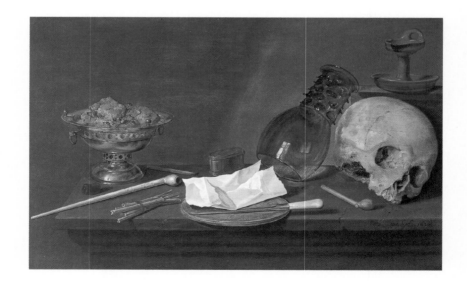

skulls, a bottle, and playing cards reminds us of recent human slaughter. Soutine's *Carcass of Beef* (1925) is similar in its intent. The dead animals familiar to still life are reinvented in this modern work as an image of horror. This canvas vividly shows us the cow's bloody entrails and with it the suggestion that the animal has just been killed. The longer you look at it, the more you feel the poor beast's screaming ended only moments ago. In all of these still lifes, from Cotán to Chardin to Claesz to the modern examples of Beckmann and Soutine, the canvases are drenched with meaning, but they cannot be reduced to "messages." The great allegorical paintings of the Dutch are not one-liners. The relationship between an object and the way it figures in these allegories is neither simple nor direct. Chardin's still lifes are heavy with emotion, but the production of that feeling cannot be reduced to the depiction of one object or another. Nevertheless, these works draw from and play with a known pictorial vocabulary through which they produce complex meanings.

Cézanne wanted something different. His still lifes are phenomenological. The spectator is alone and supreme, and the appetite that remains strong in the pictures is one for looking, not eating. I am not tempted by Cézanne's pears in *Still Life with Pitcher and Aubergines*, because they are not pears. They are forms in the space of my perception, just as the ginger jar next to them is. As in Cotán, the pears are elevated, not out of their thingness, but out of their ordinary role as food. And the light has changed. Chardin, like the Dutch and Flemish before him, worked within the darkness of thick walls and filtered light, but now the doors and windows have been thrown open and light shines onto these objects to illuminate them as *pre-linguistic* entities. It may seem odd to speak of images in terms of language. Pictures are supposed to escape the confines of words. But language is the grid through which we see the world, and in still life, naming is implied in looking. The humility of the depicted things creates a more direct relation between the noun and its meaning, a relation that is less direct, for example, in a narrative history painting. The food and vessels of Chardin are all named and known. They live inside a universe of fully articulated domestic habits that comfort us with their familiarity. There is a clove of garlic sitting next to a coffeepot. It has rolled toward the edge of the table, probably during the preparation of a meal. In Cotán, the identification of each fruit and vegetable designated in the title is cast in an almost terrifying clarity that seems to enhance their identities as God-given, as though the painter is striving toward a pre-Babel world. The

CHAIM SOUTINE
Carcass of Beef
1925

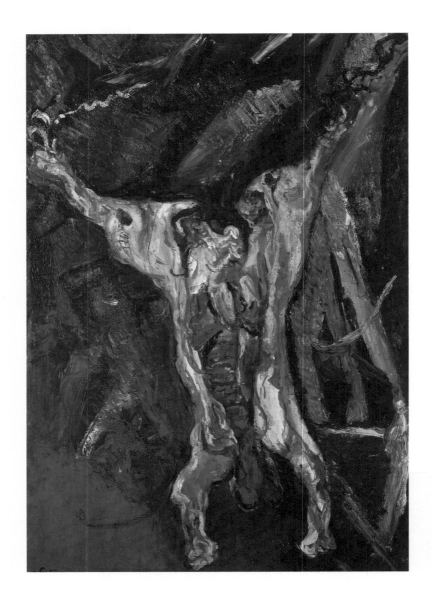

The Minneapolis Institute of the Arts.

PAUL CÉZANNE
Still Life with Pitcher and Aubergines
1893–94

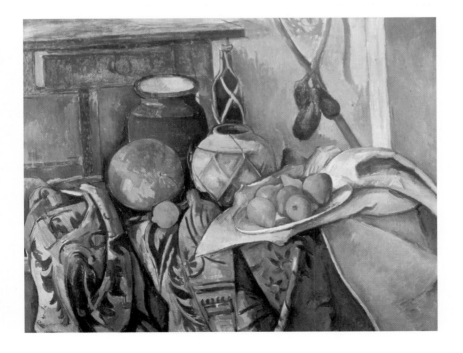

wonder of Cézanne comes from refusing the categories of a given, common language. What Chardin celebrates, Cézanne rejects.

Cézanne's still lifes feel both nondomestic and unfeminine. The food and objects he paints have been drained of their household functions, their semantic content. His objects appear *denatured* by the act of looking itself. Most people have experienced the odd sensation of estrangement that comes from looking long enough at a single object. For all of us there was a time before we knew what things were called, and then the world looked different. Cézanne's still lifes are a rigorous effort to return to a vision unburdened by meaning. In a letter to a young poet in 1896, in which he complains about his growing fame, he writes, "were it not that I am passionately fond of the contours of my own country, I should not be here." [6] The word *contours* is revealing. He does not say "landscape." He says "contours." Cézanne was searching for contours that would make us see again in paint what we have lost to language. The flatness or distortion of his canvases, the things that sometimes appear to float on the canvas serve this alienation. It is as if these objects cannot be fully assimilated into their names. A part of them flees the word and lives in its contours.

In some way the project Cézanne set for himself is impossible. Because we can identify the things he paints, they cannot be stripped of meaning, and yet within this idea of seeing the world anew is also the proposition that paint is the medium in which to do it. Cézanne does not hide the existence of the brush but lets the strokes show, and by flattening his perspective, he tacitly acknowledges the canvas as a canvas. But he is not joking or teasing his viewer with some notion of art for art's sake. The project on view in Cézanne's still lifes and the sensuality of these objects is serious. He said again and again that he was interested in looking at nature, and he had a passion for discovery that was never completely satisfied. After all, light and air never rest. Cézanne painted the same place and the same things over and over again in a constant search for the real through the imaginary. These still lifes show us mutability, not because we know that pears in the world rot, but because these pears appear to exist within a larger continuum of nature that is in constant flux.

Cézanne, as is universally acknowledged, left a deep imprint on modern still life. Matisse's still lifes bear the lessons of his predecessor. He too democratizes the visual field—flattening foreground and background into one, encouraging the spectator to take in one thing as much as another. But his

things are not denatured. In *Still Life with Blue Tablecloth*, I say to myself there is a beautiful blue tablecloth with a coffeepot, a bowl of apples, and a green bottle illuminated by sunlight that is shining into the house. The coffeepot retains its connection to domestic life without this fact being particularly important. When I look at these still lifes by Matisse, I remember how ordinary things at home are also beautiful—a white pitcher on my red table, yellow roses in a blue vase. But looking at Matisse is not like looking at things at home. It is more like a vivid, very recent memory—the imprint that remains after you have closed your eyes to the image in the light.

Cubism adopts Cézanne's idea of a new look at things without his devotion to the idea of unearthing an idea of the real—whatever the Cubists may have claimed. Cubist still life canvases are lively, intellectual exercises that dissect ordinary vision in the interest of perceptual play. Their strength is in bringing an almost musical rhythm to the genre, so that the classical Dutch convention of showing instruments in still life becomes an evocation of music's real movement, not only the idea of music as one of the fleeting pleasures we may indulge in before we die. And yet no matter how surprising these canvases must have seemed at the time, they are not mysterious. They articulate objects as much as Chardin does, but without the larger sense that this articulation is a pact of human fellowship. In Cubism, even if the image is blasted to bits, a guitar is a guitar is a guitar as long as we can detect its strings. Recognition is investigated but not subverted as it is in Cézanne. Forceful and fun, Cubism quotes the still life genre for its own purposes.

Classical still life has continued to thrive in the twentieth century. Morandi's miraculous bottles fall within the tabletop genre and tantalize the viewer with a strange dynamic between belief and doubt. His bottles suggest at once their identity as bottles in the world and an existence as spectral as Platonic shadows. If you look long enough at his paintings, the forms seem to change in their light—not sunlight, but light from some imaginary source. As in Cotán, we cannot approach these images without awe. They reside in a space of otherness that may still be construed as a table.

Picasso, Klee, and Magritte all worked squarely inside the genre at times, but unlike Morandi, they did not find a home there. Philip Guston is the most recent artist I can think of whose use of still life was not a conservative nod to an old genre but a revolutionary gesture. In his late works, Guston does not refer back to a classic form, but reinvents it. His drawings in particular—

PHILIP GUSTON
Painter's Forms
1972

of shoes, books, brushes, pencils, ladders, cans, bottles, cigarettes, trash can lids, and nails—are unlike earlier still lifes and utterly different from the blank images of pop art that preceded his late work. Guston said himself that he was overwhelmed by a desire to draw objects, that he felt "relief and a strong need to cope with tangible things."[7] Still life in Guston seems to happen as part of a larger project that also includes the human figure and that bears a powerful relation to the body. An untitled drawing with a hand and a cigarette smoked backwards (1967) feels to me very much like still life, except that in this case, what is implied in Chardin, the gestures of a body, is included, not excluded. The gesture is also inverted, creating a comic complication unallowable in Chardin. The presence of a hand in Chardin's work would disrupt its stillness. Here the hand seems to be another object in the world of objects. And while the things Chardin paints remind us of a universal domesticity, Guston's pictures are personal images of a particular inner life that begin to gain resonance for all of us.

His images repeat themselves in a mobile creation of new meanings. It is as if he is in the business of inventing a new syntax of the banal. The shoe, for example, turns up again and again. The drawing of an untied boot from 1967 is infused with a sense of comic sadness, while *The Door*, from 1976, in which we see a crowd of boot and shoe soles almost entirely blocking an open door, communicates alarm and sexual discomfort. But the shoe is a labile entity, a true poetic form. In the remarkable *Painter's Forms* (1972), a man's profile with an opened mouth appears to spew forth, among other things, a cork, a boot, a sole, and a bottle. An infant's first experience of the world is through its mouth, when it takes milk from its mother. For the first few years of life, in fact, the mouth is the primary organ of discovery. As all parents know, small children stick every object they can get their hands on into their mouths. But the mouth is also the place of speech, and *Painter's Forms* is not an image of devouring, but of expelling a vocabulary for painting.

In *Painting, Smoking, Eating* (1973), Guston links three human activities, the latter two of which are undeniably oral. And because all lists give equal status to the nouns inside it, painting is associated with smoking and eating. There is no hand visible in this picture. A man lies under the covers in bed, a cigarette stuffed in his invisible mouth. Beside him are the materials of his art. Again, we see shoe soles. But we are unable to tell whether these soles, some heavily outlined, some dimmer, are representations of footwear or the

footwear itself. It does not matter. What we witness is not a man actively painting, but the stillness of a head and its wakeful dreaming. This smoking head allows things to come into it, consciously or unconsciously, willy-nilly. The boots that fill that doorway remind me of nothing so much as my own semisleep dreams where forms keep changing and then sometimes fix themselves into an unsettling picture dredged up from a secret place in my own psyche.

In Guston, there is a rare harmony between the poetic texts he often used in his drawings and the images near them, despite the fact that the drawings are never straightforward illustrations of the words. The poems of William Corbett and Clark Coolidge, for example, are inscribed into the drawing without disjunction. Guston wrote out the texts himself with his own hand; the drawings and the words are both gestural. *Painter's Forms* is exactly what it says it is. Objects, Guston seems to tell us, are my new medium. Through them, I articulate myself and the world I live in. They are not limiting forms but liberating ones. They are outside me and inside me. They are of my body and not of it. Guston's still lifes speak to the fact that the world penetrates us. We eat, smoke, and have sex. But language and images enter us too. They become us. And in art, they are spewed forth again, transfigured and renewed.

Still life is the art of the small thing, an art of holding on to the bits and pieces of our lives. Some of these things we glimpse within the frame of a painting are ephemeral—food, cut flowers, tobacco—and others, like the clutter in a dead man's attic, are objects that will survive us. The paintings speak to our wish to live and to our dread of dying, but because the space inside the frame is a figment and the things it holds are imaginary, they have the eerie quality of the impossible: a permanent dream. I often dream of objects, and when I do, they are always close to my nose. I am pressed up against them—a toothbrush or a pair of scissors or a pen. They are dreams of uncanny scrutiny. Dreaming is part of living, and its images are a form of memory where the stuff of the everyday is recycled. Art is a kind of memory, too. A sausage is reinvented on a canvas. I will never cut it or eat it, but it is there in a parallel space that I nevertheless enter, and even though Chardin's painting is no longer in front of my eyes, the image remains. It has fixed itself in my mind as no real sausage ever could. Still life, like all art, happens through selection. One thing is chosen over another, and through the artist's

choice, my eyes find a new focus. Chardin's painting is not a reflection of the tables laid with sausages and knives that I have seen in my own life, but a spectral reincarnation of that familiarity. The experience of looking at art, like the experience of dreaming, is often more concentrated than waking life. Despite the inimitable present tense of every painting, it is always about the past. I do not mean its duration—how many years the canvas may have hung on a wall. I mean that what I am looking at is the representation of a thing, which has a history in the mind and body of another person. I am looking at a work—at "painter's forms." And this looking is a little like having someone else's dream. Because the objects of still life are ordinary—a sausage, a melon, a bowl, a boot—their translation into paint intensifies them. They are dignified by the metamorphosis we call art.

Narratives in the Body:
Goya's *Los Caprichos*

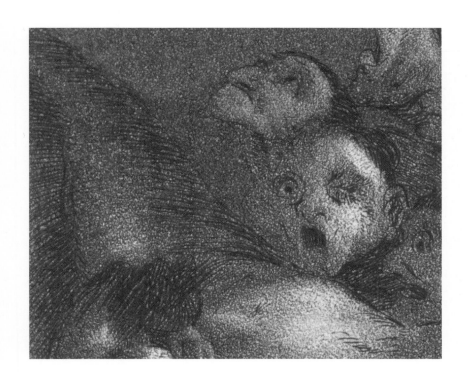

When I think about Goya, I think most often about the art he made for himself after 1792 — his private, uncommissioned works. In November of that year, he collapsed from a terrible sickness that would leave him deaf for the rest of his life. When he recovered and began to paint and draw again, the world must have looked and felt different to him because his images are marked by a change — a new freedom and mystery that make it hard to say exactly what the pictures are about. His works seem to splinter meaning, sustain contradictions, and suspend themselves in an ambiguity so tantalizing I can't stop looking at them. *Los Caprichos*, Goya's series of eighty aquatint plates made a few years after his illness, are as dense and puzzling as any images I've ever seen. The experience of studying these prints and the savage, strange, tender creatures that inhabit them is like wandering around in the slightly warped landscape of a dream. I'm never sure exactly where I am in relation to them, and although the content of the prints is often disturbing, I don't think this explains my disorientation.

Many works of art contain frightening pictures, but they aren't necessarily confusing. Three hundred years before Goya, Hieronymous Bosch made some terrifying paintings, but my experience of them is different in kind. When I examine Bosch's infernal characters with their bloody bodies and missing limbs, I am disturbed, but not baffled or dislocated, and this has something to do with the nature of the overall representation and the way this earlier painter depicted the human body. Goya's bodies aren't like any bodies in art that came before him, and it isn't easy to explain why this is so, but it has something to do with the stories he chose to tell, a quality of mutability that he was able to create in static images, and a narrowing of the distance between the viewer and the picture, which makes the spectator complicit in the scene. It is too simple to say that Goya's experience of being sick caused *Los Caprichos*, just as it is too simple to argue that Goya's work is a reflection of the period in which he lived. Talking about art is always an elusive business, and there is inevitably something false about making distinctions between the private and the public. The winds of the culture and society blow through all of us, and we in turn project our inner selves outward onto the world. Who is to say where one begins and the other ends?

"I can stand on my feet," Goya wrote to his friend Martín Zapater when he was recovering, "but so poorly I don't know if my head is on my shoulders." [1]

Don Sebastian Martínez, who cared for Goya in his house in Cadiz, elaborated on the artist's condition in another letter to Zapater: "The noises in his head and the deafness have not improved, but his vision is much better and he is no longer suffering from the disorders which made him lose his balance. He can now go up and down stairs and in a word is doing things he was not able to do before."[2] There are contemporary physicians who have linked Goya's symptoms to Ménière's disease, an inner ear dysfunction that causes tinnitis, dizziness, vomiting, vertigo, abnormal eye movements, and deafness. But the name of the sickness is less important than the nature of the artist's suffering. We know that he couldn't keep his balance, that he was plagued by sounds that weren't outside but inside his body, and that when it was all over, he had lost his hearing for good. Being sick, even for a short time, alters space. What was near—the bureau, the bathroom, the stairs—are suddenly remote, and reaching them requires efforts unthinkable in health. The derangements of vision, hearing, and balance that Goya suffered, however, caused far more serious disturbances to spatial orientation because they began in his head, and the head feels like the house of the self. Vertigo not only turns what was once solid ground into spinning, heaving space, it creates a body that has lost its familiar relation to air and earth, to up and down—the essential markers of perception.

ILLOGIC AND GUILT

Los Caprichos went up for sale on February 6, 1799, in a small shop in Madrid at 1 calle del Desengaño (Disenchantment Street), and then was quickly withdrawn, probably because the artist feared the Inquisition. Scholars have made much of the Enlightenment sources of the prints, of the influence exerted on Goya by his free-thinking, French-leaning friends, but I'm interested in something else: Why are these images so powerful now? Why do they move us two hundred years after he made them? The monstrous, absurd, and curious doings of the human beings and creatures that populate the eighty plates continue to startle and interest people who know nothing of artistic antecedents, the political upheavals of Goya's time, cryptic references, or the visual and verbal puns hidden inside the images and texts. The seduction of these pictures and words lies elsewhere. I think the plates attract us now because we continue to recognize ourselves in them, and this recognition doesn't come through an analysis of artistic conventions or prescribed forms,

FRANCISCO GOYA
Los Caprichos
Plate 1, "Francisco Goya y Lucientes, Painter"
1799

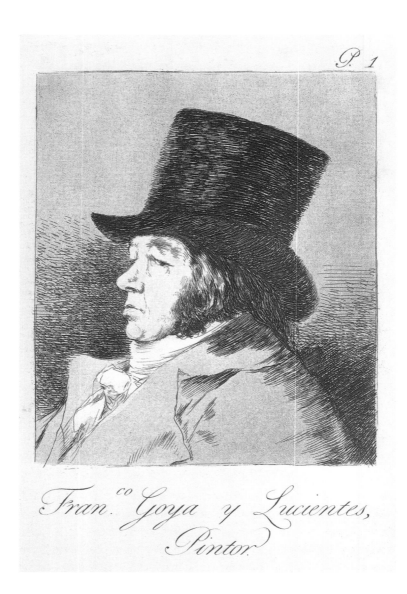

but through reading the numbered pictures as a kind of mad narrative with its own repetitions, breaks, and movements. It comes not from trying to penetrate its logic but from truly seeing its illogic.

My insatiable desire to keep looking at the prints has always been clear to me, but a moment came when I realized that my fascination was also accompanied by a vague sense of guilt. Over time, I've come to accept that a feeling of culpability is part of what it means to look at these images. Goya's renderings include a touch of sadism. The pleasure human beings take in cruelty is essential to the visual strength of these pictures, and when that pleasure is passed on to the viewer, it generates ethical queasiness. Although *Los Caprichos* exists within a tradition of satirical graphic art, it also diverges from that tradition. Unlike most satirical images, Goya's pictures are never smug and knowing, but dangerous and morally compromising. Fred Licht makes this point a little differently in his book on Goya: "Even in his broadest, most farcical satirizations, one always feels distinctly that Goya has direct personal experience of the error that is being satirized and that it is not just something he has observed from a detached vantage point."[3] Goya's perspective is mine, the spectator's, and the artist's lack of detachment becomes my own.

GOYA: WAKING AND DREAMING

Los Caprichos do not tell a story in any ordinary sense, but because the images are numbered, they have a prescribed order and are meant to be seen and read in sequence. Critics have worked hard interpreting the self-portraits in plate 1 and plate 43. The first is the cycle's frontispiece with a text that reads: "Francisco Goya y Lucientes, Painter." We see the artist in profile, dressed in a top hat and coat and looking a little dour. His fully visible left eye is cast downward, but the position of the pupil suggests a sideward glance at the viewer. As a self-portrait, it is extremely reserved, even hidden. The facial expression isn't neutral so much as ambiguous. It could signify sorrow or skepticism, irony, sternness, or a more troubled attitude. A lot has been written about the images that may have influenced the frontispiece. The art historian Eleanor Sayre has said that Goya may have borrowed the expression from Charles Le Brun's treatise on "expressions of passion" and the print in it associated with the emotion "Contempt."[4] Victor Stoichita and Anna María Coderch argue in their book *Goya: The Last Carnival* that the artist combined

GOYA
Los Caprichos
Preliminary drawing
 for plate 43 (left)
Plate 43, "The sleep of reason
 produces monsters" (below)
1799

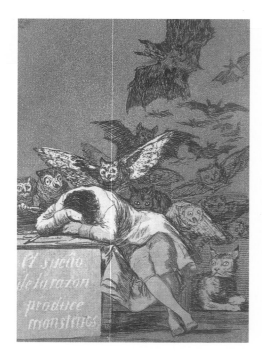

two expressions, contempt and sadness, found in the work of Le Brun's Spanish interpreter, Zeglircosac.[5] Whatever Goya's inspirations may have been, contempt is too strong a word to describe the look on the face of the man in profile, and a mixture of contempt and sadness seems reductive as well. If Goya had wanted a clearly legible expression in the portrait, I'm convinced he would have put it there. He didn't, and the face that opens the series is one with an emotional tone that is difficult to read. The artist makes his first appearance as a mysterious figure with a veiled expression against an empty background. From the very beginning, *Los Caprichos* resists clear signals to its viewer/reader. We are not told what to think or feel.

Forty-two plates later, Goya appears again. This time, the artist is asleep at his desk. Pens and sheets of paper lie under his arms and we can't see his face at all, but along the line of his slumbering body are four owls and what looks like an owlish black cat. Beyond them fly a host of winged creatures— more owls, bats, and a demonic batlike beast. Resting on the ground behind and to one side of the artist is a large cat that looks up with an expression of surprise at the throng of animals moving skyward. The caption on the desk reads: "The sleep of reason produces monsters." This plate has been subject to a lot of discussion, partly because it developed from drawings that still exist and was originally going to serve as the frontispiece for a series called *Sueños (Dreams)*. The first extant drawing was made in 1797 and provides a glimpse into the evolution of the image. This drawing includes several faces that rise from the head of the dreaming painter. One of them, mouth open and howling, melds into a grinning face that looks something like Goya, and above the latter there is a clear front-view self-portrait flanked by a paler but similar portrait lying on its side. The two faces above, one in profile and one with an open mouth, are both more or less human, but beyond them flies a donkey, its front hooves tucked up beneath its body. Fine ink lines shoot out like rays from the slumbering figure, creating areas of light and dark. The faces that rise above the sleeper's head are all in an illuminated area of the page, while the bats to the right fly in a patch of darkness. This drawing, which includes a rendering of heads detached from a man's shoulders, becomes a literal echo in visual form of the words Goya used to describe his unsteadiness during his recovery, one that at least subliminally links the experience of vertigo to both dreams and artistic creation. Goya's drawing with its several versions of his own head floating upward depicts the imagination

as the self (or self-as-head) bursting its bodily confines and sailing into the world beyond.

In another drawing from that same year, Goya suppressed the escaping heads and replaced them with nocturnal creatures and a large partial disc of light in the upper left-hand quadrant that may well be the moon—a sign of night dreaming. But in all the versions, including the final one, the artist is shown as someone whose identity crosses the boundaries of the body. The teeming content of his unconscious mind is projected into the gray space beyond his head. Each plate has an explanatory text that was apparently written by Goya and which is now preserved in the Prado. The commentary on number 43 from that manuscript reads, "Imagination abandoned by reason produces impossible monsters: united with her, she is the mother of the arts and the source of their wonders." This is a standard Enlightenment idea. The imagination is fine as long as it's tamed by reason. Without it, one risks a plunge into hallucination and madness. The artist is asleep—in a state where reason doesn't rule, and his dreaming mind has generated a swarm of hideous creatures. What is the viewer/reader meant to think? That art manufactured from dreams and the supernatural is not to be trusted?

The two self-portraits each act as an introduction to the series of images that follow, roughly splitting the book into two parts. But this isn't a perfect binary division, and therefore it's not rationally pleasing. Had Goya placed "The Sleep of Reason" exactly in the middle of the series, scholars no doubt would have read endless significance into the symmetry of the arrangement. At number 43, the cut is off-kilter, a little more than halfway in, so its meaning seems to have been ignored, but when you look through the pictures, it's clear that there are two waves of imagery, the first following the wakeful Goya and the second the sleeping Goya. Among the first forty-two, there are only three plates that refer to or include flight—19, 20, and 21—a visual trio on the theme of plucking, in which feathered and naked birds wear the heads of men and women. In the second series, after the introduction of the dreaming artist, there are no fewer than twenty-four plates that include images of flying, and many of them also contain versions of plate 43's cat, owls, and bats—creatures entirely absent from the first series. The wakeful artist ushers in a series of social satires that include men and women as beasts, but they don't draw from the well of supernatural imagery, the monsters of sleep—goblins, witches, night birds, and bats—that the final thirty-six do.

GOYA
Los Caprichos
Plate 2, "They say 'yes' and give their hand
 to the first comer"
1799

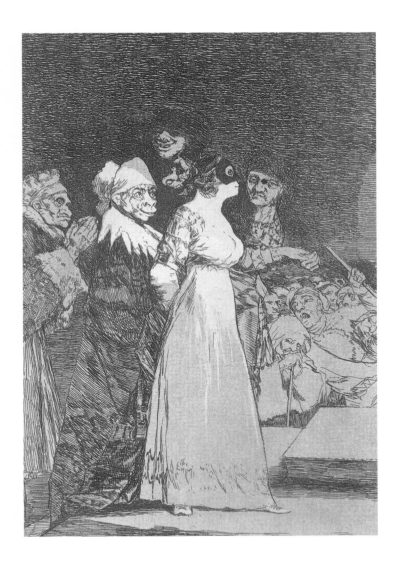

It's possible then to think of *Los Caprichos* as a work in two movements, waking and sleeping, eyes open and eyes closed, grounded and ungrounded, and yet the first movement anticipates the second, and as I move from plate to plate I feel an almost musical rhythm to the pictures, which are rife with repetitions and mutations and use the human body as their essential narrative subject, a body driven by the engine of appetite.

CRAZY SPACE

In the self-portrait that opens the series, Goya's head and shoulders appear against a shaded nowhere common to portraiture, but as soon as the viewer turns the page to the second plate, it's apparent that the action is taking place somewhere — but where? The caption tells us that we're looking at a wedding: "They say 'yes' and give their hand to the first comer." A wizened, older man is leading a masked young woman up some steps to an unseen altar. The spectator knows only that the venue of these odd nuptials is a vast, dark, windowless interior. Below the wedding party is a strange crowd that includes a howling man with a raised stick, a character more at home in an angry mob than among wedding guests, and behind the sea of heads is a faint gray opening that looks like the entrance to a cave. After scrutinizing this image, I began to feel a little tipsy. I was pulled into the picture by the line of steps that the two older women are climbing, an angle that makes me feel as if I'm looking up at the bride from below, as if I were a person in the crowd but standing on the other side. To my right, however, is an exposed step or platform, the perspective of which makes me think exactly the opposite — I would have to be above the figures to see the step that way. The angle of spectator vision in plate 2 is nonsensical.

The second plate is not an aberration. It opens the door to a new mad space liberated from the rules of conventional perspective. Nearly all the interior and exterior settings in *Los Caprichos* are minimal, free of all details superfluous to the narrative action. Steps, walls, stones, doors, simple horizon lines, silhouettes of hills and clouds, a tree or trees — all have an archetypal simplicity that nevertheless confounds the viewer after looking at them. In 12, "Out hunting for teeth," the young woman stands on a wall with lines that don't merge toward each other as they recede in space but remain equidistant. In number 33, "To the Count Palatine or Count of the Palate," the stairlike structure behind the count and his three victims is utterly mysterious. In 35,

"She fleeces him," the lines of the ceiling, window, and walls have a geometric elegance but no perspectival logic. And finally, to cite an example from late in the series, in plate 74, "Don't scream, stupid," the lines of a door on its hinge hang in midair above a roughly delineated floor line. The relation between the space of the door and the ground below it is as bizarre as the scene itself with its floating goblins.

Goya wanted his little stories to exist in a crazy space, and his intent is made clear by comparing a preliminary wash drawing he did for plate 10, "Love and death," with the finished work. In the drawing, both the line of the wall and the shadow the dying man throws against it are conventionally rendered. The discarded sword rests in front of the wall. This "correct" perspective is in harmony with the lovers, two young, attractive people, who are suffering beautifully. In the final version, the wall has grown stubby and its corner irrational, part of another, less legible space that incorporates a new horizon—the outline of a hill, or perhaps a division of sky, which at one point dips close to the man's neck like a small visual threat. The lovers' postures and facial expressions have been dramatically altered—the dying man is slumped in the woman's arms as she struggles to hold his dead weight, and their faces are contorted with agony. The scarf around the man's neck appears to cut his head from his body, and the sword lies at a new angle, tipping upward and incomprehensibly toward the wall close to his hat.

In the preliminary drawing, I feel separated from the lovers, in part because they appear farther away, but also because the foreground is clear and readable. In the final version, I, as spectator, find it difficult to orient myself in relation to them. The perspective at the bottom of the image suggests that I am looking at the couple from below, but the longer I look, the more I doubt the angle of my view as well as the illusion of depth. Where, for example, is the man's right foot in relation to the hat that lies near the wall? The two-toned horizon line acts as a squeezing force—a kind of false perspective line that presses down on the image from above, a line that, when seen together with the shading in the lower left and right of the picture, creates a funnel effect on the image as a whole. The revision uncovers Goya's need for a space that is inseparable from the story he is telling. By playing with the rules, he throws his spectator off balance and his rooms and landscapes begin to tilt and wobble in a world that has come down with a bad case of vertigo.

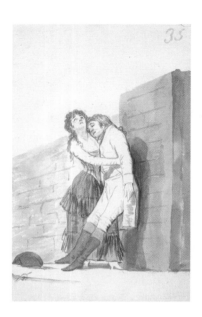

GOYA
"Young Woman Holding up her
 Dying Lover," preliminary drawing
 for plate 10 (left)
1797
Los Caprichos plate 10,
 "Love and death" (below)
1799

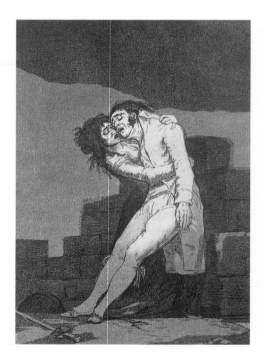

Perspective, of course, is simply a learned illusion, a thing of art and its history, and no one is more aware of this than a representational artist who studies the tricks that direct the eye to see depth on a flat surface. From its inception, what became *Los Caprichos* was connected to dreams and dreaming. The pictures evolved over time, gaining a new frontispiece and a new name, but they developed at least partly out of a desire to depict the stuff of the unconscious mind. This is not to say that Goya wasn't interested in social criticism, but rather that his particular form of satire also drew from universal human experiences that are separate from ordinary waking consciousness. A good percentage of everybody's life is spent asleep, seeing and doing things we would never see or do while awake. At one time or another, most of us experience some form of visual disturbance — fever dreams, for example, or the disequilibrium caused by simple drunkenness. Others of us, like Goya, know what it means to suffer from hallucinations, auras, and vertigo, none of which can be portrayed through the norms of one-point linear perspective.

I've long been interested in semisleep dreams, the pictures that crowd the mind before one falls asleep — those weird involuntary scenes that mutate from one thing to another, by turns grotesque, fascinating, and sometimes terrifying. It's interesting to ask where these scenes occur, and what is the character of the space in which we see them. For me, the pictures often float in darkness, but at other times I see rooms with simple furniture — chairs and tables — or primitive architectural features — hallways, doors, windows, and stairs. I've watched people slowly turn into ghouls and monsters or give way to animal forms. Noses, mouths, genitals, and limbs grow and shrink in this presleep cinema. In semisleep, I am always an outsider, an observer of silent pictures, whereas in the dreams of deep sleep I enter the dream as a participant and am able to talk. Whatever one might think of Freud's dream theory, it is undeniable that he was right in arguing that most of the material that floats through our minds at night is taken from the day before, that these hours of dreaming revisit and reinvent the hours of consciousness. Dreams and hallucinations inevitably borrow their content from the world — a world that includes books, music, and visual art.

Late in 1792, just as his illness was beginning, Goya wrote a letter to Zapater in which he said, "Now I don't fear witches, hobgoblins, ghosts, giants, rogues and liars or any kind of body except human ones."[6] This often-quoted letter interests me because its list of no-longer feared beings, witches,

hobgoblins, ghosts, and giants, all fantastical, are not separated from rogues and liars. Instead, it indicates that Goya had a loosely constructed notion of the imaginary. Rogues and liars aren't supernatural, but like witches and ghosts they are common characters of fiction, and he may have added them to the list because they were among the figures that appeared to him when he became sick, the phantasms of his delirium.

We can't photograph our dreams or near-dreams, our auras or hallucinations, or even reconstruct them in our minds, but they leave their marks on our memory, and sometimes they leave their scars. I'm convinced that the pictures of *Los Caprichos*, with their brigands and cowards, their spirits and ghosts, share the elemental qualities of these semiconscious and unconscious experiences. Sleep is the universal human elsewhere, the domain where the experiences of the day are reconfigured and collapsed into another space, one in which the laws of waking life don't apply.

HOVERING, FLYING, AND FALLING

When I was a child, I flew high in my dreams, soaring above towns and fields like the ghouls in plate 64 and the witches in plates 66 and 68. As an adult, I can still lift myself off the ground, but my flights are mostly down stairways, airborne leaps during which my feet never touch the ground, and unlike some of my other dream experiences in which I suspect I am dreaming, I am absolutely convinced that these levitations are real. In the forty-one pictures that follow the awake, observant Goya, there is only one image of high flyers, the bird-people in plate 19, but there are many figures who have lost their secure connection to the ground. Plate 2, the wedding scene, features a man whose head is elevated above the rest of the company. No doubt the *pater familias*, he grins with pride as he bestows his blessing on the happy couple, but there is no rational explanation for his fantastic height, and because his body has vanished into the darkness, he is turned into a ghostly paternal head hovering above the others. The sixth plate, "Nobody knows himself," includes a skeletal figure that turns its head toward the masked couple in the foreground, a character that, like the father in plate 2, may be either unreasonably tall or ungrounded. In plate 8, "They carried her off," a faceless man and another person, represented only by a hooded cloak, have lifted a young woman off her feet, and while there is nothing illogical about the girl's position, a close look at the second figure reveals that no face, hand, or foot is visible. The

draped figure echoes one seen earlier in plate 3, "Here comes the bogey-man"—a nonperson who is nothing but a shroud—and is repeated again in the partially hidden young woman of 36, "A bad night," whose face is covered by her dress lifted high in a wind. Other figures as well have a dubious connection to the ground. In 12, the hanged man's feet dangle above a wall, and in plate 33 Count Palantine is hard to situate. Is he behind the counter or in front of it? Logic dictates that the man's legs are behind the table, but still, there's something weird about his position, and he seems to float in the air like a legless phantom above his patient, whom he is forcibly plying with some dangerous palliative. And in 42, "Those who canst not," two men are bearing donkeys on their backs as the beasts' hooves hang above the earth. To be un-grounded, to lose your footing, to float, or to be swept away—all are metaphors for confusion and loss, and the repetition of these images, when coupled with Goya's tipping, tilting spaces, delineates a vertiginous reality that continues to destabilize the viewer.

The three scenes in the first movement that allude directly to flight—plate 19, "All will fall"; plate 20, "There they go, plucked (i.e. fleeced)"; and plate 21, "How they pluck her"—stand out as one of several mininarratives among the tales told in *Los Caprichos*. All three portray plucked birds with human heads. These birds are distinct from the birds that appear in the plates after the slumbering self-portrait in 43 because they are birds of the day, not the night, and when first seen, the unplucked among them are dressed in the hats and collars worn by men and women of society. The first scene, plate 19, includes a thin tree trunk with a perch, a detail that both links the airborne fowl to the four figures on the ground and augurs the trajectory of falling. A distressed-looking hen with a prominent bosom has come to rest on the perch as several male creatures fly eagerly in her direction. Below the action in the sky, two young women and one old hag are sitting on the ground. The girls are busily tugging out feathers near the anus of a male bird. Their smiles give the business a sadistic turn that is mirrored in the crone's lascivious expression, as she looks skyward for the next one to plummet.

In plate 20, four women sweep three naked humanoid birds from the house, presumably male members of the fallen, while above and behind them are two others—still feathered, desperately flapping and turned to the wall. The third in the plucking series is the most enigmatic. The tormentors this time are male, not female, and the action is grounded. Three leonine,

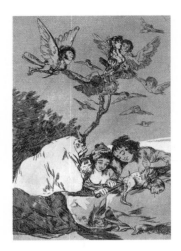

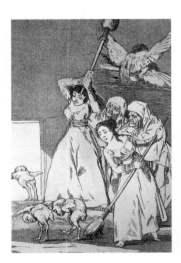

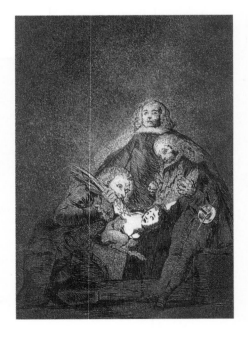

GOYA
Los Caprichos
Plate 19, "All will fall" (left top)
Plate 20, "There they go, plucked" (left bottom)
Plate 21, "How they pluck her" (below)
1799

well-dressed figures have trapped a woman-bird by her wings. One gnaws at her feathers with his teeth, while another has seized her left wing with his claws. Human breasts are visible above the bird's body as she crouches on another confounding piece of Goya furniture—a slanted series of boxes or platforms, the top of which can't be made out and which seems to merge into the cloak of the tallest lion. Despite the fact that they are engaged in torture, the male figures look rather benign, and the tall one, without visible arms or body under his wide cloak, seems almost beatific as he looks up with an expression that suggests he is beseeching someone for help.

This third leonine face bears a resemblance to the floating head in Goya's first drawing for plate 43, and also to one Goya did between 1795 and 1800, a self-portrait that, Stoichita and Coderch argue, shows the artist as lion— a figure of strength, nobility, and power—a physiognomy they say was once again borrowed from Le Brun.[7] In it, a bearded Goya looks down from under bushy brows, and there is no question that the portrait hints at the king of beasts. They don't mention plate 21 or the preliminary drawing for 43 in this regard, which would further their argument, but I think the connections are there. Goya again implicates himself in the series, this time by hiding himself as a character in a scene in which he is both a participant and a spectator. Allied to the other figures by dress and bestial features, he nevertheless does not take part in the action. While his two comrades denude the fallen bird-woman, the third, a masked version of the artist himself, stares up into the emptiness with an expression of helpless sorrow. It won't be the last time he disguises himself either. He will figure again, but not until after plate 43 when sleep spills his demons and the story of *Los Caprichos* quickens into another, higher register to form a pictorial nocturne.

What was precarious and unstable in the first movement becomes a genuine loss of gravity in the second, when we witness creatures who fly, soar, tumble, and sail through the air, with or without wings. Twenty of them (plates 45, 46, 48, 51, 52, 56, 60–62, 64–72, 74, and 75) include beings who have left the ground. Flying becomes a dominant visual trope for what emerges from the artist's unconscious. In dreams, all bets are off and everything becomes possible.

THE SHIFTING BOUNDARIES OF THE BODY

Looking at the plates of *Los Caprichos,* I become acutely aware of my own body. I feel myself as matter—bone and muscle and tissue—and I feel my vulnerability

GOYA
Self-Portrait
1795–1800

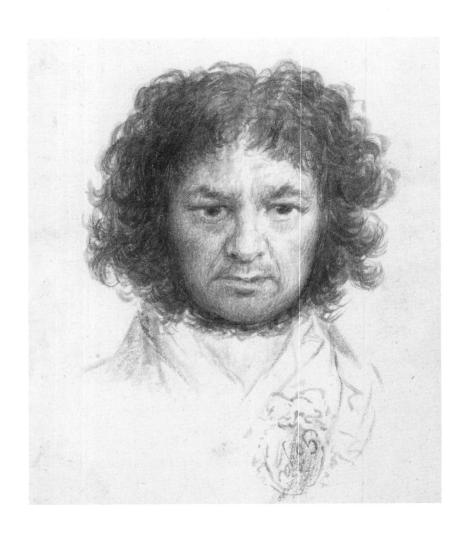

as a thing that won't last. I am reminded of my animal self, of my cravings for food and sleep and sex. This intense consciousness of my own physicality is connected to the fact that the human forms in the plates always seem to be in various stages of becoming beasts, and again, I find it hard to keep myself at a safe distance. Even in the first movement, corporeal transformations are rampant. Not only are there bird- and lion-people, but people who upon examination seem to be just beginning on their way to another mammalian state, like the flat-faced bride in plate 2 who no doubt will come to resemble her positively simian mother. There are the sheep-men of plate 24 and the monkey-man in 33 and the clothed and unclothed donkeys behaving very much like people in 37 through 42. Noses flatten or elongate, arms become wings, ankles revert to hooves. Among the ghouls that populate the second movement are mixtures so dense they defy analysis—the bear, donkey, owl, and human figure in plate 63, for example. But what is this mixing of forms really about?

The portrayal of men as beasts is a familiar feature in the history of satire. People are supposed to remain high on the chain of being and not sink to the level of animals, which have no control over their appetites and no access to reason and language. And yet, no matter how grotesque, Goya's figures seem unpleasantly close to the human. It was Baudelaire who first articulated this quality in Goya after seeing *Los Caprichos* in Paris:

> *Goya's great merit consists in his having created a credible form of the monstrous. His monsters are born viable, harmonious. No one has ventured further than he in the direction of the possible absurd. All those distortions, all those diabolic grimaces of his are impregnated with humanity. Even from the special viewpoint of natural history it would be hard to condemn them, so great is the analogy and harmony between all parts of their being. In a word, the line of suture, the point of juncture between the real and the fantastic is impossible to grasp; it is a vague frontier which not even the subtlest analyst could trace, such is the extent to which the transcendent and the natural concur in his art.* [8]

Baudelaire's commentary is a perfect footnote to Goya's statement in his letter to Zapater that he didn't fear "any kind of body except human ones." The poet's penetration of what he had seen turns on the phrase "the line of suture." It is exactly this cut, this threshold or boundary between one thing and another that has blurred in the world of *Los Caprichos*, making its transformations seem natural because, despite their supernatural appearance, they are deeply

connected to lived experience. Yet again there is a link to semisleep metamorphoses and to dreaming. In my dreams, the people closest to me don't look like themselves anymore. They are wearing the faces of others or have sprouted peculiar lumps or grown fur. I discover that my teeth have fallen out or that I have an enormous tumor on my arm. I bleed a river or a pool or change sex and discover that I'm no longer a woman but a man. Unconscious life and its distortions give me access to the world of *Los Caprichos*, but it isn't only the link to sleep that makes these pictures potent, it is that what we see in these bodies reverberates with our own vulnerable anatomies, in particular those parts of the body where there is no line of suture, where we are literally open to what is outside us.

The plates demonstrate an almost obsessive interest in corporeal orifices — mouths and anuses, in particular, but noses and genitalia as well—all anatomical passageways that absorb and excrete. As Mary Douglas writes in *Purity and Danger*,

> *All margins are dangerous. If they are pulled this way or that the shape of fundamental experience is altered. Any structure of ideas is vulnerable at its margins. We should expect orifices of the body to symbolize specially vulnerable points. Matter issuing from them is marginal stuff of the most obvious kind. Spittle, blood, urine, feces or tears by simply issuing forth have traversed the boundary of the body … the mistake is to treat bodily margins in isolation from all other margins.*[9]

Among the plates in the first wave of imagery that include a focus on mouths are the baby-man in 4, who sucks his fingers; the woman in 12, who reaches into a dead man's mouth; the gorging monks in 13; the drooling bird-man in 19; and the vomiting patient in 33. In 25, "Yes he broke the pot," a mother spanks her son, his shirt clenched between her teeth as she whacks his naked buttocks with a shoe — an image where mother's mouth and child's anus are contiguous. Both the texts and the pictures play on human anatomy in a circulating metaphorical game of resemblances and inversions. Ingesting and excreting, mouth and anus, head and buttocks, up and down are continually identified and then reversed.

These inversions run throughout both movements. The indecently clad girls in plate 26 wear chairs on their heads instead of sitting on them. In 54, a man lifts a spoon to his mouth from another man's bowl, but his penislike

nose gives him away—one lust merges with another. The Prado manuscript informs us that men with such "indecent" faces should "put them in their breeches." The agonized old man in plate 30, "Why hide them?" holds out two sacks of money that look like his own aged, impotent testicles. After the artist goes to sleep in plate 43 and the night demons are unleashed, the allusions to oral activity—eating, sucking, talking, spitting, and vomiting—multiply and become more zealous. The hobgoblins of 49 and chinchillas of 50 are eating, and plates 53, 54, and 58 all turn on oral functions. Several others show creatures with jaws splayed wide. Plate 45, "There is plenty to suck," uses nursing as its trope—yet another body opening, the one that secretes milk. Unlike the wrinkled and useless testicles of the old man, these crones' shrunken breasts are hidden, and the babies will not take milk from them—the witches will suck the children in a reversal of the maternal function. There's the oral wind in 48 streaming from the mouth of a ghoul flying over four bulbous buttock-like forms releasing two additional gusts, and the great anal "blow" of 69 that also features the lusty cannibalism of infants.

The ins and outs of eating, digesting, and excreting form a narrative continuum in the plates that doesn't, as Baudelaire intimated, leave the human body behind so much as explore the body's realities. In one picture after another, *Los Caprichos* roam the body's contours and openings—tugging here, pressing there, playing with similarity and difference until the boundaries begin to lose their fixity and it becomes hard to tell where one body begins and another ends. The universal experience of infancy, lost to memory but present in us nevertheless, is exactly that—a lack of boundaries—a state not yet subject to category and difference. Goya's use of infants as food is not only a reversal of feeding and being fed, but it summons up the ravenous infant-self, the hungry babe attached to a breast it doesn't recognize as separate from itself.

SEX, HEADS, AND GENERATION

The protean inhabitants of *Los Caprichos* are creatures of appetite whose lust for satisfaction is a driving force in the narrative images. The desire for food and for sex mingle in this hungry world, which despite its sanctioning texts and satirical intent, looks startlingly amoral. Whether slurping up food, breaking wind, yowling in the night, or leering at some chubby infant morsel or desirable sexual tidbit, these voluptuaries are often seen pursuing their physical needs with such zest that the viewer can't help but feel a touch of

GOYA

(clockwise from top left)

"He puts her down as a hermaphrodite," sketch from the Madrid notebooks, 1796–97

"Masquerade of Caricatures," preliminary drawing for plate 57, 1799

"The Lineage," preliminary drawing for plate 57, 1799

Los Caprichos plate 57, "The filiation," 1799

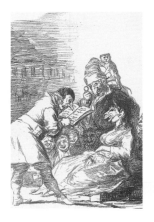

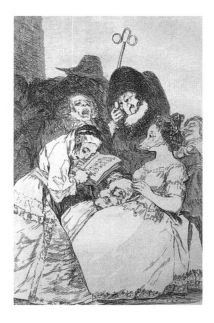

envy, and that envy complicates the images. It may be that Goya's depiction of the irrational and unconscious underworld of human desire is so powerful that some of the plates simply fail as cautionary tales. Morality, after all, is about making distinctions between people, respecting the integrity of the other as separate from the self. It erects barriers to keep order among us, but these thresholds are also liable to collapse. In every culture, sexual activity is subject to taboo; copulation means physical merging—one body enters another—the two-headed beast. This double animal of sexual union haunts the eighty plates of *Los Caprichos* without ever appearing as its undisguised pornographic self.

Sexual games and exploitation take up considerable space in the first movement of *Los Caprichos* and broadly include, by my count, twenty-three plates. A number of them hinge on the problem of seeing and not seeing, revealing and hiding, a drama essential to the story of any seduction. Masks are worn in plates 2 and 6. In 7, "Even thus he cannot make her out," a man holds up a monocle in a vain attempt to see the woman in front of him. In plate 14, the hunchbacked fiancé glares hungrily at the breasts of his young and pretty wife-to-be, who averts her eyes. The girls in 17, 26, 31, and 36 have exposed their legs either on purpose or by accident, but in every case they are inciting temptation. The physical coupling or merging of men and women implied in the first movement finds its complex resolution in the second.

Plate 57, "The Filiation," or "The Lineage," one of six plates in the second movement that don't draw directly from the imagery of witchcraft, collapses in a single picture many aspects of the erotic material seen in the earlier plates and illustrates the ongoing drama of blurred margins that creates a problem of identification. There are three preparatory drawings for this work—one a sketch from the Madrid notebooks, one for *Sueños*, and one for *Los Caprichos*. The first one, from the notebooks, "He puts her down as an hermaphrodite," features four people and a head. Two men with prominent noses and a smaller masked figure are exclaiming over a clothed woman who wears a canine animal mask over her face. The object of their surprise is a human head protruding from between her legs. Its eyes are wide open, as if it too is startled by what it is seeing. The head's mouth closely resembles the vaginal slit, while its nose indicates a penis. A man in profile, pen in hand, is apparently inscribing this anomaly in his notebook. Because the hermaphrodite is an example of a type that defies category—a two-in-one—Goya seems to be mocking the

encyclopedic obsessions of his own period and the optimism inherent in the idea that absolute delineation and definition are not only possible but crucial to all knowledge.

In the second drawing, for *Sueños*, Goya makes the image more elaborate. He adds more people, a city background, a monkey, and a monocle. The monocle will remain in the final version and serve as a visual echo of the earlier one in plate 7. The *Sueños* drawing keeps the genital face explicit, but this time the head has grown a pubic-hair beard, its nose is longer, and its eyes are shut, as if the addition of the monocle has taken the place of the head's eyes. In the preliminary drawing for *Los Caprichos*, however, the allusion to genitalia becomes far more muted. The vertical vaginal mouth has tilted into a horizontal position, and the phallic nose has been shortened. A small chin indentation remains the only hint of the former slit, and the head no longer seems to emerge directly from the woman's draped loins, but rests on her lap, its eyes still closed. Her dog mask remains, but the monkey has vanished. The work now has two magnifying instruments: the monocle is still present, and a lorgnette has been added, which hovers over the company like a talisman of vision. A new character also appears: a man who looks upward with an expression of misery, while the man with the notebook looks directly at the head and acknowledges it with a friendly gesture. In the fourth and final version, the unhappy man has become a different person altogether, a person whose suffering now looks like despair. The scribe has lost all his gaiety, and the head now appears to be sound asleep.

Together the three preparatory drawings make up a narrative of artistic concealment, which interestingly enough touches on the announced theme of the picture itself and *Los Caprichos* as a whole—the hidden. The Prado manuscript informs us that plate 57 is about deceiving a potential bridegroom: "Here is a question of fooling the fiancé by letting him see, through her pedigree, who were the parents, grandparents, great grandparents, and great, great grandparents of the young lady. And who is she? He will find that out later." The future bride displays her lineage but hides herself. What began as an explicit inversion of top and bottom, heads and genitals, which had the simplicity of a joke—a game of hermaphroditic doubling and the quandary of naming a monster—has evolved into a far more cryptic image. The problem of identification has expanded to include genealogy, and the original comic exchange of surprised glances has developed into an elliptical and elusive play

with eyeglasses in an image where nobody's eyes actually meet. The once wakeful head goes to sleep, and a man (the bridegroom?) apparently horrified by what he has seen, looks upward and cries out.

In "The Filiation," Goya created an image of profound and disorienting sexual ambiguity—head, penis, and finally, the vagina as the site of generation mingle in a genital blur of the masculine and feminine that resists ordinary vision and linguistic attempts to define it. The two eyeglasses and the scribe with his pen and notebook depict the methods dear to eighteenth-century science—close observation and classification—but not as triumphal forces of the Enlightenment come to the rescue. Quite the contrary, the monstrous conundrum remains and yet, among the players in the scene, there is only one character who responds with horror.

The man in the final version of plate 57 who has thrown his head back and appears to be emitting a loud wail drew me to look more closely at him. If he is playing the role of bridegroom, then he looks as if he knows that he is being deceived, a fact that belies the text. He seems to have no relation to anyone else in the image, but in terms of the composition, his facial expression is the polar opposite of the head's peaceful oblivion. The line of his hunched shoulders is dimly visible, but like so many beings in *Los Caprichos*, the rest of him loses all definition as he blends into the murk of indistinguishable bodies. He is less of a caricature than the other people in the plate, and he exists in no other version. Goya clearly changed his mind about this character and gave him a new identity. The man's expression is similar to the agonized face that rises from Goya's own head in the initial pen drawing for plate 43, and this character has Goya's hair—hair that bushes out at his jawline like the lion figure's in plate 21. Also like the lion, this person is a man apart, a spectator/actor who looks upward. His expression is similar as well to the uppermost winged figure in plate 69, another character with unruly hair who beseeches the heavens and is not part of the action. Immediately below him is another head and torso with a similar face, a person who holds two babies in his arms, another incarnation of the artist in a more diabolical role.

After studying the images in the plates and the drawings, I am convinced that Goya decided to insert disguised versions of himself among the plates, and that the drawing from 1800, with its multiple and metamorphosing self-portraits that emanate from his dreaming self, suggests that in its earliest incarnation "The sleep of reason produces monsters" may have included a hint

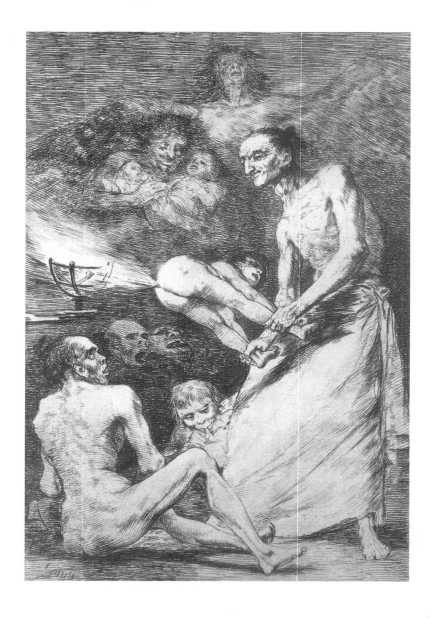

to the viewer that in the subsequent plates we would find the artist in various forms. In "The Filiation," Goya revisits material he introduced in plate 43. Like Zeus, the sleeping artist gives birth from his head, and that birth, an inversion of real vaginal birth, spawns a host of corporeal transformations.

Creative energy and sexual energy are bound up together in this narrative of the human body. The engendering head and the engendering penis begin to circulate wildly in the second movement as Goya's imaginary beings sprout phallic heads where sexual organs should be. The cat head in 48, the owl heads in 52 and 65, the ass heads in 63, the goblin head in 70, and the skeletal head in 77 are all depictions of heads in the genital position, but this exchange between heads and penises doesn't allow for a reductive equation that turns *every* head into a penis. In Goya, the phallic head, indeed all the heads peeking out from between the legs of his creatures, as well as the hermaphroditic head in plate 57, have a natural source—the heads that appear between women's legs when they are giving birth. Although there are three older children in the first movement, there are no babies. After 43, infants appear suddenly and briefly in quick succession. Plates 44, 45, and 47 all include babies so small that they can only be seen as newborns. Birth is the ordinary miracle, a violent and bloody process in which the borders between one person and another become indistinguishable. The inside becomes the outside as a being is thrust across the borders of the mother's body.

Goya wasn't the first to play with the similarities between penises and noses, vaginas and mouths, or with the idea that the artist combines sexes, that he is both penetrating phallic male and birthing woman, but nothing before or after has ever looked like Los Caprichos. The scholars who have linked the plates to carnival traditions are surely correct in their assumptions, but Goya's prints don't only play with the disguises and sexual inversions that belong to the world of carnival, they erode the very idea of the body as separate and distinct from other bodies, the notion that the world is a place of decisive boundaries and articulated, knowable space. In the first movement, a wakeful painter introduces us to a world askew. Its inhabitants are indisputably beastly, vicious, and stupid, but they are also people whose heads and bodies often seem precarious in relation to the dizzying space they occupy. In the second movement, Goya's pregnant head engenders more heads, some of which mimic the baby-heads of birth and others that are detached. The ghoul that flies in the moonlight of "Bon voyage," plate 64, carries five loose

GOYA
Los Caprichos
Plate 48, "Blasts of wind"
1799

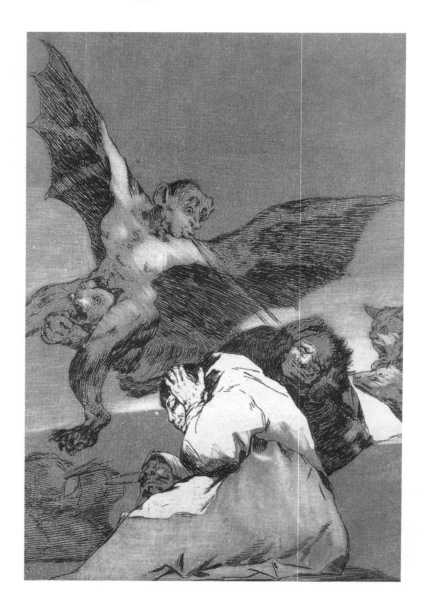

GOYA
Los Caprichos
Plate 70, "The devout profession"
1799

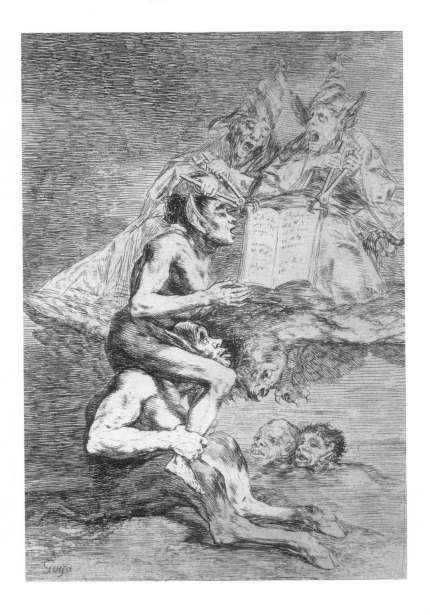

GOYA
Los Caprichos
Plate 64, "Bon voyage"
1799

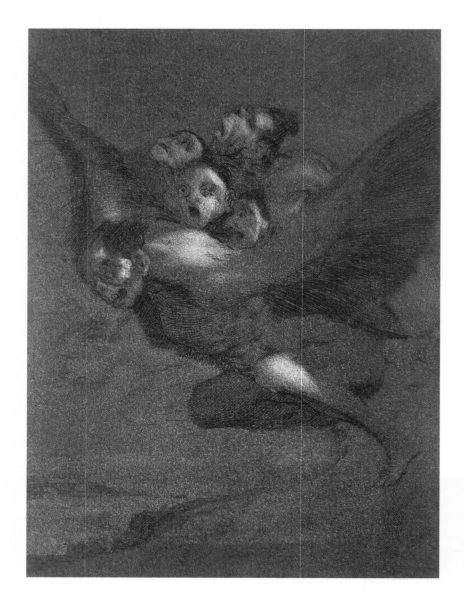

heads on his back. In number 70, two heads emerge as if from a lake in the sky. Heads bob and float and hover. It is as if the unreliable landscapes and vulnerable bodies of the first part of Los Caprichos have been pushed to new extremes in the second. We have entered the land of sleep, delirium, and hallucination. The laws of gravity are suspended. Heads lose their connection to shoulders. Distinct anatomies merge seamlessly to create new and monstrous beings. The last movement ends with number 80, "It is time." Four goblins are seen yawning uncontrollably. The Prado manuscript explains that it is dawn and these nocturnal creatures disappear by day and nobody knows where they hide themselves. Perhaps the light will wake the sleeping painter from his dreams.

Los Caprichos is a mysterious work that cries out for interpretation. Its secrets have mystified scholars for years, many of whom have treated its plates as signs in a code that might be cracked if only the right key could be discovered. But while I'm certain that many aspects of these astounding pictures still remain hidden from me, I'm equally sure that the eighty prints cannot be approached as a rationalist puzzle or a series of clever conceits that, once understood, will offer up clear-cut answers. While Goya's little book may well contain veiled allusions to the queen and various members of a reactionary nobility in a Spain that has now disappeared, its power as a work of art lies in its raw evocation of our own hidden lives and animal selves. Taken as a whole, the prints tell a story of what it means to live in our mortal bodies—an adventure of desire and vulnerability that in Goya defies both definition and category. Inside and outside mingle. Borders collapse. The ground under our feet shifts. Day enters night in our dreams. The painter may well have been partial to the secular and liberal thought of his period, but he couldn't have believed that reason would change human nature or alter the way we live. Like the incarnations of himself hidden among the plates of Los Caprichos, he remains a man apart, looking up toward a vacant heaven. Although this disguised Goya may be subject to despair, what the viewer sees in his images are people too hungry, too greedy, too alive to be dominated by that emotion. In its deepest sense, Los Caprichos can't be read as a morality tale. Rather, it is a brutal and exhilarating story of human beings and our deepest corporeal instinct—the will to survive. But it is also a narrative about Goya himself—the artist who gave birth to multitudes—torn from his own glorious, fractious, teeming head.

More Goya:
"There Are No Rules
in Painting"

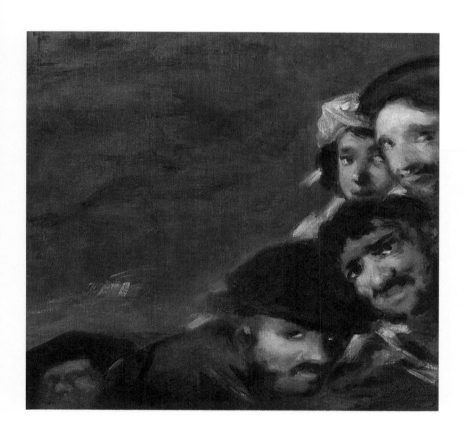

Since the Greeks, representations of the human body in Western art have been as various and contradictory as our notions of the body itself. The body is central to the history of art for the simple reason that every spectator of a painting or drawing is also a person, which means that pictures of human bodies inevitably produce a mirroring effect. We are always looking at ourselves. It is also true that every body that appears on canvas or paper is imaginary—a trace left by another body, the artist's, and what we see in front of us is the ghostly product of that absent being. In the work Goya produced after his illness in 1792, he was repeatedly drawn to depictions of the body in crisis. Not only did he feel close to death during his own sickness, but after his recovery he lived through years of turmoil, widespread suffering, and war in Spain. The etchings in *Disasters of War* are perhaps the most horrifying pictures of combat and its brutality on record. Among them are images I find nearly unbearable to look at. One of Goya's most famous paintings, *The Third of May*, also includes portraits of slain bodies. The canvas tells the story of the execution of Spanish citizens who had rebelled against Napoleon's invading army in 1808. Painted six years after the event, it has been generally recognized as a turning point in the genre known as history painting, a startlingly modern work that exploded the conventions of the form. But *The Third of May* can also be read as a further development of Goya's vision of the body in art. The vulnerable anatomies in irrational space that he created in the plates of *Los Caprichos* are not anomalies in his work or limited to particular genres. They are also present in this historical canvas. And, as in *Los Caprichos*, Goya chose to implicate himself in the story he was telling—becoming simultaneously artist, witness, and subject of the historical event he took it upon himself to record.

For hundreds of years, there were only a few stories possible in Western art. Didactic Medieval painting relied on multiple panels that depicted the life of Christ, the life of the Virgin, and the lives of the saints, or else on the visual conventions that allowed the spectator to identify the part of the narrative he happened to be looking at: the Annunciation, the Crucifixion, the Deposition, and so on. Later, mythological subjects were added to the canon, so that the viewer could recognize the stories of the ancient gods and heroes. Although considerable freedom in the depiction of these stories was possible, there was general agreement about which stories should be told and how they should be

FRANCISCO GOYA

The Third of May

1814

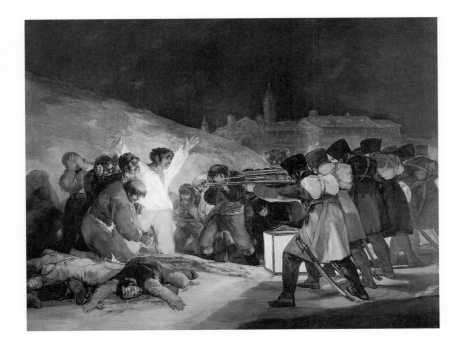

interpreted. The seventeenth-century Dutch painters broke with these narratives and created new subjects grounded in daily life, but the idea of coded images remained strong in their allegories, which carried within them moral and spiritual messages that contemporary viewers could usually understand without difficulty. It was only during the Enlightenment that the old notions of what and how to paint suddenly were open to question. The narratives in William Hogarth's *The Rake's Progress* (1735), for example, were a radical departure in his day, but his message about vice and virtue is unambiguous. In the more optimistic corners of Enlightenment thinking, reason filled in for God. Order and light now belonged to the realm of human thought.

Before he fell ill in 1792, Goya gave an address to the Royal Academy of San Fernando about methods of teaching the visual arts. In it he vehemently advocated the importance of working from nature and not from other paintings, sculptures, or casts, which was the common practice in art academies all over Europe at the time. "I will give a proof to demonstrate with facts that *there are no rules in painting,* and that oppression or servile obligation of making all study or follow the same path, is a great impediment for the young who profess this very difficult art." He then added, "He who wishes to distance himself, to correct [nature] without seeking the best of it, can he help but fall into a reprehensible and monotonous manner?"[1] Goya was still working as a tapestry painter at the time, making cartoons for the royal factory of Santa Barbara, a job he disliked and resented, but while he was employed there he allowed himself the liberty of expanding its narratives. As Janis Tomlinson points out in her book *From El Greco to Goya*, he used scenes from contemporary life rather than limiting himself to the codified stories of myth or history.[2] Ironically, it was illness that liberated him from commissions for a time, and in a letter written to Don Bernardo de Iriarte, Vice Protector of the Academy in 1794, he reiterated his desire to be free from the tedium of prescribed genres. He tells Iriarte that he is sending "a set of cabinet pictures in which I have managed to make observations for which there is normally no opportunity in commissioned works, which give no scope for fantasy and invention."[3] Clearly balking at all constraints on his imagination, the artist pursued his own projects in which he alone was master. In his book on Goya, Robert Hughes writes that Goya *asked* for a commission to paint *The Second of May* and *The Third of May.*[4] In other words, he hoped to use the system to his advantage—to be funded for works he knew he wanted to paint. No one knows

exactly where Goya was on May 3, 1808, and what he saw or didn't see remains an open question, but I doubt he executed the painting from memory because, despite its documentary feeling, the canvas is both ideological and symbolic.

GOYA AND DAVID: MARTYRDOM

The same year Goya gave his address to the Academy in Spain, Jacques-Louis David addressed the National Convention in France to propose the commission of a funerary monument as well as a medallion to honor the Revolution's heroic dead. "I wish," he said,

> *that my proposal to strike medallions be realized for all the glorious and auspicious events of the Republic that have already taken place and will take place; this in imitation of the Greeks and Romans, who through their series of medallions, have not only given us knowledge of remarkable events, knowledge of the* grands hommes, *but also of the progress of their arts.*[5]

Like Goya, David was interested in telling a contemporary story—the narrative of the French Revolution. In sharp contrast to his Spanish contemporary, however, David developed a style that is heavily codified by neoclassical ideas. He took his cues from Alberti, the Renaissance painter, sculptor, architect, and theorist, who encouraged painting from nature but also argued that copying nature didn't guarantee beauty. Beauty required that nature be enhanced. This is precisely the position Goya objected to so strenuously in his Academy address when he insisted that nature needed no correction.

David's neoclassicism, with its dramatic improvements upon nature, did not produce "a monotonous and reprehensible manner," however. Out of his methods came an extraordinary painting: *Marat Assassinated*. The murdered revolutionary slumped in his bathtub has a wondrous body—smooth, pale skin illuminated from above by what seems to be an almost divine light. The drapery of the cloth beneath his arm, echoed by the folds of his turban, connotes High Renaissance canvases, but without their opulent color; and the tragic expression of the dead martyr, with its hint of resignation, recalls the sacrifice of Jesus on the Cross. David wasn't interested in simple imitation; he used past forms to reinvent the present. His *Marat* floats in a fantastic ethereal nowhere. The absence of any identifiable background, even the limits of an empty room, lifts the sublimely rendered corpse into the arena of heroic transcendence and universality.

JACQUES-LOUIS DAVID
Marat Assassinated
1793

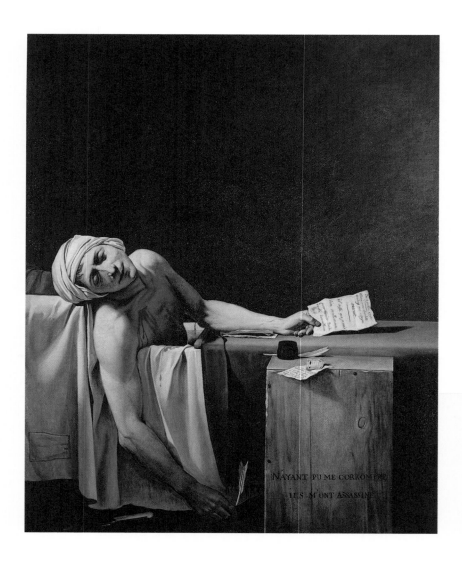

It is safe to say that Marat never looked like this. After Charlotte Corday stabbed him, he couldn't have been a lovely sight, and it's unlikely that he slumped over so gracefully with the page of his manuscript still in his hand. David visited Marat the day before he was murdered. He had a conversation with that "hero of the people" while he was in the bath writing an article, and the memory of the exchange no doubt influenced the way in which the painter chose to portray his subject. What fascinates me, however, is that after Marat was killed, David wasn't only assigned the task of commemorating him in a painting, he was also involved in arranging the funeral and exhibiting the body to the public. In his address to the Convention on that occasion, David explained: "We cannot uncover certain parts of his body because you know he was leprous and that his blood was diseased. But I thought it would be interesting to offer him in the pose I found him in, writing for the happiness of the people." [6] As it turned out, the Convention decided not to prop up the already embalmed corpse in a bathtub or wrench its hands into a position that would allow them to hold a pen and paper, but David's proposal is nothing short of astounding as an aesthetic idea. His plan was to turn the corpse itself into statuary—to metamorphose what once was a man into a work of art. It may be argued that all embalming, all viewing of the dead stretched out on tables or in coffins, dressed in their Sunday clothes with rouge on their cheeks, partakes of artistic manipulation, but David wasn't intent on prettifying a dead husband for a widow's eyes. He was on an official and public mission, which required that a corpse be suffused with the idea of heroism, and this demanded disguise at another level.

Marat spent innumerable hours in his bathtub because it was the only place he could find relief from a terrible skin disease he had contracted while hiding in the Paris sewers. David knew that showing the weals and welts on his subject's skin, whether on the corpse itself or on canvas, would not only be unpalatable to the viewer, it would interfere with the Greek ideal of the human body he wanted to project: Marat must be viewed as a *grand homme*, not an ordinary man. Therefore the representation of Marat necessitated the suppression of the real body with its scabrous, oozing skin disease. David's canvas is a form of exalted propaganda, one that entailed ferocious editing of the corpse the artist actually saw. In cruder hands, similar manipulations would result in the absurdities of Soviet Socialist Realism and the hideous bombast of Nazi art. *Marat Assassinated* is a rare modern example of great art in the

service of established power. The political ironies at work in the differences between David's *Marat* and Goya's *The Third of May* are obvious: revolutionary France produced David; repressive monarchical Spain produced Goya.

David's canvas acts as the perfect counterpoint to Goya's because each picture takes a different approach to what is essentially the same problem—depicting a martyr to a cause. The fact that they were painted in roughly the same period underscores their striking separateness. The emotional heart of *The Third of May* is the face of the kneeling man with his arms in the air. His face, with its expression of terror in the moment before he is about to be shot, is illuminated by the light from a lantern, which sits on the ground in front of his executioners—the line of uniformed French soldiers who have their backs to the viewer. Nearly every commentary I have read makes much of the contrast between the anonymous line of soldiers and the recognizable faces of the victims. Napoleon's troops are portrayed as a single entity in the canvas—an inhuman killing machine rather than a group of individuals, an early depiction of modern warfare and mechanized murder. Had Goya chosen to show the soldiers' faces, the painting's effect would have been entirely altered. Each man would have to have been somebody. As it is, the soldiers are nobodies, and this serves the painting's cause, which is unambiguous. It commemorates and mourns the mass slaughter of the *madrileños* on May 3, 1808, and turns them into martyrs for Spain. But the viewer doesn't need to know a thing about Spanish history to read the painting's story correctly. The line of rifles and the three corpses lying on the ground tell all. The blood that runs profusely from their wounds has mingled and stained the ground beneath them. Goya's rendering of these corpses is essential to the broader meanings of the canvas and the idea of martyrdom.

To be a martyr, one's body must be wounded or injured. This idea can be traced back to early Christian thinkers, who were victims of persecution and for whom the possibility of being mutilated and murdered for their faith was a constant and real threat. Early in the third century, Tertullian of Carthage focused tremendous intellectual energy on the problem of the dead martyr's tortured and broken body and worried about how salvation through corporeal resurrection would actually work. As he pointed out in a direct and passionate way—"For what dead man is entire, though he dies entire? Who is without hurt, that is without life? What body is uninjured when it is dead, when it is cold, when it is ghastly, when it is stiff, when it is a corpse?" [7] Both David and

Goya painted scenes of secular martyrdom—dying not for God but for a political cause. Yet Tertullian's graphic description of the dead body is far closer to Goya's representation of corpses than it is to David's. Goya's dead are not abstract or aesthetic; they are truly ghastly.

The depictions of Christ's wounds in Western art are countless, and they range from the gruesome to the nearly invisible. Although the Passion story is bloody and horrible, it ends with the Resurrection, and the portrayals of the Crucifixion required that the idea of the restored body somehow be incorporated into the image. When Dostoyevsky saw Holbein's *Dead Christ*, the painting horrified him because its realism seemed to preclude the possibility of resurrection. Christ's wounds often had a double purpose; they were part depiction and part sign, and eventually it became enough to suggest his suffering rather than recreate the realities of anatomical damage. David gave his *Marat* the sign of a fatal injury—an exquisite knife wound that produces a single line of blood. It runs down the dead man's torso to the sheet that covers the edge of the bath. The injury harks directly back to Renaissance pictures of narrow streams of red blood that trickle down the pale torso of Christ on the Cross. One example among many is Fra Angelico's *Deposition* (1433–34), in which a similar ribbon of red runs from a tiny, precise cut in the Savior's side to the cloth wrapped around his hips. Like many Renaissance painters, David includes an idea of resurrection in his canvas through the physical wholeness of his corpse. The body of his *Marat* will be redeemed, not by God, but by history literally *transfigured* in art. David's message of immortality is communicated not only through the Greek splendor of Marat's body, but by the delicate character of the wound, which inevitably conjures up resonances with the history of religious painting. The cut is a tiny opening in an otherwise perfect, whole, closed body. It is impossible to imagine this body decomposing, because we are not meant to be deluded about what it is: a work of art, a corpse as gorgeous statue, a thing preserved forever in paint.

In fact, David's technique defies the possibility of a mortal wound because it doesn't admit to the truth that a real corpse is waste, which must be quickly embalmed or buried before decay sets in. The margins of Marat's body and every object in the canvas appear absolute, unyielding, frozen. A border of exact definition divides the canvas above its middle and runs from the drapery to the turban, over Marat's shoulder and arm to the hand and the page it holds and finally across the green cloth that covers the bath. The effect of

looking at the actual canvas—which is large—was for me like suddenly having fantastically good vision. The body and its small cut, the folds in the cloth, the quills, the inkpot, the paper, and the knife have a heightened clarity even when in shadow, which signifies an order of clean separations among all visible things, a world in which blur, doubt, and ambiguity have been banished and truth is knowable. The intense pleasure the painting evokes in me is, I think, due to its confidence in the essential order of things, and to the fact that although it proposes itself as a narrative canvas, the depiction of an actual historical event, it doesn't tell a story. The essential element of all stories is motion—change—and *Marat Assassinated* is a canvas that includes a tacit acknowledgement of its own stasis as an art object.

Despite its allusions to Greek statuary and Renaissance religious painting, *Marat* is an Enlightenment canvas—one might even argue an Encyclopedist painting—a work in which the world may be divided, classified, and thereby conquered. David managed to portray the aftermath of a violent murder committed by a deranged woman as an eminently rational image, to render the slain body of a man with a skin disease and every one of the few objects around it as gloriously distinct and stable.

To turn from David's *Marat* to Goya's *The Third of May* is to move from the beauty of clarity to the misery of chaos. Goya's dead may be poignant, but they are also ugly. The head wound of the corpse in the foreground is a hideous gash of destroyed bone and flesh. When I stood several feet away from the image in the Prado, the opening in the dead man's head struck me as intensely realistic. I had to move very close to see that it is composed of several rough brush strokes that nevertheless, at a distance, suggest an intimate knowledge of the appearance of actual head injuries. The dead man has collapsed on top of another corpse, but the legs that belong to the body underneath him are difficult to locate. When I examined the canvas, it became clear that Goya didn't bother to raise the position of the uppermost corpse to make it look as if the body beneath it had legs. The two corpses merge with each other and also with a third, and the mangled bodies appear to run together and become an indifferent heap of limbs, torsos, and heads. No longer individuals, they are war's refuse—a contaminated, seeping mass—in which the distinctions between one body and another have lost their meaning. Goya's hectic, almost crude brushstrokes and ragged edges enhance the painting's atmosphere of blended, opened bodies, a technique as remote from David as one can possibly

imagine. The style of the canvas is deliberately antiaesthetic. It refuses to make slaughter beautiful, and that refusal separates Goya not only from David, but from all his predecessors. Neither beauty nor refinement plays a role in the canvas, which may be read through Goya's declaration: *There are no rules in painting.*

The "rules" of the past that Goya resisted are systems of meaning that include not only the illusion of perspective but also the enhancement of nature and modes of representing certain subjects. They are nothing less than codes for seeing the world and interpreting it. Had Goya abandoned all the rules, we wouldn't be able to *read* the painting as a story at all, but he defied enough of them to create a highly unconventional work that forces the viewer to look again. Goya's irritation with conventional academic methods didn't begin with his speech in 1792. The commission he was granted in 1776 to paint frescoes in the cupola of El Pilar and its four pendentives was executed in 1780, but the *Queen of the Martyrs* did not please the building committee because the powers-that-were regarded Goya's work as unfinished. The artist fumed at the injustice. In a letter to Martín Zapater, he wrote that he was trying to forget "those vile men who had so little faith in my merit." [8] Goya accepted a compromise for El Pilar, but it's interesting to consider what the building committee wanted. For them, finishing the image meant greater clarity and definition, which would enhance the borders of every figure and object in the frescoes.

In the context of his ongoing rebellion against inherited conventions, it is pertinent to note that Goya chose to give his central figure, the man with opened arms, clearly visible stigmata on his right hand—a direct reference to Christ and the saints, a reference even more symbolic and obvious than the one David makes with Marat's side wound. Unlike every other injury in the canvas, this one is not gushing blood. The small, round indentation in the man's splayed hand functions as a symbolic link to the many religious martyrdom paintings of the past. Fred Licht draws attention to the stigmata, the position of the man's arms that echo the Crucifixion, and to the colors the man is wearing, yellow and white—the colors of the church—but he argues passionately and convincingly that the man "never achieves the sanctity of or the meaning of Christ or of a lesser martyr." [9] For Licht, and indeed for most modern commentators on the painting, the man is not even a hero, but a victim of senseless warfare. Nevertheless, Goya made the decision to give the

man the symbolic mark of the Crucifixion, and the imprint on his hand must be regarded at the very least as a sign of his innocence. There is nothing in the canvas that suggests that this man will suffer a fate different from his compatriots. He will fall like them and die and rot with them, but the mark on his hand is a message to the viewer that his fate is undeserved, as was Christ's and the saints' who suffered for their faith. But Licht is right. In Goya's canvas there is no possibility of a redeemed body because there is nothing whole about his vision of death—it is a fragmented state. His corpses are going to pieces.

The fact that Goya chose to illuminate his martyr, or antimartyr, with a light source within the painting rather than outside it also affects the work's meaning. The lantern is the only illumination on a dark night. Its purpose is practical—lighting the victims so that they can be killed. Everything the spectator views in the canvas is seen because of this light. His vision dims at the periphery, where the lantern no longer shines so brightly. In other words, the lamp's location creates varying degrees of definition in the scene. The sharpest border in the canvas runs along the soldier's knee, which partially blocks our view of the lantern itself. The relative clarity of this corporeal margin in relation to the victims' fuzzier outlines functions as a trope within the story being told. The soldiers will remain whole and alive; the Spanish citizens will be broken and die. As they recede from the lamplight, the cornered victims blend more and more into the background and become increasingly difficult to see. The man on the left side of the painting, who has covered his face with his hands, is painted in a palette similar to the hill, and the huddled figure at the edge of the canvas, who seems to be a woman draped in a cloak, is more shadow than person, a dark ghost of the landscape, a being whose borders can't be made out. Below her is another darker and even more vague person whose sex can't even be guessed at. Through their lack of definition and their colors that match the earth around them, Goya employs a visual language to describe a process that is already under way—the decay of corpses returning to the ground. Goya has chosen to paint time, not timelessness. He throws his spectator into a terrible moment seen in a transient light, a moment from which there is no escape and of which there is no perfect or clear view, but rather one that dims and fogs beyond the immediate radiance of the lantern's light.

In David's painting, the viewer is granted the happiness of distance. His hero is nothing less than a monument that has been theatrically lit and

stopped in time. The peaceful corpse awes me, but when I look at it I am barred entrance into the space it inhabits. Despite the large size of the canvas, I can't even fantasize about stepping into that abstract space. Looking at Goya's painting, however, I am drawn close to the murders, and this is at least partly because there is something unusual about my perspective. Similar to the crazy space in *Los Caprichos*, but on a far grander scale, *The Third of May* creates subtly shifting perspectives. For example, I feel that I am looking down on the corpses but up at the soldiers. The effect is that I lose a secure angle of vision, a definite sense of how to interpret the space. Indeed, the only flat ground in the painting is under the feet of the French soldiers. The victims have no such foothold. They are all kneeling, crouching, or climbing as the earth beneath them undulates and dips. Where, for example, are the rest of the legs of the pugilistic monk? With the single exception of the boots that belong to corpses, we cannot see the feet of a single Spaniard. In fact, the spectator is presented with a view in which not one body among the *madrileños* can be seen whole. The tipping perspective, the lack of visible ground beneath the victims, and the merging of figures, in which legs, feet, and parts of bodies seem to vanish or blend into one another, disorient the viewer and mirror the confusion and violence of the bloodshed being portrayed. Again, Goya has chosen an emotional perspective over a rational one. The perspective is cinematic before the invention of movies. By refusing to give its spectator a single point of view, the canvas creates narrative action through the illusion of movement and tips the onlooker into the horror itself.

TRAUMA

As Robert Hughes points out, *The Third of May* "has lived on for almost two centuries as the undiminished and unrivaled archetype of images of suffering and brutality in war." [10] When compared with earlier pictures, Hughes insists that it is better "because the truth offered by previous paintings of war is not raw but manifestly cooked; while Goya's extraordinary image is not raw either, but cooked in a different and startlingly unprecedented way, so that it looks raw." [11] I would argue that this "cooking" or illusion of rawness acts so powerfully on the viewer because Goya's techniques—his staging of the scene with its faceless killers and illuminated victims who have no visible feet, his tilting perspective, and his rough brush strokes that merge corpses in the dirt and blend figures into the hill—create not only a closeness to

this particular scene of murder but also reverberate with the reality of traumatic experience.

In her book *Powers of Horror*, Julia Kristeva describes abjection as a debilitating "narcissistic crisis" of someone who witnesses "the breaking down of a world that has erased its borders." Abjection is that which disturbs "identity, system, order."[12] In war, this disturbance is triggered by seeing the unspeakable, by facing nonexistence, the imminent danger of the "I" becoming "it"— a corpse, human waste. In battle, all rituals for the dead, the elaborate cultural procedures that separate the living from the bodies of the dead, are suspended. Soldiers wade in the gore of their comrades, and for the survivors, the memory of this often takes the form of returning hallucinations, seeing or reliving the same moment over and over again. In *History Beyond Trauma*, Françoise Davoine and Jean-Max Gaudillière tell of their therapeutic work with people badly damaged by experiences of war. "Subject and object are confused: here and there, inside and outside. The past is present. The dead return. It is a child's voice that is speaking, in a session, through the mouth of the adult he has become, in the name of an entire society threatened with disappearance."[13] The truth is it is normal to break down when faced with horror, and the resulting psychic confusion for those who live has been given many names: shell shock, war neuroses, post-traumatic stress disorder. Whatever it's called, ordinary human beings who have seen too much suffer from a host of symptoms that include nightmares and visions, hypersensitivity or a lack of feeling, and a powerful sense that they are not part of the world, that they live outside ordinary time.[14]

In *The Third of May*, Goya subtly and deftly mirrors the breakdown and confusion of trauma by blurring the visual borders in the canvas and creating with his brush a feeling of borders collapsing as well as their imminent collapse. The terrified protagonist is kneeling in the blood of his compatriots; red lines of blood run on the ground between his legs and along the edge of his yellow trousers. The narrative force of the picture is such that we know this threshold between the living and the dead can't hold. At the same time, this is a painting, and however much we feel the moment to come, what we see is a frozen image of a single instant in hell, just before the rifles fire and a man's body, bleeding and ripped by bullets, drops to the ground. I, the viewer, focus on this brilliantly lit man, am drawn to him in his final seconds, and my identification with him is made stronger by the angle of my vision that

destabilizes me, puts me on that undulating ground with him. In effect, Goya has turned his spectator into a witness, a witness who, like those traumatized by war, must look again and again at a single catastrophic moment when real time is paralyzed and replaced by a returning hallucination. Then is now. The past is present. In the series of plates now known as *The Disasters of War*, which Goya worked on between 1810 and 1815, plate 19, an image that depicts rape and murder, has been given the caption, "There is no more time." In etching after etching, we are given images that make us want to turn away. "I saw it," Goya inscribes under plate 44. In Goya's pictorial testimony to war, there becomes here, and all meaning is in crisis. In the second plate of the series we see an image that echoes or more likely prefigures *The Third of May*. Several French soldiers with their backs to the viewer and muskets raised are aiming at two men. One is bleeding and holds a knife. The other aims a lance at the uniformed men. The text reads, "With or without reason." The eighty-three pictures of the *Disasters of War* and *The Third of May* turn every ideological justification for war into cant. My father was a soldier during World War II in New Guinea and the Philippines. He fought in the battle of Luzon. Although he spoke of other aspects of the war and his experiences, he never talked about the actual fighting. Once, however, when I asked him about it, he gave me no descriptions of warfare, but he said, "I just kept saying to myself, 'This is insane. This is insane.'"

FINDING GOYA'S HEAD

In June 2003 I went to look at *The Third of May* in the Prado. Before that, I had seen it reproduced in a number of books I own about Goya, but even in reproduction there was a part of the painting I found both mysterious and bothersome—the left side of the canvas above the corpse whose face can't be seen, just below the two phantom figures. In all the commentaries I've read about the painting, those two figures are never mentioned. It's as if they've been left out of the story altogether. When I looked at the reproductions, I always puzzled over that mottled space. I spent about an hour and a half in front of *The Third of May* in the museum. I knew the painting was large, but it was considerably bigger than I had imagined. There was a lot to see. I sat in a chair for a while and then walked back and forth examining parts of the canvas. Near the end of my viewing, I stood in front of the shadowy space and began to study it. What had Goya intended to convey with these shadows?

GOYA
The Third of May (detail)
1814

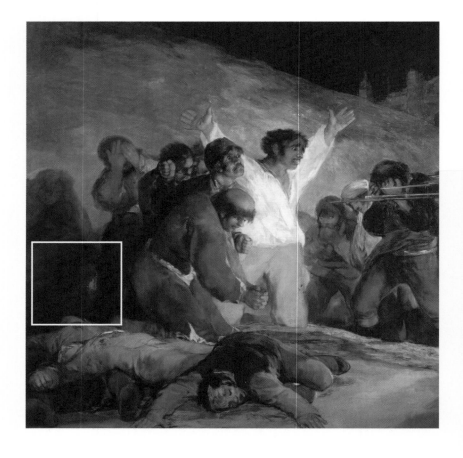

Who are the two draped figures? Two female mourners who represent the grieving mothers of the dying men? That made sense, I thought, and then I looked at the area below them and began to imagine that something was there. I stepped backward and forward, altering my position only by inches, and then suddenly, I saw a face — Goya's face — emerging from the shadows. To be honest, I thought I had looked too long. Like children who begin to see animals and people in the clouds overhead, I assumed I had fantasized his image. I left the canvas, visited the Black Paintings, and then returned to my spot. I saw him again. Despite its dimness, the image is unmistakable once you've seen it. The features are rendered very simply. Goya has a round face, large frightened eyes, a flat nose, an open mouth, and that signature hair with its leonine bushiness coming out from around the jawline. I can't overstate my astonishment. How could it be that I had never read about this self-portrait hidden in the canvas? I walked backward, lost the face, moved forward, and there he was again. In a fit of excitement, I ran to find my husband, my daughter, and a friend who were waiting for me in the museum café. I dragged the three of them upstairs to the canvas, placed them in position, and demanded that they look at the shadowy area. All three of them saw the face immediately and, without the slightest hesitation, my husband identified the face as Goya's.

Nevertheless, I wasn't absolutely certain that no one had written about that image before. After I returned to New York, I told two friends about the discovery. One of them, Nicole Krauss, a young novelist and art writer, was about to go off on a tour for art critics and historians to view Manet's seascapes and the sites in France where he had painted them. When she returned, she told me that Juliet Wilson-Bareau, an expert on Goya, had also been on the trip. She mentioned my little revelation to her and asked whether anyone had written about it before. Ms. Wilson-Bareau said no. Given her intimate knowledge of Goya scholarship, I accepted her statement as true. Nevertheless, some time later, when I was invited to do a public conversation at Hunter College about Goya with Robert Hughes, just after his book on Goya had been published, I asked him if he had ever read anything about a hidden self-portrait in the canvas. He also stated without hesitation that there was no scholarship on it at all, either in Spanish or English.

I published two short articles on the find, one in the *Observer* of London and one in *Modern Painters*. A friend of mine, Jean Frémon, a novelist and one of

GOYA
Self-portrait with Dr. Arrieta
1820

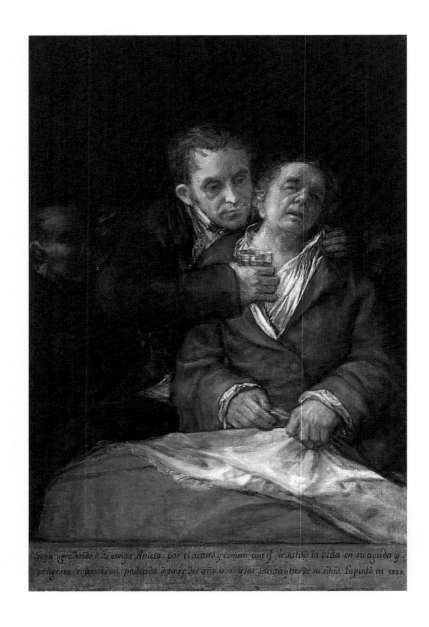

the directors of the Galerie Lelong in Paris and New York, read the piece in *Modern Painters*, and when he was in Madrid a couple of months later, visited the Prado and quickly found the disembodied head.

In light of my theory that the artist had also disguised himself as various characters in *Los Caprichos*, the discovery of his face in *The Third of May* made perfect sense to me. But what does it mean that Goya painted himself into the canvas? The suspended head beneath the cloaked figures suggests that the artist chose to enter the story he was telling as a phantom presence—a being in harmony with the two ghostly mourners above him. The expression he gave himself—startled and open-mouthed, as if he is crying out—makes it clear that there is nothing coy about this representation of himself. It is more than a portrait as signature. The tormented features resonate strongly with those that appear on the heads that rise from the sleeping Goya in the first extant drawing for plate 43 in *Los Caprichos*, with the agonized face of the man in plate 57, and with the uppermost figure in 69, who appears to be beseeching the sky. Again, Goya is a head only—a head made of shadows, bleary and difficult to see, that hovers at the edge of a bloody scene.

DR. ARRIETA

Six years after he painted *The Third of May*, Goya suffered another near-fatal illness. When he recovered, he painted a portrait of himself with his physician, Dr. Arrieta, and offered the canvas to the doctor as a gift. The work mimics the form of an ex-voto—the little paintings donated to holy places as a token of thanks for a miraculous occurrence by believers throughout the Catholic world. Lenz Kriss-Rettenbeck, a German scholar, has outlined the necessary elements in an ex-voto: the heavenly operative, divine being, saint, or holy place; the figure who turns to the heavenly domain (the person with the problem); the event or condition that was the cause of the communication between the earthly personage and the divine person or symbol (the problem); and finally, the inscription that records the condition, event, or hope.[15] Goya's inscription reads: "Goya thankful to his friend Arrieta: for the skill and care with which he saved his life during this short and dangerous illness, endured at the end of 1819, at seventy-three years of age. He painted it in 1820." In the canvas, Goya used the ex-voto form but secularized it, replacing the heavenly operative with a human one—the doctor. Arrieta would have read the gift through the lens of the ex-voto and understood that he was being

thanked for what Goya regarded as a miracle—his survival. The painting includes three mysterious figures behind Goya and Arrieta who seem to emerge from the solid black background of the canvas.

When I saw the painting in the collection of the Minneapolis Institute of Arts, I asked the curator, Evan Maurer, "Who are those people?" He answered, "Nobody knows." The person to the far left is holding a chalice, a fact that caused Janis Tomlinson to identify him as a priest and the two others as the cleric's attendants.[16] Fred Licht suggests that they are hallucinatory fever images, a much better guess to my mind.[17] When you look at the painting in Minneapolis, the palette of the three dim faces is quite distinct from that of the two main figures, and their height—the tops of their heads reach the doctor's shoulder—becomes even more mysterious. Where would these strange people be standing or sitting in relation to the bed? Two of the figures are visible only as heads, and the one farthest to the right isn't a complete head, but a mysteriously lit partial countenance floating in the blackness. Although the face of the third man in the Arrieta canvas is far more visible and realistic than the hidden face of Goya in *The Third of May*, the technique used to create the emerging but also veiled features is similar.

It is interesting to me that there are two cups in the picture—the medicinal glass the doctor offers his patient and a ghostly chalice—one mundane, the other sacramental. The doctor's cup offers life; the chalice held by the strange man to the left may be the drink of the Last Supper, of final rites, of death. My guess is that these mysterious people are the dead, figures in an ex-voto painting created by a man who had felt death in his body, almost touched it, and that the image is a vision of Goya literally being pulled out of blackness—the world of the dead—and forward into the light of this world by his able physician. Similarly, in *The Third of May*, Goya takes a known form—the martyrdom painting—and secularizes it. The central character's position, his stigmata, and his imminent death may be read through martyrdom conventions, just as the Arrieta painting may be read through those for an ex-voto, but with a turn—God has been banished from this bloody landscape and there is nothing to fill in the blank: no system, no logic, nothing. All that can be done is to bear witness to the anonymous dead, not through a monument that offers up war as glory, but in a work of art that refuses to make the dead glamorous, a canvas that breaks the rules. By hiding himself as if he were a ghost hovering over the corpses below, Goya mirrors the role he has also

given to his viewer. He becomes an imaginary witness of slaughter, and not a sanguine, distant one: he is a man screaming. At the same time, he acknowledges his role as the hidden author of the painting, which has set out to recreate an actual event. Goya has used his own head before, in *Los Caprichos*, as a metaphor for imagination and dreaming, and its reappearance in *The Third of May* reasserts the trope. For Goya, the distinction critics have made between the grotesque and supernatural qualities of *Los Caprichos* versus the so-called naturalism of *The Third of May* wouldn't have been terribly important. He was always portraying the world he knew and for him that included the role of the imagination. The veiled mourners on the hillside, Goya's hidden face, and the phantoms in the Arrieta painting are all imaginary creatures projected onto the canvas as beings of the artist's fertile brain. As Baudelaire argued, Goya's supernaturalism is essentially a form of naturalism.

THE BLACK PAINTINGS

The monsters and transformations of *Los Caprichos*, the three ghosts in the Arrieta canvas, as well as the phantom self-portrait in *The Third of May* are all images that seem to portend the so-called Black Paintings, which scholars have long thought were painted soon after Goya's self-portrait with his doctor. The connections between these earlier works and the Black Paintings are so apparent that I was astonished when I discovered that the authorship of the latter paintings has been called into question. An article in an issue of *The New York Times Magazine* reported that the Spanish art historian Juan José Junquera has determined that Goya could not have painted the fourteen works that were taken off the walls of his house outside Madrid, the Quinta del Sordo.[18] Through an analysis of the bill of sale for the house Goya bought in 1819, which describes two one-story buildings, and a later document, written after the artist's death, which lists Goya's renovations to the house, but which does not include the addition of another floor, Junquera has concluded that if there were no second story when Goya lived there, he couldn't have painted the Black Paintings because some of them were on those second-story walls.

I can't help feeling that such a conclusion makes a fetish of documentation. Documents can be in error. Because an official record omits mention of a second story doesn't mean it wasn't there. Building inspection, like every

GOYA
The Procession of San Isidro
1820–23

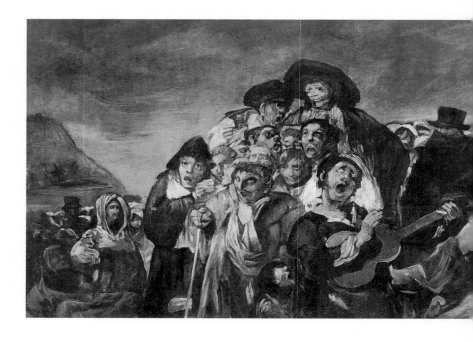

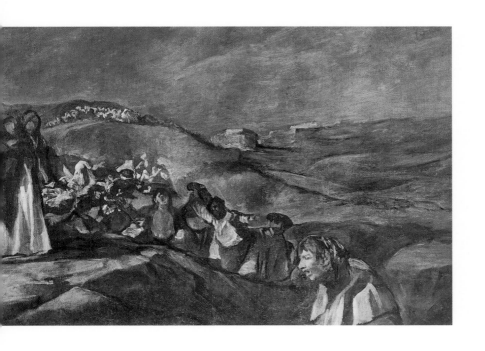

other human activity, is subject to imperfection. If Junquera is right in his assumption, I am forced to ask myself how it is that the Black Paintings repeat Goya's deeply private obsessions—with heads and decapitation, for example. Saturn eats his son—a headless corpse. Judith decapitates Holofernes, the head of a small dog protrudes from a quagmire, a gruesome monk with a gaping mouth has a hand but no visible body in *Two Monks*. *The Procession of San Isidro* includes piles of heads, one on top of the other, as if they were boulders in the landscape, bizarre outcroppings with howling faces. Behind the figures in the foreground of *Witches Sabbath* is another sea of heads. This theme is repeated in another disputed work, owned by Stanley Moss of New York City, *Capricho with Five Heads*. In that picture, completed around the same time as the Black Paintings, five heads appear in the lower right-hand corner of the canvas with a mountain behind them. Who else but Goya would even have considered such a composition? Not only that, Goya's vertiginous perspective, similar to the one he used both in *Los Caprichos* and in *The Third of May,* is also present in this canvas. It is impossible to reconstruct the missing bodies beyond the picture frame. If the men are standing, they are not resting on level ground, and they aren't in a ditch because the two top heads would have disappeared from view. This is an illogical space typical of Goya, one that is both unique and subtle.

Beneath the figures in the Black Painting called *The Readers* are vague phantom shadows very much like the ones in *The Third of May*, also ignored by art historians but which I find significant, because the forms hint at more ghosts emerging from the darkness. Goya and his doctor Arrieta, painted in 1820 with its explicit message of gratitude, is not a canvas in dispute. Its three ghostly characters may be linked to those in the Black Paintings, not only because they are beings of darkness and death, but because they are painted in a palette similar to many of the figures from the walls of the Quinta del Sordo.

Who could have duplicated this radical and utterly personal style of painting, and what crazy person would have placed the images on the walls of a house if he planned to make money from claiming those works were by Goya? Wouldn't it be much easier to turn out fake canvases for instant cash? The only person the debunkers have come up with is Javier, the artist's son, who didn't live with his father and who, by all accounts, was rather greedy for money. Evidence for his role as forger is slim. In 1805 Javier listed his

GOYA
Capricho with Five Heads
c. 1820–21

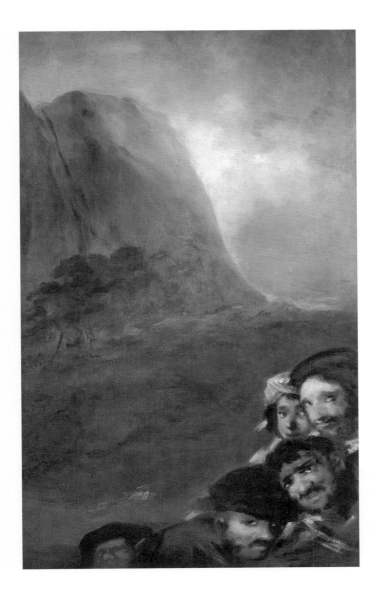

profession as "painter" on his marriage certificate, and much later, after he died, Iriarte mentioned that a painting removed from the house was believed to be by Javier, not his father.[19] Junquera suggests that Javier may have painted the walls to raise the value of the house that had been deeded to Goya's grandson, Mariano.[20] As great as the Black Paintings are, what buyer would want to face them day in and day out? What kind of a person could bear to be greeted by Saturn's cannibalism upon waking in the morning, or worse, upon going to bed at night? Also, underneath the paintings, X-rays have revealed other murals, done in a sunny, pastel palette, which show light-hearted pastoral scenes. Why paint terrifying pictures over pretty works that are easy to live with if you hoped to increase your profit on a sale? It doesn't make any sense. If Javier were the artist of the Black Paintings, it would mean that the son took on the inner life of the father—including decapitation obsession and vertigo—that he essentially *became* his father and stole the contents of that famous head. From a psychological point of view, this is preposterous, but then psychology doesn't enter the argument. It is an argument founded on a few pieces of official paper.

To my mind, the connections among the uncommissioned works Goya made after his illness in 1792 are too strong to go unseen. The art I've discussed, in depth or in passing—*Los Caprichos*, *The Third of May*, *The Disasters of War*, the self-portrait with Arrieta, The Black Paintings, and *Capricho with Five Heads*—are bound together by one man's singular vision, an artist with a radical and courageous imagination who had a profound emotional stake in the ruin, destruction, and bloodshed he had witnessed in his country, as well as an artist with extraordinary access to his own inner life—to the monsters and ghosts of dreams and hallucinations. In these works by Goya, the inside can't be separated from the outside. The horror exists both outside the artist in the world and inside his own head. Perception is also emotional. We are not in David's world of clean borders and sharp edges that delineate difference, order, and wholeness. There are no beautiful corpses here. They spill open. They gush blood. Some have been hacked to pieces. We are in a world haunted by traumatic visions of the monstrously human. "I saw it," he wrote. Perhaps he had seen too much. Even when terrible events are over and peace has returned, the memory of them is not erased. We don't know what Goya saw during the war, only that he was prompted to work for years on etchings that treated its carnage. We know that illness brought him close to death

twice. The insanity of war and the delirium of sickness merge in this work as a loss of borders and of secure ground. Goya is perhaps the greatest artist of nonsense—that nonsense we feel within us and recognize in the world around us as frightening and brutally, sometimes unbearably, real.

Giorgio Morandi:
Not Just Bottles

I had just arrived at the Peggy Guggenheim Gallery in Venice. My eleven-year-old daughter, Sophie, who accompanied me, settled herself on the floor of the first room with her sketchbook and pencil. We had come to look at the exhibition of Giorgio Morandi's late work, from 1950 to 1964, the year of the artist's death, and Sophie knew that we were going to be there for a long time. The gallery wasn't crowded, but it wasn't empty either, and as I stood in that first room, trying to digest what I was seeing, I heard an exchange between an American couple. The husband, who apparently had entered the gallery through the other door and had come to the first paintings last, looked around him with a somewhat bewildered expression on his face and called to his wife, "More bottles!" From the other room, I heard her answer him in an accusatory voice, "I told you. They're all the same!"

I don't quote this couple to make fun of them, but rather to begin with what they so succinctly pointed out. In his last years, Morandi mostly painted the same things, and he did paint a lot of bottles. He did not, however, paint only bottles, and yet the man's comment resonates with the experience of seeing the work, because the most recognizable objects in these canvases are often bottles. Almost every work includes at least one bottle, although there are paintings that feature a pitcher or some other quickly identifiable object. Near the paintings in the gallery were small texts that included the names of some of the other things—a cigar box, for example. But the boxes and cylinders that accompany the bottles in these paintings do not scream cigars or matches or salt. It is impossible to know what they are without being told.

The first question when you look at Morandi, which may also be the last question, is "What exactly am I looking at?" This question brings up the further questions, "How should I look?" and "Where should I look?" One could argue that nearly every painting, both representational and abstract, elicits these questions, but I think with Morandi they go to the heart of the work. The identities of the artist's bottles, vases, cups, and boxes are recessive, by which I mean that as you look at the objects before you on the canvas, the sense of them as ordinary named things diminishes over time. The objects seem to pull away from you into another spatial dimension, a second world that you recognize, but its content has changed.

This impression of otherness continued to grow as I looked. I kept asking myself where I should rest my eyes. It turned out that as quiet as these paintings are and as beautiful as they are as a whole, there is something restless

about them, too; they challenge the spectator to work at unpacking the curious relations among the objects in front of him. Among the first works in the show is a configuration of bottles, vases, and a pitcher. The white bottle is flanked from behind by a yellow bottle on the left and a rusty red or terracotta-colored vase on the right. Directly beside it on the right is a small white vase, and between the yellow and the red object is a dark gray pitcher that has been turned away from the viewer and is barely recognizable. Except for a small open space of light near the mouth of the red vase, its darkness fills up the entire space between the adjacent things.

In the gallery, I sketched the shapes in a notebook, a simple act that brings out very clearly the relations between the neighboring shapes. The pitcher's handle follows closely but not exactly the line of the yellow bottle's neck. The small white vase imperfectly echoes the curve of the fluted bottle. The lower side of the red vase moves along the neck of the white bottle. Furthermore, adjustments in the shapes of the bottles have been made for their neighbors. What is undoubtedly a symmetrical object in the studio becomes asymmetrical on the canvas. When you look closely at the lower, bulbous section of the white fluted bottle, you see that the side that borders the small vase has been shorn of its fullness and a blackened area marks the space between them. It is very dark. The light and shadow of real perception cannot account for it. This is not an imitation of sensory experience. The diffuse gray light that illuminates these paintings would never produce such blackness. Morandi has invented it, and the recurring black and deep gray places in the paintings accentuate what the artist is after, which is not only to render the things themselves but the spaces between them—the drama of their relations. Although normal perception tells us that the pitcher stands behind the white bottle, the paint tells us that they touch, that these things are closely bound in a space where separations and distances are muted at best. The fluted white bottle is drawn close to the object that appears farthest from it by an inexplicable long gray shadow, which ends in a darker gray shape that nearly touches the rear of the yellow bottle. It flirts with proximity.

It can be argued that these objects create a formal arrangement that plays with abstraction, that mimesis is secondary to the space of the canvas itself. The exhibition's excellent and thorough catalogue mentions the links that have been made between Morandi and abstract artists, including Rothko, Albers, Judd, and Mondrian. While it is easy to see these connections,

GIORGIO MORANDI
Still Life, c. 1916 (top)
Still Life, c. 1952 (bottom)

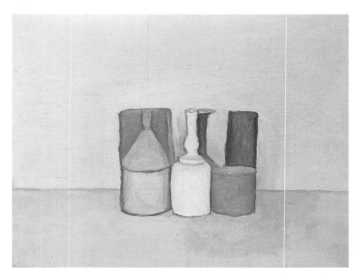

particularly to Rothko's luminous canvases and to Mondrian's development from his architectural trees to his famous rhythms of primary squares, I think that the project Morandi undertook for himself is finally very different from that of painters who ended up in a thoroughly abstract space. Morandi stubbornly resisted the debate about abstraction that raged around him during the years when he painted these canvases. He stuck to his bottles. In a radio interview in 1957, he said, "For me nothing is abstract. In fact, I believe there is nothing more surreal, nothing more abstract than reality." [1] This curious statement contains a paradox. Morandi first says that nothing is abstract and then he says that reality itself is abstract: Everything is abstract. So which is it? I think it is not either/or, but both—an almost mystical statement about the problem of seeing. What I see and paint is real. I paint the real and that reality looks like this: abstracted. Morandi did not hold himself back from the abstract expressionists out of some conservative urge to resist temptation. He simply did not see the world in their terms, and he wanted to paint what he experienced as a truth about what he saw. But what was he seeing?

The overall visual effect of the paintings as you walk from room to room in the gallery is one of a refinement that nearly aches with subtlety. The colors, the light, the little things on a vanishing table or shelf create an impression of an exquisite, cerebral distance, but the fact is that when you get close to the paint, when you stick your nose right up to a canvas, there is something rough and suggestive about the way the objects are painted. The canvas shows through. The lines delineating the objects wobble and wave. These things do not compose geometries or systems. In a painting from 1953–54, Morandi essentially divided his canvas in half, although the upper gray portion of the painting is in fact longer than its gray-brown counterpart on the bottom. The group of objects—three boxes, two bottles, and two cups—are grouped together in the painting's lower half. The tops of the bottles actually touch the line of division. Again, when you look closely at the row of objects, you see how one thing accommodates the other, how the line of the blue bottle is pushed by the cup that ordinary vision suggests should be behind it. It is as if the cup were a soft, not a solid body. The blue bottle's lines are sketchy, as if its outlines have been drawn, not painted. The bottom rim of the white cup to the left is rumpled, its proportions squeezed by the things on either side of it. It too is a hard object that is not hard. The illusion of depth is undermined in the canvas by the three boxes, shown as pure, flat rectangles that

repeat the two large rectangular spaces which divide the painting itself. The red box to the right is so blurred that it appears to vanish into the table, occupying a zone between thing and shadow.

Before I went to Venice, Karen Wright, the editor of *Modern Painters*, told me something that originated in the mouth of the art critic David Sylvester, whose book on Giacometti I greatly admire. Mr. Sylvester is reported to have said that he thought Morandi's late paintings were more closely related to the cityscape of Bologna than to still life. I carried this astute comment with me to Venice. The division in the painting with the three boxes does seem more closely linked to the horizon than to any tabletop. Even in its coloring, it is like the line between sky and ground. The boxes and bottles have an architectural feeling to them, as do the objects in many of the canvases. The painting with three boxes in front of three bottles and a pitcher, for example, looks like towers behind squat buildings. Apparently, Sylvester was not alone in this insight. The critic Carlo Ludovico Ragghianti is quoted in the show's catalogue as saying that Morandi's still lifes are "wholly architectural, so much so that it should prompt us to think of cathedrals rather than of bottles." [2] And to illustrate this point, the catalogue includes a black-and-white reproduction from the Pinacoteca Nazionale in Bologna of the city held in the hands of St. Petronius. [3] It is a powerful image, for in the hands of the saint, the city is miniaturized—reduced to a still life.

The colors in all the paintings are colors you see when you walk the streets of almost any Italian town, hues baked and lightened by the sun—green and blue shutters, yellow walls, old terra-cotta turned pink, and stone, lots of stone, varying in shade from a pale white-gray to sooty black. And there is the changing sky, too, its blues and grays and cloudy alterations. These are the colors Morandi uses, and he did paint many landscapes. But the question then becomes, if it is really landscape you are interested in, why paint so many still lifes? Why paint objects instead of what you see out your window? Why paint a city as bottles? Weather alters everything you see. Buildings vanish behind clouds. The sun makes a hill rise up in clarity, while on other days its glare makes the hill disappear. There is morning light and evening light and the light of high noon. Morandi's still lifes are haunted by weather, by the forms and colors of earth and city. The mutable landscape Morandi saw from his window every day was part of, but not the end of, an idea he had about reality. The little bottles and objects he worked with and carefully

tended by allowing them to get dustier and dustier until a heavy film blurred their outlines became the obsessive focus of a man's quest for the real. In these still lifes, we are neither outside nor inside, but both inside and outside. The mysterious light that shines on these objects seems influenced by the effects of natural light on things but doesn't look like natural light. Morandi used a system of veils on his window to cut, alter, and change sunlight to produce in the studio a strange, eternal illumination for his dusty little things. He manipulated light for his own purpose.

That Morandi looked at and loved the outlines and architecture of his own city seems obvious, but the ghostly cities that lie suggestively behind his paintings are also cities of paint. Before I left Venice, Sophie and I visited the Accademia. Even in August, when tourists crowd the streets, this museum that contains some of the world's greatest paintings is strangely empty. I have been there four times, always at peak season, and each time the Accademia has felt curiously abandoned. In most of its rooms, Sophie and I were alone. We had little time, and I rushed to look again at what is perhaps my favorite painting in the world: Giorgione's *The Tempest*. After spending hours with Morandi, I found myself looking at the dead city in the background of that canvas and at the strange wall, topped by two curious cylinders closer to the foreground, with new eyes. Giorgione's columns and rectangles brought Morandi's still lifes into clearer focus. The city of *The Tempest* is not a real city, but a mixture of classical towers and Venetian rural buildings. Looking at the Giorgione painting again did not make me believe that Morandi was referring directly to it, but rather that the weird city in *The Tempest* is a particularly mysterious example of the countless little cities that appear in the background of Renaissance Italian painting. For example, in Giovanni Bellini's *The Madonna of the Meadow*, at the National Gallery in Washington, the city in the distance creates a harmony of spatial forms that is both mimetic and abstract, of the world and not of it. After my visit to the Accademia, I read in the catalogue that John Berger felt the presence of the Renaissance in Morandi and made general comparisons between him and Bellini, as well as Piero della Francesca, in his catalogue essay for the Italian show at the Museum of Modern Art in 1949.[4]

Architecture in Renaissance painting was of course increasingly influenced by the actual vision of the painter. Bellini was asked to put Paris in the background of a painting and said he couldn't do it, because he had never

seen it. But architectural forms in Renaissance painting, particularly early Renaissance painting, nevertheless served a spiritual idea of harmonies and order that went beyond the merely seen. And in this lies the deep affinity between Morandi and the formal abstractions of Renaissance painting. Looking at these late canvases, I kept thinking of the words *behind*, *under*, *beyond*. These are not bottles and vases and cups, and although they may suggest a city, they are not cities either. After looking for a while, they did not even seem like still lifes anymore. It was as if I were seeing forms that evoked *idea* rather than *thing*. The object—bottle, cup, cloth, vase—receded into some larger mystery.

When I looked at the series of six paintings from 1952, which all include a yellow cloth and were hung together in one room in the gallery, I felt as if the canvases were having a mute conversation with one another. The white fluted bottle, its ridges less evident in this series than in some of the other paintings, remains as an anchor on the right in all of them. The striking yellow cloth remains front and center. The cup and cylindrical vase are constant anchors on the left. What changes is the object between the flanking white bottle and vase. A brown form, described as a basket, is substituted by a green bowl in others, the hue of which changes dramatically between two canvases, from dark green in one to a much yellower tone in the other. In these two canvases, there is an additional object, an extended cylindrical white form that appears behind the white bottle. In the series, the shifting happens in the space between white objects, from one brown to another, from one green to another. It made me think that Morandi was exploring *between-ness* itself, asking what constitutes a border. In the canvas with the paler green bowl, the bowl seems to tip upward. Its edge behind the white cylinder is outlined in a deep gray, which continues downward to divide the yellow cloth and white cup, a fine dark line of distinction that is nearly erotic in its closeness. After looking for a while, I found this darkness between cup and cloth obsessively interesting, more interesting than the objects themselves.

Nevertheless, the yellow cloth announces itself in the show, because these six paintings are the only ones that include it as an element. I asked myself whether the cloth was folded identically from one painting to the next. Had the folds changed or had Morandi merely shifted the angle of the cloth as a whole? I'm not sure. The sensibility of the painter suggests that every change would have been made both deliberately and carefully. Significantly, the

MORANDI
Still Life with Yellow Cloth
1952

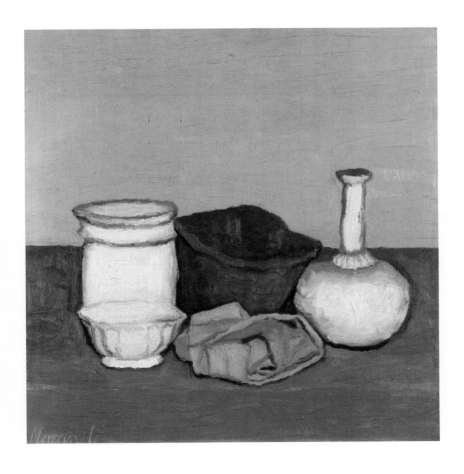

cloth itself—its creases, shadows, interstices—does not contrast sharply with the other objects. It is not a soft body next to hard ones. The material of the brown basket appears to fold slightly in harmony with the cloth. Again I was drawn back to Renaissance painting, to the countless examples of drapery and clothing that fall, fold, and knot over architecture, but especially over bodies. The small rounded knot of cloth appears and reappears in canvas after canvas during High Renaissance painting. Even the most cursory look at Pontormo's *Deposition*, for example, shows countless examples of folded cloth draped sinuously over heads and shoulders and arms, and then there is the roselike tie or knot of material looped around Christ's hips. This rose of cloth hides Christ's genitals in innumerable pietàs, entombments, and crucifixions. An example of this knot in a painting with a classical theme may be seen in Titian's *Rape of Lucretia (Tarquin and Lucretia)*. A rose of pale cloth lies between Lucretia's legs, surrounded by the deep shadow along the crease of her thighs. While it would be far-fetched to say that Morandi is referring directly to any of these paintings, the cloth evokes these other cloths in the delicacy of the painting, as well as in the sensual pleasures of looking at fabric. In Morandi the spectator is invited to consider the nature of *threshold* itself, the boundaries between one body and another—all bodies—both inanimate and animate. Just as Morandi is not painting cities as bottles, he is not painting human bodies as objects either, but the world of the flesh is not as far from these paintings as one might think. In the strange give and take between and among forms in the canvases, in the often barely perceptible wrinkling or folding inward, in the deep shadowed crevices and the mysterious softness of their material, these things make us think about the physical world, and from that meditation, we begin to think about thingness and about what is there and what is not there.

There are several examples of a thing that is at once present and absent. The simplest occur in two paintings from 1957. They both include the shadow of an object beyond the borders of the canvas. In one, two bottles and a cylinder stand in the center of the painting. All cast shadows backward and to the right, but at the edge of the canvas, just below the line of the table, is a shadow from something else that we can't see. Exactly how this object could cast a shadow in that direction, considering the illusion created in the painting about the angle of light, is a mystery. In the second painting, the presence of an invisible object is subtler, but to the far right is a gray triangular shadow

that implies the presence of another thing we cannot see. A canvas from 1959 shows two similar pale bottles, the small white vase viewed in earlier paintings, and a smoky gray-black rectangular form that appears to float out of the side of the bottle on the left. It is impossible to identify this form and impossible to penetrate its position in terms of conventional vision. A drawing from 1958 and a watercolor from 1959, reproduced in the exhibition's catalogue, show the same two bottles. The space between them is differently shaded, but remains the site of intense focus in both. The black rectangle of the painting is a sober occupant of space, but it is not a thing as the bottles are things. It is neither shadow nor object. Indeed, the difference between the objects and the space between them increasingly loses its significance as you look at that dark form in relation to what is around it. The growing focus in Morandi on the spaces between objects is philosophical. The lines we draw between the objects we see and live with are the product of our vision, a vision determined by the living language we use, a language that has profound and changing cultural meanings. To simplify this statement in terms of painting, one can say that a cup in a painting done in 1390 is different from a cup in a painting done in 1998. The conventions, the language of looking, the perspective we use to decipher meaning, have changed.

Giorgio Morandi is in the business of subverting the conventions of seeing. It makes perfect sense that he loved Cézanne, who had a related desire to strip things down, to see them again as if for the first time. Morandi shares Cézanne's acute attentiveness and desire to lift off the veil of convention from visual experience, but there is in Morandi something belated, something beyond the present moment that is not found in Cézanne. The very last paintings in this show are almost like afterimages: those blots of shape and color and light that remain even after you have closed your eyes to the things themselves. In these last works, the relations between objects and empty space, between solid form and air, between the edge of one thing and another are persistently questioned. Where does one thing begin and another end? In the exhibition's remarkable last painting, one wonders if the ghostly white bottle is actually coming out of the dark one that stands beneath it. Looking at Morandi's work, I felt a lingering Platonism that may well come from the overwhelming power of the painterly past, that great translation of Pauline Christianity into art, which reinvented Platonic thought through the events of the life of Jesus. The ideas in these paintings feel more real than the things

themselves: "For me nothing is abstract. In fact, I believe nothing is more abstract, more surreal than reality."

The legacy of Christian thought is far-reaching. Among the deep marks it has left on the Western soul is a feeling many people have that what we see is not everything, that there is something more lurking behind the merely physical—a spiritual dimension to life. But the thought may be turned around as well: whatever one may believe about spirituality, it seems undeniably true that the idea of an object creates its reality to a large extent. The physical world is mysterious, and the longer and harder you look at it, the stranger it becomes. Of this much I am certain: Morandi felt that he was painting the world in those bottles. He did not feel that by reducing the numbers of the objects he painted, he reduced the range of his vision. On the contrary, the very narrowness of the field became the vehicle of his liberation. This is a modernist position. As for Giacometti, as for Beckett (to give a literary example), reduction opened up possibilities that inclusiveness did not have. From a few things, you get everything.

Freedom, however, remains a relative term. A friend of mine, the poet Bill Corbett, reported to me yet another second-hand story that comes from Nick Carone, an Italian-born painter who lives in New York. Carone was with Morandi at the Venice Biennale in 1948, when the artist first saw the canvases of Pollock, de Kooning, and other abstract expressionist painters. Jackson Pollock's work prompted this comment from Morandi: "He just jumps in before he knows how to swim." The utterance was apparently not made without admiration, but it speaks directly to the artist's aesthetic. He may have found his path to freedom, but that path was one of restraint, patience, repression, and suggestion. His canvases are controlled and masterly. Looking at the actual paintings is important, because the light that seems to come out of them reproduces very poorly. These canvases reveal themselves slowly and reward the spectator who bothers to look long and hard. In the end, they create a surprising tension between thought and the senses.

The paintings in this exhibition are also the works of a man's maturity and require a certain maturity in the spectator. Sophie didn't know what to make of Morandi, and for an eleven-year-old, she has a very good eye. In the Accademia, she pulled me away from Giorgione to the room filled with Tintoretto's huge canvases. She remembered them from an earlier visit, and I watched her as she stood spellbound before them. "I like this museum better

than the other one, Mom," she confided to me later. I did not argue with her. And yet, if there's one thing I've understood about art in general, it's that there are thousands of different ways of getting at the world and what we experience as its truths. In Morandi's case, the path to that truth was by the way of "more bottles."

Joan Mitchell:
Remembering in Color

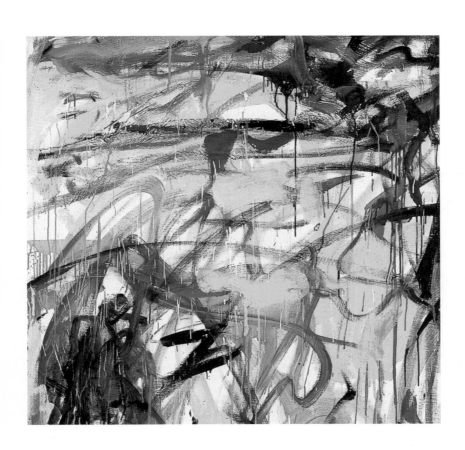

Twenty years ago, at the Musée National d'Art Moderne in Paris, I shook Joan Mitchell's hand. I was the new wife of an old friend of hers—Paul Auster. They had met in the early seventies through the poet, Jacques Dupin, whom Paul had translated. Jacques also worked at the Galerie Maeght, which showed the art of the man Mitchell was living with at the time, the French Canadian painter, Jean-Paul Riopelle. I had been informed that Mitchell's character, like certain kinds of weather, chanced a thunderstorm now and again, and I braced myself. But what I remember from that day is that when Joan Mitchell saw my husband, she threw herself into his arms and hugged him. Ten years earlier, the then twenty-four-year old Paul had survived a memorable dinner party given by Jacques Dupin and his wife, Christine. Over the course of the evening, Mitchell had insulted Paul, not once or twice, but steadily, without respite, for hours. While Riopelle, in a spirit of avoidance and contented oblivion, slept soundly on the sofa, the Dupins did their best to follow the barrage of verbal missiles that were flying across the table in English—"Who do you think you are, Lord Byron?" But Paul's unflappable demeanor under fire (a sanguine mixture of astonishment and amusement) seemed to win the painter's affection, and after that grueling but never-to-be-repeated initiation, they became friends. It was Joan who introduced Paul to Samuel Beckett, Joan who gave him an etching of a sunflower for the cover of the small literary magazine, *Living Hand*, that he had started with a friend, and Joan who wanted signed manuscripts of his poems to keep. She got them.

I remember the hug, and I remember the paintings in the museum. At the time, I had never seen any of Mitchell's work. What fascinates me now is what I have retained of the pictures hanging on those walls, because I think my memory may hold some clues to their character. I remember no single canvas perfectly, but there was little doubt in my mind that the paintings were not purely abstract but referred to landscapes. I remember deep and lighter greens, a host of blues, a feeling of movement in foliage, and white light through leaves. I recall one work in particular that covered a whole wall, and I'm quite sure it had four panels. I was standing at a distance to take in its sweep. Memory has simplified the image, and what remains are copses in a broad, wild meadow and a sense that I am looking at something beautiful, fierce, and touched by melancholy.

The exhibition at the Whitney Museum in New York in the summer of 2002 of fifty-nine paintings by Joan Mitchell allowed me to take another look

at the artist's work. The show, organized by Jane Livingston, included canvases from 1951 to 1992, the year of Mitchell's death. Most of the canvases are large and several, mostly from the seventies, are huge. *Clearing* (1973), for example, is roughly nine by eighteen feet. An unusually small canvas in the show, *Untitled* (c. 1960), which is only twenty-four by nineteen-and-five-eighths inches, brought home to me how different Mitchell's work would be had she chosen to paint on a more diminutive scale. This little canvas allows the spectator a view of the entire painted space without having to withdraw from it. The simple fact that it's smaller than the spectator's body makes the work intimate, friendly, manageable, and the single red slash not quite at the painting's center feels like a visual echo of the viewer's heart. It has a poignancy a big picture cannot have. But this canvas is a notable exception to the rule. Mitchell's suprahuman works mean that you have to move back to see them whole, and that the largest ones dwarf you—the way a view of the horizon or a huge lake or a big sky can make you feel puny.

Mitchell had a tendency to denigrate smaller works as feminine. Klaus Kertess, a curator of drawings at the Whitney, reports in his book on Mitchell's art that she called him to come and retrieve a series of pastels he wanted for an exhibition. "Get your ass over here. I'm tired of the pastel dust on my studio floor. It makes me feel like a 'Lady Artist.'"[1] It's true that large paintings as opposed to pastels require an energy and physicality traditionally not associated with women. It's also true that "Lady Artist," like "Lady Novelist," screams of a condescension meant to shrink and wither the object. Nobody wants to feel like a "Lady Artist." Mitchell's big, bold paintings defy such diminution, annihilating the adjective, so that only "Artist" is left standing.

In a culture that may still undervalue the artistic achievements of women, it is easy to make an issue of Mitchell's sex, to explain her work through it, but I think this is a dangerous course. The artist was proud, and like every artist, she hated to have her work reduced to any catch phrase, because it was usually an excuse for blindness to content. "Second-generation Abstract Expressionist" was another tag inevitably attached to Mitchell, one that she recognized as an insult. Livingston quotes Mitchell saying, "I don't care. I call myself a 'lady painter' and AEOH—Abstract Expressionist Old Hat."[2] I think Mitchell's statement is at once serious and ironic. She was a woman and she was a painter of an abstract expressionist bent, but the work shows that however sensitive she may have been to categories that limited her in the eyes of

the world, she truly didn't care, because she went on doing her paintings in her own "unfashionable" way.

Would Mitchell have had an easier time as a man? In some ways, she probably would have. But was being a woman more important to her work than the fact that she was independently wealthy or was born in Chicago or that she was the daughter of a doctor who drew very well and a highly literate mother who edited *Poetry* magazine or that she was a figure-skating champion as a girl or that she moved to France in 1959 and later lived in Vétheuil on the same property where Monet had lived and painted for four years or countless other details in her personal history? While the size of Mitchell's canvases and the force of some of her brush strokes may signify masculinity, according to the codes alive in the culture, the delicacy and fragility of other strokes might be interpreted as feminine. This makes her paintings, like much of art, hermaphrodites.

Walking through the exhibition, I recognized that during the twenty-year gap between my viewing of Mitchell's paintings, they had become more representational in my memory than they actually are. While it is true that the canvases I saw in 1982 probably included works like *Tilleul* (1978), which alludes directly to trees, something else was at work. Livingston points to Mitchell's inarticulate comments about her work: "She kept insisting that *feeling a place, transforming a memory*, recording something specifically recalled from experience, with all its intense light and joy and perhaps anguish, was what she was doing."[3] Although such private explanations may well seem vague, I think I understand what Mitchell means. The visual experience of her pictures gives the viewer a feeling of recollection. Recollected, they give the viewer a feeling of place. Why this is, I can't say, but it very probably relates to perception and the brain, and to the strong physiological response people have to color and light and their subsequent memory of it.

A couple of years ago, I traveled in Mexico, a country in which Mitchell also spent time, and I visited Oaxaca. Even now, I can close my eyes and bring back not the details of the streets and its low houses, but the brilliant colors of walls in the sunlight, nearly bruising in their intensity—pinks, blues, yellows, and ochres. The memory is physical, and I think this is what Mitchell was up to, at least in part: an artistic effort to reclaim sense memories. Barney Rosset, the man who turned Grove Press into a famous literary publishing house, was married to Mitchell for a few years and remained a lifelong friend. He was kind enough to see me, and during our conversation, he said suddenly,

"Nobody talks about Mexico. Mexico was very important." I was startled because I had already made my notes for this essay about my own memories of Mexico and the lasting effects of its light and color. While Mitchell was still a student, she and a friend spent two summers in Mexico painting in Guanajuato, outside Mexico City. While there, the two girls sought out José Clemente Orozco, and went to meet him. The vibrant colors and scale of some of that painter's murals, combined with the sun-baked hues of that particular landscape, seem to have left their marks on Mitchell's work. *Wet Orange* (1971–72), for example, is alive with the colors of the south and sun.

I am inclined to take Mitchell at her word—her project included the reclamation of memory with its necessary losses and dimming of imagery. In February 1947, she wrote to Rosset: "It seems like years since I've seen you and I can no longer visualize your face all in one piece—I almost get it together and then it gets screwed up like dropping pebbles over a reflection in water…"[4] Losing a clear memory of the beloved's face is an old complaint. Like Proust's Marcel, who is startled that he can't recall Albertine with any real clarity, we find ourselves missing a good picture of even those closest to us— lovers, parents, siblings, and friends. Our brains aren't cameras, but they also record what a mechanical instrument can't—an emotional tone. Memory is invariably accompanied by feeling—sometimes it's literally *colored* by emotion. My own memories have a tendency to be drained of color as well. The elementary school I attended in Minnesota, for example, has turned to a single, somber shade of gray.

In an interview Mitchell did with Yves Michaud in 1986, she spoke of being ill and in the hospital.

> [T]hey moved me to a room with a window and suddenly through the window I saw two fir trees in a park, and the gray sky, and the beautiful gray rain, and I was so happy. It had something to do with being alive. I could see the pine trees, and I felt I could paint…. Last year, I could not paint. For a while I did not react to anything. All I saw was a white metallic color.[5]

Color as feeling, feeling as color—these two are closely connected.

At one point, my talk with Barney Rosset meandered to Samuel Beckett, and he mentioned spending an entire day with the writer and Mitchell. He told me that the two of them never stopped talking. "What did they talk about?" I asked him. "Color, all they talked about was color. For hours. All day.

Shades of blues and yellows. A lot about blue." Blue may be the most heavily weighted color in the culture—blue blood, blue chip, blue devils, blue grass, blue collar, blue movie, bluestocking, feeling blue, singing the blues. Its chromatic scale corresponds to an emotional spectrum of highly complex associations that move from the airy transparency linked with joy to the saturated depths we connect with sorrow. Mitchell's sensitivity to colors included a profound awareness of their emotional resonance. Three short passages taken from letters that Mitchell wrote to Rosset, a year after she mourned losing his face, give a further glimpse into an artistic imagination that would develop into a singular project.

> *I like being awake at night—I like watching the dawn or at least the sky become that strange blue color…*

> *…the ironic morning sunlight—turn the canvases against the wall—I want to dream of a boat landing and the sunlight on that boat and its whiteness and not that of these walls and these canvases—you against it—yellows and grays and warm you smiling…*

> *…there's little to say about loneliness—dark green and clinging—loneliness at night driving or in the hot sun…*[6]

The translation of visual memory into painting is not a science, and I don't want to imply that Mitchell was a primitive sensualist attempting to copy the imprints left in her memory in any direct or naïve way, but rather that her claim that she carried her landscapes inside her makes sense, and that she drew from mnemonic experience as well as from other artists to make her work. The first two canvases in the exhibition loudly proclaim what she had inherited as a painter. Both were done in 1951, when Mitchell was twenty-five years old. *Cross Section of a Bridge* quotes Cubism and Duchamp. I noticed the influence of de Kooning and Gorky, but I also felt Cézanne's late landscapes in it and in the untitled painting from the same year—both in their angular structures and in their colors. By 1953, however, with *Rose Cottage*, the traces left by Mitchell's brush have changed and lost all reference to Cubist forms, becoming freer and more calligraphic. She had been very impressed by Franz Klein's painting, and it shows.

As early as the mid-fifties, her work seems to have become independent of outside influences. It changes and evolves but does so within a circumscribed

vocabulary she has made her own. The ironies and figuration of the sixties don't touch her work, nor do any developments thereafter. She had learned and taken what she wanted, and the rest be damned. In *Hudson River Day Line* (1955), she combined light, attenuated strokes with denser blots of pigment against the pale whitish background that would remain a recurring presence in her work. Mitchell never abandoned the idea of the frame. Even in the so-called "all-over" paintings in which the strokes touch the edges of the canvas, as in *Lady Bug* (1957) or *La Grande Vallée* VI (1984), there are hints of a white edge—an end to the work—and the compositions inevitably have a strong feeling of order and centeredness. She accepted the old metaphor of the painting as window inside which something is seen. She saw no reason to imply a beyond.

The use of this pale ground as a stage for painted events becomes more dramatic in the sixties, when dense forms begin to distinguish themselves more completely from other areas of the canvas and float like strange clouds against it: *Blue Tree* (1964), *Calvi* (1964), and *Untitled* (*Cheim Some Bells*) (1964). These isolates change the mood of the paintings into something slower and more brooding. Comparing the hectic excitement of a painting like *Evenings on Seventy-third Street* (1957) with the somber *Calvi* feels almost like opposing action to thought. But there is an active brush in both paintings, and the difference lies not only in the brilliant palette of the former and the darker one of the latter, but in the difference between open and closed forms and their effect on the viewer.

The clump of darkness in *Calvi* that loosens at its edges and drops color from its underside has no specific reference, but it is nevertheless rife with associations. We read the single form that dominates the picture through its color, density, and isolation on the canvas—all of which resonate as signs of loneliness. Mitchell called these her "black paintings," evoking Goya to describe their atmosphere, not their color. In the seventies, Mitchell left these solitary forms and began to make what I started calling "patches" to myself. These shapes are more rectangular in shape and no longer appear alone on the canvas, but with patch "allies" in similar colors. To my mind, the monumental paintings of that decade are among Mitchell's best and most original. *Low Water* (1969), *Salut Sally* (1970), *La Ligne de la Rupture* (1970–71), *Mooring* (1971), *Clearing* (1973), *Field for Skyes* (1973), *La Vie en Rose* (1979), and *Salut Tom* (1979) are studies in a kind of painterly counterpoint—two or more

MITCHELL
Calvi (top)
1964
Mooring (bottom)
1971

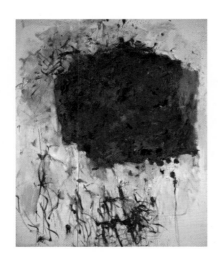

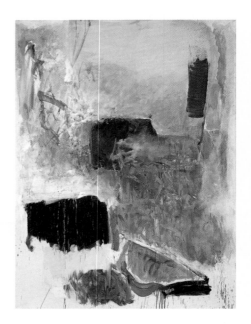

chromatic and formal harmonies at work together. The repetition of dense, dark patches of color against a paler but always complex ground turn these canvases into windows of meditation.

In *Mooring*, four deeply colored patches create a stairway upward that leads to an airy opening—a thin washed space of the lightest pink-violet and gray. The highest vertical patch stands like a sentry to the right of the aperture and is flanked by a similar orange and yellow form—its brilliant echo, shadow, or cousin. The second highest dark patch has an orange echo, as does the third, but only the faintest cloud of that color, and the narrow patch of cobalt and gray in the lower right of the canvas is touched by a waving strip of orange that moves up and out between green and violet forms. The effect is a slow rhythm of visual variations that create beats of similarity and difference, seducing the viewer into a reverie of possible allusion—to vaporous skies, to mists over grasses, to nearly black bark or dark gray stepping stones.

In the larger, multipaneled works, the patch repetitions become even more complex. Panels inevitably produce a sense of narrative, of moving in time from one space to another, and because each of Mitchell's panels has integrity—no form or stroke bleeds from one into the next—the viewer necessarily distinguishes each panel as a single part of a whole movement. In the triptych *Clearing*, the simple version of the story is one of mirroring. The dark patch in the first panel doubles in the second and once again stands alone in the third. The blue-violet doughnut of the first panel shifts into a form with no hole in the second and then its reflection reappears in the third in another position. And yet no two shapes are identical; the mirroring is an illusion, a play on color and form, resemblance and mutation, that gets its power from the way the visual ideas resonate inside the viewer—a movement from one to two, attachments and separations, couplings and partings. In *Salut Tom*, a quadriptych, the variously floating or anchored patches in different colors against yellows, whites, blues, and greens move from one panel to another in a dance of shifting levitations. The yellow "sky" is a constant in varying hues, but the grounded darkness of the first panel has leapt toward that golden space by the fourth, and that lift has an emotional effect on the viewer, as if we are looking at a story of a spirit's rising.

In the eighties, Mitchell returned to a more energetic and less contemplative style that in some way recalls her painting from the fifties, in which distinct forms are lost in fields of varied color or remain open in brush strokes

MITCHELL
Clearing
1973

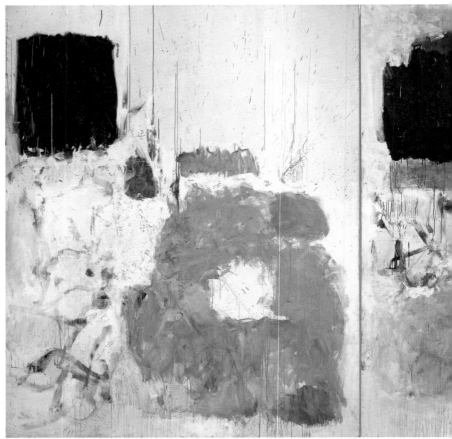

Whitney Museum of American Art, New York.

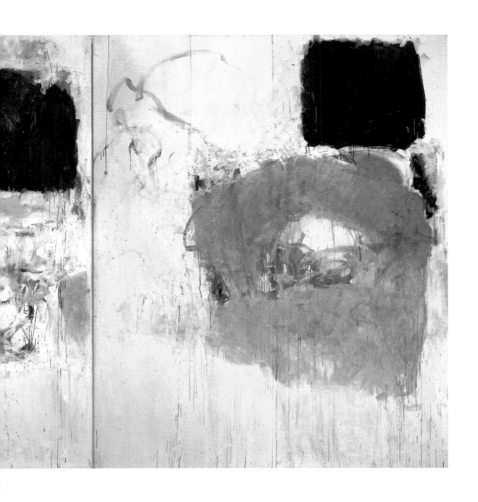

MITCHELL
Untitled
1992

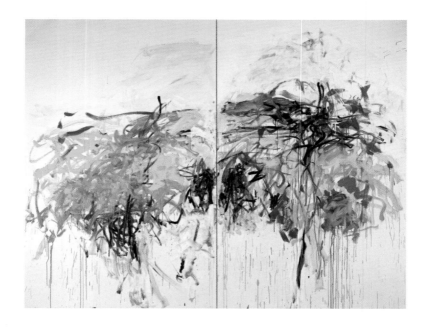

that "write" on the canvas. Works like *Begonia* (1982) and the paintings from the suite *Grande Vallée* (1983–84) feel more direct and passionate than the work she did in the seventies because the viewer feels the painter's arm and hand, indeed her whole body, in these gestural pictures. Unlike the earlier works in which each panel of a multipaneled work is discrete, strokes bleed from one panel to another in *Grande Vallée*, a device in harmony with the new emotional register, which quickened into more manic ups and downs. The series looks and feels wild, summoning both untamed nature and an untamed soul.

The last work in the show, an untitled canvas, was painted the year of Mitchell's death. This diptych, with its two blazing forms that stand against an open white ground, seems to fulfill the grandeur needed for a last statement. I can't help but read them as two trees—blooming madly in yellow and orange, the colors of a fiery sun. The first image is inverted in the second, as if the second tree is really the mirror of the first in water, its reflected roots floating near the surface of a river or a lake. I found the inversion of this image very moving. In it, tree and tree reflected are equals, and it made me think again about memory as a reflection of what has been seen and is seen again in the mind. Most of life consists of these reflections, either indelible or dimming. I carried this particular painting in my mind for months before I returned to look at it again, this time in reproduction. I realized that I had made the double image more treelike over time. I had the colors right and the basic composition, but because I had understood the diptych as a tree mirrored in water, it had merged with my own memories, not of art, but of real flowering trees and lakes and rivers. I have a feeling that Mitchell wouldn't have minded this at all, that her paintings are also an avenue to the natural world, of looking hard at it and looking again.

Mitchell wanted to hold on to her landscapes, to seize the "out there" through the "in here," to depict the mysterious flux of perception, not as it's immediately seen, but as it's remembered and felt in the body. That is the flux of being. To do this she used a painterly method she inherited and then refined, calling on her sunlit whites, her lonely greens, and her beloved blues and yellows. Remembering Joan Mitchell's paintings makes me happy, not because every work is gleeful or ecstatic, but because recalling them throws me into the solitary realm of my own sensual awareness, making it keener and more vigorous. The pleasure I found in them has, as she said, "something to do with being alive."

Gerhard Richter:
Why Paint?

After seeing the retrospective of Gerhard Richter's paintings at the Museum of Modern Art in New York in 2002, I began to think about iconoclasm and the fact that in the West it lives on, not in its old haunts—religion or politics—but in modern art. Even now, long after Clement Greenberg's dogmas have faded and Ad Reinhardt's teleological works have entered art history, the unself-conscious anachronism remains an arch enemy of the contemporary art business. By business, I mean the buying and selling of new art, museum shows, and the critical apparatus that attends to it. Visual art, painting in particular, has had a singularly radical modern history that separates it from literature, music, and film. Lots of people can go to movies or buy CDs and books, but few have either the money or the desire to buy art by living artists. Although the relative smallness of the art world has freed painting from the conservative drag put on more popular genres, it has also boxed it into an almost continual endgame.

Since the invention of photography in the nineteenth century, the painting—that familiar flat rectangle—has been seen as a space in crisis. The death of the novel is declared almost as often the death of painting, but such comments about literature are generally ignored by working novelists and have little effect on them. The well-made, old-fashioned book is widely championed by most reviewers, who have little interest in literary history. Joyce, Stein, Beckett, not to mention Dada, could just as well have never existed. Therefore, although the act of making art now—whether it is a work of fiction, a film, a piece of music, or a painting—may be theoretically problematic, it is only in the world of contemporary visual art that the philosophical issues of *why* and *how* to make art are crucial to a work's reception. Gerhard Richter's painting manages to sit squarely inside the ongoing critical debate about the form itself while deftly eluding it at the same time. Richter's work is one of active resistance to ideological category, a continual refusal to be squeezed into the perimeters of the very theories that, ironically, have helped to catapult him onto the aesthetic mountain where he now finds himself.

Richter turned seventy not long ago. His career spans a period of tumultuous changes in the art world—from the early sixties to the present—and he didn't spend all those years as a darling of the critics. As he tells Robert Storr, his curator at MoMA, he worked outside critical sanction from the late sixties to the mid-seventies. "I didn't know what to do but to paint," Richter tells Storr, "I was 'out.'" [1] When Storr suggests that being out might have offered avenues

of freedom previously blocked to him, Richter replies with typical honesty: "Well, the freedom and the comfort gained from being out were not very substantial. Being out didn't have such a positive effect. After all, I wanted to be on the inside."[2]

Curated according to a meaningful but unslavish chronology, the show is a walk through a man's life as a painter. The farther you go, the more information you accumulate about decisions made, avenues tried, dead ends, and revelations. Richter's biography is by no means a requirement for "reading" his work, but since all art is the product of personal history and cultural history—as well as the intersections between the two—knowing the story is valuable. Richter was born in Dresden in 1932. When he was three, his family left the city for a town in Saxony and then moved again in 1942 to an even smaller town. As a schoolteacher, Gerhard's father, Horst Richter, became a member of the Nazi party. He served in the German army during the war, survived, and then, like so many others, returned to another world. "He shared most fathers' fate at the time," Richter tells Storr. "Nobody wanted them."[3]

By the time he was fourteen, Richter had lived through the war, witnessed the cataclysmic end of National Socialism, the exposure of the Holocaust, and found himself in a divided Germany. For a boy who would decide to become an artist, one can safely say that the upheavals had left him on the wrong side. As a young painter in Dresden at the Art Academy, he was forced to work within the long-calcified dictates of Socialist Realism and eventually became a mural painter and employee of the state. His position allowed him to travel, however, and on a trip to the West in 1959, he saw the exhibition Dokumenta 2 in Kassel, which included works by Jackson Pollack and Lucian Fontana. Two years later, Richter was in Düsseldorf. "I might almost say that those paintings were the real reason I left the GDR [German Democratic Republic]."[4]

PHOTOGRAPHY AND ALIENATION

Richter first used the photograph as a vehicle of liberation. In 1972, he told Rolf Schön in an interview for *Deutsche Zeitung* that he was attracted to the photograph because "it had no style, no composition, no judgment. It freed me from personal experience."[5] The photo as a crib for subject matter offered Richter a necessary leap from the first person into the third—a formal way to jettison the big "I" of Abstract Expressionism and its Romantic precursors.

In this, of course, he wasn't alone, but what I am interested in is his peculiar take on the problem. Examining the early photo-paintings in the show, I was struck first by how little they finally looked like photographs, and second, by their recurring subject matter.

There is something alienating about these paintings, a distancing quality that for me became an important part of their fascination. Real photographs always evoke loss. Looking at a snapshot, even when I am unfamiliar with the people, the room, or the landscape it captures, I feel that I am holding a trace of what has disappeared. Ordinary families document these losses regularly and with nostalgia for babies now grown up, young women turned into grandmothers, the youthful former self and, most importantly, the dead. As Roland Barthes wrote in *Camera Lucida*: "Painting can feign reality without having seen it."[6] The lens, unlike the painter, must have something *out there* to record. The photographs Richter projects and then paints over haunt his finished works as fragments of reality without actually *being* the paintings themselves. Depending on how you look at it, the painting is either the ghost of the photo or the photo is the ghost of the painting, or perhaps they are the two things at once. Because in this culture we *believe* more in the truth-value of photographs than we do in paintings, Richter borrows our belief and then subverts it through art.

The photo-painting *Uncle Rudi* (1965) serves as a case in point. The canvas depicts a smiling German officer posing for a picture. The title immediately places the image in a family context, one of countless pictures we all have in albums or stuffed into boxes. Whether we know that it depicts the artist's uncle or not is less important than its obvious connection to the familiar. While the black-and-white palette of the painting mimics what we recognize as a snapshot, the brush strokes that define the figure of the man and the banal urban background behind him create an atmosphere of partial erasure and dimness, as if he's in the process of vanishing. The lack of clarity *suggests* the blurring of an out-of-focus snapshot, but it does not reproduce it. This is not photo-realism. The viewer recognizes the gestures left by the painter's hand.

The artist has come between the photo that recorded someone in time and the spectator who is looking at its translation on a canvas. *Uncle Rudi*, like many of Richter's photo-paintings, combines the documentary quality of the snapshot and its accompanying feelings of loss with the presence and dignity of traditional painting. Together they create a strain of doubt and ambiguity

that simultaneously undermines and enhances the viewer's perception of the image. *Uncle Rudi* feels at once alien and terribly familiar. This tension is alive even when the subject matter appears more trivial: a phantom kitchen chair, two paintings of strangely luminous toilet paper; a chandelier from a lower-middle-class interior; an ugly administration building; *Egyptian Landscape*, four pictures that suggest faded travel slides; and a newspaper ad (with some text) for a Ferrari, in which every saleable feature of the commodity has disappeared in a wash of gray. The apparent randomness of subject matter has led some critics, like Benjamin Buchloh, to insist that the artist's subjects are purely arbitrary,[7] but I disagree. Richter has admitted to being attracted to certain pictures over others. He did not pick them out of a hat.

The elevation of toilet paper to painterly status made me think not so much of Pop Art, despite the obvious connection, but of Dutch still life ennobling the leftovers on a table. Richter returned to still life more pointedly later in his career with pictures of candles, a skull, and the ethereal record player in the Baader-Meinhof series. And yet, the obvious link to the early genre and its theme of mortality is both changed and reinforced by the pictures' mechanical origin, which brings the viewer back to the oddly spectral character of the photograph itself and its role as another object, just more paper, in our lives.

In *Uncle Rudi*, the allusion to family document is enveloped in the chilling realities of history. The man's Wehrmacht uniform is immediately recognizable, although its symbols—the swastika and eagle—which we know are there on his cap, can't be made out. And yet, the preexistence of the photo and the associations that surround it make the inference not only possible, but inevitable. The painting in which the insignias of National Socialism are illegible could be read as the very image of the repression of fathers in Germany after the war and the willed amnesia of horror. It is this, *and* it is the smiling family member innocently posing for a picture.

Barthes argues that photography is where we put death in modern society, now that it has left religion and ritual, that it finds its anthropological context in "this image which produces Death while trying to preserve life."[8] Richter uses the inherently morbid quality of all photography, and then in a number of works, layers that "dead instant," the actual lost moment that will never return, with references to broader cultural memories of the dead—a theme that reaches its peak in the Baader-Meinhof paintings, *October 18, 1977*. But the predilection for painting the dead and for allusions to death run

through the early works as well—in *Coffin Bearers*; *Dead*; *Mustang Squadron*; *Bombers*; *Phantom Interceptors*; two pictures of Helga Matura, a murdered prostitute; the eight nurses killed by Richard Speck; a beautiful, disguised image of Jacqueline Kennedy with her hand over her mouth, called *Woman with an Umbrella*; and the forty-eight encyclopedia photo-paintings of prominent men.

The latter portraits seem to have been widely misunderstood. It struck me as comic that Richter has been criticized for not including women in his catalogue of luminaries. For me, the work so clearly refers to the paternal that to put women in the series would have disrupted its very essence. At the same time, these black-and-white heads are not hanging on the wall encased in glass as an ironic joke about dead fathers. They are not the Old World equivalents of Warhol's Pop icons that blankly trumpet the excesses of capitalist star culture. They are the emblems of a lost Europe, of trauma and dead hopes—a loss not expressed by the work these men produced, which is irrelevant, but by the encyclopedic idea itself, born of the Enlightenment and its optimistic ideas about certainty, category, and truth. To borrow a term from psychoanalysis, Richter's heads are *overdetermined*. The artist has lifted his pictures from the book that claims to have dissected human knowledge alphabetically, and then he has reorganized them according to another rigid and equally arbitrary formula, this time visual—the faces turn gradually from either side toward the center—an exercise that felt to me like an embalming ritual, at once futile and eminently serious. It is also worth remembering that Richter's *Atlas*, a vast collection of photographs and clippings, some used and some unused in his work, have been mounted and shown as art. This compendium of a life's labor demonstrates, at the very least, a classical penchant for order.

ICONOCLASM

The mistrust of images is age-old. Pictures have long been credited with great power, given magical properties to heal, destroy, and seduce. From the ancient story of Pygmalion to the suppressions of the Reformation, the artist has been seen as a kind of sorcerer whose illusions, depending on the moment, are praised or decried. Richter is certainly a creature of the more recent battles in art, the stormy what-is-possible debates that shape the minute-to-minute world of galleries and shows, but his is now a long career, and his references stretch backward in time, much further than most artists' quotations and allusions do, into the heart of Western culture and the politics of seeing.

He partakes not only of the now, but of the then, and his imagination is stamped with a worry about pictures that is not only contemporary but part of a long tradition about what representation means.

Richter's self-consciousness has deceived many critics into the belief that his work is made without the unconscious—that his art is purely theoretical, that he paints to show that painting can't be done. This is nonsense, and if it were true his work would be boring, nothing more. The discipline and sorrow that accompany Richter's struggles with representation are both intellectual and emotional, and they have led him down paths he's had to take alone, even when they've been trod before him. How else to explain the color charts or the monochrome gray canvases? The man needed to go to the end of his own vision. I'm sure he thought of Malevich and Newman while he was going there, but he was compelled to explore the annihilation of images himself.

The heads of the forty-eight men on the wall are painted almost as if they were blown-up photographs—not quite, but almost—and they correspond to the viewer's expectations of what the camera does. The heads exist at one end of a scale that moves between the relative clarity of a recognizable image to its erasure, blotting out, or disappearance into the gestures of abstraction. Richter has commented that painting can't be blurred, painting is painting. He's right, of course. It can't be blurred, but it can refer to blurred photography, for example, or to nonfigurative painting, or to our own romantic notions about veils, mist, and fog, so that the viewer holds at least two, sometimes several images in his mind when looking at one of Richter's pictures.

A painting from 1962 called *Table* is the first example of suppression and multiple reference. The gray image of a table taken from a decorating magazine is painted over with a fast brush—a gesture that necessarily resembles the hand of the abstract painter. In its doubleness, *Table* is a simpler painting than many of Richter's landscapes and abstractions from the seventies and eighties, in which the boundaries between photograph and abstract painting collapse entirely. The highly painted black, gray, and white urban pictures like the one of Madrid; the mysterious blackened depths of his *Himalaya*; his cloud pictures—the one from 1970 that looks like a cloud, and the clouds from 1982 that look like a colorful abstract picture—his *Seascape*; his *Gray Streaks*; his *Brown Detail*; and his *Un-painting (Gray)*, in which the gray palette of photography is turned into an abstract canvas: all merge as experiments in

both perception and naming. A canvas from 1984 called *Abstract Picture* and one from 1985 called *Bush* are certainly different, but the one designated as abstract is no more or less abstract than the one identified as a bush. The play at work in these titles is revelatory of a complex host of allusions not only to the history of art but to its perception through cultural fictions at work in us whether we are students of that history or not.

I have always wished that I could look at a mountain, any mountain, before Romanticism got ahold of it and clothed it in glory. Cézanne wanted nudity, not a return to Classicism after Romanticism, but a whole re-seeing of a mountain, and set about trying to do it with *Mont Sainte-Victoire*. This was his optimism, one that doesn't exist in Richter. In 1986, Richter wrote in his journal, "Of course my landscapes are not only beautiful or nostalgic, with a Romantic or Classical suggestion of lost Paradises, but above all 'untruthful'... By untruthful I mean the glorifying way we look at Nature." [9] The viewer doesn't need Richter's commentary, because this untruth or lie is embedded in the pictures through their proximity to or distance from established notions of how to read a landscape, ranging from the seductive beauty of an iceberg that quotes Friedrich to a banal meadow that makes one think of a family picnic in the country, during which somebody stood up and snapped a photo. Every Richter image teeters inside a semantic tension between icon and anti-icon that no photograph could possibly achieve. But the desire for beauty in these pictures is real and strong and hopeful, and sometimes allowed to stand without erasure. The painting of his daughter, Betty, her head to one side, is like a color photograph turned into a Bronzino. It is as startlingly clear as his *Annunciation*, taken from Titian, is veiled in a romantic "blur."

OCTOBER 18, 1977

The first time I walked into the room at MoMA that holds the Baader-Meinhof paintings, I immediately felt their emotional power. It was like entering a sanctuary for the dead. Neither the theme nor the form of these paintings was new, and yet these fifteen works taken from photographs and film stills of the young German terrorists—Andreas Baader, Gudrun Ensslin, Holger Meins, and Ulrike Meinhof—seemed to have elevated the stakes of Richter's uncompromising technique to a new plane.

I knew about the imprisonment of the members of the Red Army Faction (RAF), the so-called Baader-Meinhof group in the Stammheim prison in the

early seventies, and about the controversy over their deaths in that same prison, but I knew about them the way a reasonably well-informed American who reads American newspapers would know about them, not as a German citizen. On the other hand, I looked at these pictures while my own city was still uncovering the bits and pieces of the dead at the site of the World Trade Center, and the images of these ferociously ideological young people was given a wrenching historical twist. The second time I saw them, I had read the catalogue, several interviews, and essays. I remembered the concentration camp photographs included in Richter's *Atlas* and his statement to Storr that *for him* the camp pictures were "unpaintable." [10] The scale of events matters — a single image from a death camp represents millions of victims; one picture of a body or part of a body from Ground Zero signifies thousands. In the Baader-Meinhof works, Richter took on an event that has deep resonances in German history but is different in kind from the camp pictures he couldn't use. The acts of terror committed by these four people and their subsequent deaths were important because they exposed a wound in German culture, a cleft between generations that cuts back to the Nazi era and the denial and repression that followed it. Nevertheless, the people Richter painted were not innocents. They lived and died violently.

Only a glance at the lurid photographs that were the basis for these works is needed to make clear that the paintings are radically different from their models. The paintings are lined, smeared, and dragged with paint. They look blurred, recessive, shrouded. The two *Arrest* canvases are so washed in gray that the small human figure of Meins can hardly be seen in them. Gudrun Ensslin walks, turns to the camera, and smiles, then lowers her head and continues walking in the trio of canvases: *Confrontation 1, 2,* and *3.* In another, she is hanged—a very thin, very foggy corpse. *Man Shot Down 1* and *2* show the same image of Baader twice—gray, dead, and hazy. The empty cell and the record player are bleary evocations of human absence, as is the monumental funeral canvas of a barely differentiated crowd gathered to bury the dead, marked at the top of the canvas by a tree in the shape of a cross.

In an interview, Richter said that for him beauty is that which is *uninjured.* [11] The *October* paintings are in part a meditation on the idea of injury, wounding, and death, not in the present, but in the past. The first picture in the series, *Youth Portrait,* is also the most lucid and least altered from its

RICHTER
Confrontation 2 (left top)
Confrontation 3 (left bottom)
Hanged (below)
1988

Digital Images © The Museum of Modern Art/Licensed by SCALA/Art Resource, NY.

model—a studio photo of Ulrike Meinhof as a girl. Meinhof was found hung in her cell on May 9, 1976. As with the other prisoners, there was suspicion of murder, but her death was ruled a suicide. The contrast between the picture of the childish Meinhof and the three canvases of her dead face in profile is indicative of Richter's approach to his subject. In both the conventional child portrait and the death picture, she is cropped at the shoulders—a fact that links the two images as heads only. But the three visions of the corpse are less distinct than the undamaged face of the young girl. The dark cut on Meinhof's neck can be seen in all three canvases, but the appearance of the wound changes. In the smallest and dimmest painting it can still be seen, but it looks wider and grayer than the darker, sharper incision in the second canvas. There is nothing graphic or clinical about the depiction of the injury. The shadow that runs across her throat is a phantom signifier of a death that we are asked to look at three times. Each time we look, her image diminishes, and the shrinkage creates the illusion of distance, as if she is farther and farther away from us, moving into the nothingness of forgetting.

Richter's fragmented chronicle of real events rests partly on a simple, physiological truth: our direct visual perception of things in the world is far clearer than the memory pictures we retain of them. It is disappointing but true that the mental images of the past that we carry around in our heads are serviceable but vague. They offer not clarity so much as tools for recognition. The face you can't summon vividly in your mind is nevertheless present enough so that you will recognize the real face on the street. To some degree, these canvases conjure the feeling of remembering itself, which is always a clouded or faded version of what was once seen. At the same time, the Baader-Meinhof narrative is one that was already mediated for Richter—the memory is a memory of the press and its pictures. Twelve years after the fact, he offers up the old images that were seen on TV, in magazines and newspapers, images every German would recognize, but now they have grown dim. Like revenants, these pictures return to haunt the living, not as documents anymore, but as transfigured images of a collective injury remembered—an ugly sore that time has turned into a scar.

Standing in that room, I felt that with these paintings Richter broke through an invisible barrier, and after I had left it, I became more convinced that I was right. There is something oddly liberating about looking at those pictures of the dead, as if the artist had discovered an extraordinary

RICHTER
Youth Portrait
1988

RICHTER
Dead 1
1988

RICHTER
Dead 2 (top)
Dead 3 (bottom)
1988

RICHTER
January
1989

balance between perception and memory, recognition and blindness, photo-document and apparition. The corpse, after all, is human erasure. It means becoming nobody.

There is a greater freedom in the works that follow the *October* paintings. Richter's discipline and restraint are intact, but the art is imbued with a new emotional tenor. To be blunt, there is more joy. Emerging from the room that held the Baader-Meinhof paintings, the viewer is met with three huge abstract canvases painted a year later and named after the winter months that follow October—*November, December, January*. Gray, black, and white remain as a base palette on these scraped and dragged pictures that are touched by flecks of brilliance—blues, reds, yellows. They are unabashedly beautiful, as are the other abstractions in which the game of naming continues—figure and nonfigure: *Ice 2* (1991) and *Abstract Picture* (1990). The large, gray, two-paneled mirror and the smaller, blood-red one, in which we find ourselves as colored wraiths, are beautiful, too. The gorgeous picture of his daughter, Betty, in a red and white jacket turning away from the viewer into a deep gray background is the very image of *uninjured beauty*, looking into an ambiguous and threatening world.

The essential struggle in Richter's work, however, is unchanged. *Reading*, a contemporary homage to Vermeer (no one has failed to notice), nevertheless keeps its photographic edge, its snapshot origin, which cools the picture and prevents sentimentality. The series of Madonna pictures of Richter's wife and child have surprised some critics, no doubt because they have an abhorrence for "the subjective"—a terrain on which Richter isn't supposed to tread or where he must go only with irony. But this series of images, with its varying degrees of clarity and covering over, interruptions, and streaking, seems perfectly in harmony with the character of his work—a desire to see where it is possible to go with a picture without losing a necessary tension. In a culture where images are produced at a rate that is nothing short of bewildering—where photographs, films, ads, and computer and video pictures are churned out so quickly that our heads spin and we feel continually battered, manipulated, and suspicious—evoking Titian, Vermeer, Raphael, and the transcendence represented by those images begins to look rather subversive.

I think Richter would be the first to say that he doesn't subscribe to any of the belief systems that have ruled art in the West since the Greeks, but that doesn't mean these ideas aren't within us in varying forms—that vestiges of classical naturalism, the magical thinking associated with the Byzantine icon, the illusionism of Renaissance perspective and, more recently, Romanticism—aren't still alive in us when we look at a canvas, just as our fear of illusions is also ongoing—not just our anxiety about marketing and persuasion, but older qualms as well. I have the long-standing Protestant version, one I think Richter carries along with him, too, not as an active practitioner of Lutheranism, but as a remnant of his early life. Protestants chose the Cross over the Crucifix—the abstract sign over the bloody body. Gerhard Richter was commissioned to make a cross, something he discusses with Storr in the catalogue interview.[12] He gave the symbol the proportions of a body—lengthening the cross bar to match the proportions of a man's arms. In this way, the body is there and not there at the same time: the iconic and the abstract meet. This encapsulates Richter's ambition, which is nothing less than the metaphysics and history of representation—the passionate whys and hows of art itself.

RICHTER
Reading
1994

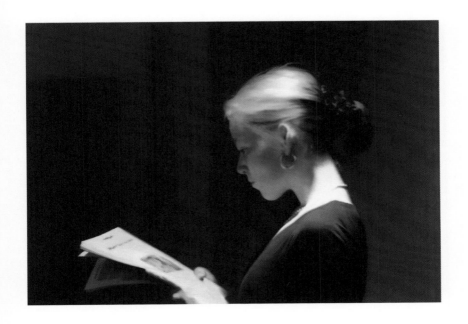

NOTES

INTRODUCTION

1 Quoted in Daniel Dorman, M.D., *Dante's Cure: A Journey Out of Madness* (New York: Other Press, 2003), 245.

2 Mark Solms and Oliver Turnbull, *The Brain and the Inner World: An Introduction to the Neuroscience of Subjective Experience* (New York: Other Press, 2002), 81.

3 Aleksander Luria, *The Mind of a Mnemonist* (Cambridge, Mass.: Harvard University Press, 1987).

4 Temple Grandin, *Thinking in Pictures and Other Reports from a Life with Autism* (New York: Vintage Books, 1995), 31.

5 For his argument, see David Hockney, *Secret Knowledge: Rediscovering the Lost Techniques of the Old Masters* (London: Thames & Hudson, 2001).

6 David Freedberg, *The Power of Images: Studies in the History and Theory of Response* (Chicago: The University of Chicago Press, 1991), xix.

7 Quoted in Leon Edel, *Henry James: A Life* (New York: Harper & Row, 1985), 250.

THE PLEASURES OF BEWILDERMENT

1 Letter, *The New York Times*. 11 March, 1999.

2 Salvatore Settis, *Giorgione's* The Tempest: *Interpreting the Hidden Subject,* trans. Ellen Bianchini (Chicago: The University of Chicago Press, 1990), 115–16.

3 Jaynie Anderson, *Giorgione: the Painter of Poetic Beauty* (Paris, New York: Flammarion, 1996), 165–70.

4 Kenneth Clark, *Landscape into Art* (New York: Harper and Row, 1976), 58.

5 Anderson, *Giorgione*, 165.

6 Settis, *Giorgione's* The Tempest, 127–59.

VERMEER'S ANNUNCIATION

1 Johannes Vermeer, National Gallery of Art, Washington D.C., 12 November 1995–
 11 February 1996.
2 Arthur K. Wheelock, Jr., and Ben Broos, "Woman with a Pearl Necklace" in
 catalogue for the exhibition, *Johannes Vermeer* (Washington, D.C.: National Gallery
 of Art and The Hague: Royal Cabinet of Paintings Mauritshuis, 1995), 154.
3 Tzvetan Todorov, *Éloge du quotidién: Essai sur la peinture hollandaise du XVIIe siècle*
 (Paris: Société nouvelle Adam Biro, 1993), 160.
4 Ibid, 107–17.
5 Edward A. Snow, *A Study of Vermeer* (Berkeley and Los Angeles: University
 of California Press, 1979), 124.
6 Wheelock, catalogue, 154.
7 Snow, *A Study of Vermeer*, 64.
8 Todorov, *Éloge du quotidién*, 160.
9 For these two examples, see reproductions of the Annunciation by Giusto de'
 Menabuoi (48) and an Annunciation by Dieric Bouts (296) in Jill Dunkerton,
 Susan Foister, Dillian Gordon, and Nicholas Penny, *Giotto to Dürer: Early Renaissance
 Painting in the National Gallery* (New Haven: Yale University Press, 1991).
10 Michael Baxandall, *Painting and Experience in Fifteenth Century Italy* (Oxford:
 Oxford University Press, 1972), 51. The five stages of the "Angelic Colloquy" are:
 1. *Conturbatio* (Disquiet) 2. *Cogitatio* (Reflection) 3. *Interragatio* (Inquiry)
 4. *Humiliatio* (Submission) 5. *Meritatio* (Merit).
11 Albert Blankert, "Vermeer's Modern Themes and Their Traditions," in National
 Gallery of Art catalogue, 39.

THE MAN WITH THE RED CRAYON

1 Denis Diderot, *Diderot on Art*, vol. I: *The Salon of 1765 and Notes on Painting*, trans.
 John Goodman (New Haven and London: Yale University Press, 1990), 34, 56,
 59, 73, 152. See also *Diderot on Art*, vol. II: *The Salon of 1767* for references to
 Chardin's gift for hanging the exhibitions, 138, 219, 257.
2 *Diderot on Art*, vol. I, 60.
3 Marcel Proust, "Chardin," in *On Art and Literature 1896–1919*, trans. Sylvia Townsend
 Warner (New York: Carroll & Graf Publishers, Inc., 1957), 324–25.
4 Pierre Rosenberg, *Chardin*, trans. Helga Harrison (New York: Rizzoli, 1991), 57–60.
5 Katie Scott, "Chardin Multiplied" in catalogue for the exhibition, *Chardin*
 (Paris: Galeries du Grand Palais, 7 September–22 November 1999), 61–73.
6 Ibid., 61.
7 Jules and Edmond Goncourt, "Chardin," *Gazette des Beaux Arts*, vol. XV.
 December 1863, 532.
8 Pierre Rosenberg, *Chardin*, catalogue for a special exhibition (Paris: Réunion des
 Musées Nationaux, Grand Palais, 1979), 292.
9 Proust, *Chardin*, 336.

10 Quoted in Rosenberg, *Chardin* (1991), 96.

11 Vincent Van Gogh, *The Complete Letters of Vincent Van Gogh*, vol. II
(Boston: New York Graphic Society, 1958), 431.

12 Quoted in Rosenberg, *Chardin* (1991), 99.

GHOSTS AT THE TABLE

1 Denis Diderot, *Diderot on Art*, vol. I: *The Salon of 1765 and Notes on Painting*, trans.
John Goodman (New Haven and London: Yale University Press, 1990), 60, 71.

2 Norman Bryson, *Looking at the Overlooked: Four Essays on Still Life Painting*
(Cambridge, Mass.: Harvard University Press, 1990), 92–94.

3 Ibid., 64–70.

4 Ibid., 66.

5 Roland Barthes, *Sade/Fourier/Loyola*, trans. Richard Miller
(New York: Hill and Wang, 1976), 49.

6 Quoted in John Rewald, *Cézanne: A Biography* (New York: Harry N. Abrams, 1986), 209.

7 Quoted in Musa Mayer, *Night Studio: A Memoir of Philip Guston*
(New York: Knopf, 1988), 141.

NARRATIVES IN THE BODY: GOYA'S *LOS CAPRICHOS*

1 Quoted in Anthony Hull, *Goya: Man among Kings* (New York: Madison Books, 1987), 79.

2 Quoted in Pierre Gassier, Juliet Wilson, and François Lachenal, *Goya: Life and Work*
(Köln: Evergreen, Benedikt Taschen Verlag, 1971), 106.

3 Fred Licht, *Goya* (New York, London: Abbeville Press, 2001), 132.

4 Victor I. Stoichita and Anna María Coderch, *Goya: The Last Carnival*
(London: Reaktion Books, 1999), 178.

5 Ibid., 178.

6 Quoted in Hull, *Goya*, 97.

7 Stoichita and Coderch, *Goya*, 71–73.

8 Charles Baudelaire, *The Mirror of Art: Critical Studies by Baudelaire*, trans. Jonathan
Mayne (Garden City, N.Y.: Doubleday Anchor Books, 1956), 185–86.

9 Mary Douglas, *Purity and Danger: An Analysis of the Concepts of Pollution and Taboo*
(London: Routledge & Kegan Paul), 121.

MORE GOYA: "THERE ARE NO RULES IN PAINTING"

1 Quoted in Janis Tomlinson, *Francisco Goya y Lucientes, 1746–1828*
(London: Phaidon Press Ltd., 1994), 306. Author's italics.

2 Janis Tomlinson, *From El Greco to Goya: Painting in Spain, 1561–1828*
(New York: Harry N. Abrams, 1997), 141.

3 Quoted in Pierre Gassier, Juliet Wilson, and François Lachenal, *Goya: Life and Work*
(Köln: Evergreen, Benedikt Taschen Verlag, 1971), 307.

4 Robert Hughes, *Goya* (New York: Alfred A. Knopf. 2003), 307.

5 Quoted in Dorothy Johnson, *Jacques-Louis David: Art in Metamorphosis* (Princeton,
N.J.: Princeton University Press, 1993), 74.

6 Ibid., 102.
7 Quoted in Caroline Walker Bynum, *The Resurrection of the Body in Western Christianity,*
 200–1336 (New York: Columbia University Press, 1995), 43.
8 Quoted in Gassier, Wilson, Lachenal, *Goya,* 51.
9 Fred Licht, *Goya* (New York, London: Abbeville Press, 2001), 170.
10 Hughes, *Goya,* 313.
11 Ibid.
12 Julia Kristeva, *Powers of Horror: An Essay on Abjection,* trans. Leon Rudiez
 (New York: Columbia University Press, 1982), 11.
13 Françoise Davoine and Jean Max Gaudilliere, *History Beyond Trauma:*
 Whereof one cannot speak, thereof one cannot stay silent, trans. Susan Fairfield
 (New York: Other Press, 2004), xxvii.
14 Ibid., 115.
15 Cited by David Freedberg, *The Power of Images: Studies in the History and Theory*
 of Response (Chicago: The University of Chicago Press, 1991), 153.
16 Tomlinson, *Francisco Goya y Lucientes,* 252.
17 Licht, Goya, 207.
18 Arthur Lubov, "The Secret of the Black Paintings," *The New York Times Magazine.*
 27 July, 2003: 24–27.
19 Ibid., 27.
20 Ibid., 26.

GIORGIO MORANDI: NOT JUST BOTTLES
1 Quoted in Laura Mattioli Rossi, ed., *The Later Morandi: Still Lifes, 1950–1964*
 (Venice: Mazzota, 1999), 13. Catalogue for the exhibition at the Peggy Guggenheim
 Gallery, Venice, 30 April–13 September 1999.
2 Ibid., 104.
3 Ibid., 101.
4 Ibid., 56.

JOAN MITCHELL: REMEMBERING IN COLOR
1 Quoted in Klaus Kertess, *Joan Mitchell* (New York: Harry N. Abrams, 1997), 9.
2 Quoted in Jane Livingston, "The Paintings of Joan Mitchell," in *The Paintings of Joan*
 Mitchell (New York: Whitney Museum of American Art; Berkeley: University
 of California Press, 2002), 36. Catalogue for the exhibition at the Whitney Museum
 of American Art, New York, 20 June–29 September 2002.
3 Ibid., 38
4 Letter from Joan Mitchell to Barney Rosset (1947) in the private collection
 of Barney Rosset.
5 Livingston, "The Paintings of Joan Mitchell," 41.
6 Letters from Joan Mitchell to Barney Rosset (1948) in the private collection
 of Barney Rosset.

1 Quoted in Robert Storr, "Interview," in *Gerhard Richter: Forty Years of Painting* (New York: Museum of Modern Art, 2002), 303. Catalogue for the exhibition at the Museum of Modern Art, New York, 14 February–21 May 2002.

2 Ibid., 303.

3 Ibid., 19.

4 Ibid., 22.

5 Quoted in Armin Zweite, "Gerhard Richter's 'Album of Photographs, Collages and Sketches'" in B.D.H. Buchloh, J.F. Chevrier, A. Zweite, and R. Rochlitz, *Photography and Painting in the Work of Gerhard Richter: Four Essays on* Atlas (published on the occasion of the exhibition in Barcelona, Museu d'Art Contemporani, 1999), 94.

6 Roland Barthes, *Camera Lucida: Reflections on Photographs,* trans. Richard Howard (New York: Hill and Wang, 1981) 76.

7 Benjamin Buchloh, "Readymade, Photography, and Painting in the Painting of Gerhard Richter," in *Neo-Avantgarde and Culture Industry: Essays on European and American Art from 1955 to 1975* (Cambridge, Mass.: MIT Press, 2000), 381. Buchloh's chief concern is to place Richter in the context of cultural and art history. See also his essay in the catalogue for Richter's exhibition at Marian Goodman Gallery, New York, 14 September–27 October, 2001.

8 Barthes, *Camera Lucida*, 92.

9 Gerhard Richter, "Notes, 1986," in Hans Ulrich Obrist, ed., *Gerhard Richter: The Daily Practice of Painting, Writing and Interviews, 1962–1993* (Cambridge, Mass.: MIT Press; London: Anthony d'Offay Gallery, 1995), 124.

10 Storr, "Interview," 290.

11 Richter, "Notes, 1983," in *Daily Practice*, 102.

12 Robert Storr, "Permission Granted," in *Gerhard Richter: Forty Years of Painting*, 83.

ILLUSTRATION CREDITS

THE PLEASURES OF BEWILDERMENT

3 *The Tempest.* Giorgione (1477–after 1510). Oil on canvas, 32 ¼ × 28 ¾ in. SCALA/Art Resource, New York. Museo dell'Opera Metropolitana, Siena, Italy.

VERMEER'S ANNUNCIATION

13 *Young Woman with a Pearl Necklace.* Jan (Johannes) Vermeer (1632–1675). Oil on canvas, 21 ½ × 17 ½ in. Photo: Joerg P. Anders. Bildarchiv Preussischer Kulturbesitz/Art Resource, New York. Gemaeldegalerie, Staatliche Museen zu Berlin, Germany (post-restoration. inv.: 912b). **20** *Annunciation of the Death of the Virgin.* Duccio (di Buoninsegna). Tempera on wood panel, from the Maestà altarpiece. SCALA/Art Resource, New York. Museo dell'Opera Metropolitana, Siena, Italy. **22** The Annunciation, attributed to Petrus Christus (active by 1444–died 1475/76). Oil on wood, 31 × 25 ⅞ in. The Metropolitan Museum of Art, The Friedsam Collection, bequest of Michael Friedsam, 1931 (32.100.3). Photo © 1993 The Metropolitan Museum of Art, New York.

THE MAN WITH THE RED CRAYON

34 *A Glass of Water and a Coffee-pot*, Jean-Baptiste-Siméon Chardin (1699–1779). Oil on canvas, 12 ½ × 16 ¹⁄₁₀ in. Erich Lessing/Art Resource, New York. Carnegie Museum of Art, Pittsburgh, Pennsylvania. **37** *Young Student Drawing*, Jean-Baptiste-Siméon Chardin (1699–1779). Oil on panel, 8 ¼ × 6 ¾ in. The National Museum of Fine Arts, Stockholm, Sweden. **40** *Self-Portrait with pince-nez*, Jean-Baptiste-Siméon Chardin (1699–1779). Pastel, 16 × 12 ⅝ in. Erich Lessing/Art Resource, New York. Louvre, Paris, France.

47 *Quince, Cabbage, Melon and Cucumber.* Cotán, Juan Sánchez Cotán (1560–1627). Oil on canvas, 27 ⅛ × 33 ¼ in. San Diego Museum of Art, gift of Anne R. and Amy Putnam. **50** *Vanitas*, Willem Claesz. Heda (1594–1680). Oil on panel, 17 ¾ × 27 ¹⁄₁₀ in. Haags Gemeentemuseum, The Hague, Netherlands/Bridgeman Art Library. **52** *Carcass of Beef*, Chaim Soutine (1894–1943). Oil on canvas, 45 ¾ × 31 ¾ in. The Minneapolis Institute of Arts, Gift of Mr. and Mrs. Donald Winston and an anonymous donor. © 2004 Artists Rights Sociey (ARS), New York/ADAGP, Paris. **53** *Still Life with Pitcher and Aubergines*, Paul Cézanne (1839–1906). Oil on canvas, 26 ½ × 36 in. Pushkin Museum, Moscow/Bridgeman Art Library. **56** *Painter's Forms*, Philip Guston (1913–1980). Oil on panel, 48 × 60 in. Estate of Philip Guston/David McKee, McKee Gallery, New York.

NARRATIVES IN THE BODY: GOYA'S *LOS CAPRICHOS*

64 "Self Portrait," plate 1 of *Los Caprichos*, Francisco José de Goya y Lucientes (1746–1828). Etching, 8 ½ × 5 ⅞ in. Index/Bridgeman Art Library. **66** Preliminary drawing for plate 43 of *Los Caprichos*, Francisco José de Goya y Lucientes (1746–1828). Pen and sepia ink, 9 × 6 in. Derechos Reservados © Museo Nacional del Prado, Madrid, Spain. **66** "The sleep of reason produces monsters," plate 43 of *Los Caprichos*, Francisco José de Goya y Lucientes (1746–1828). Etching and aquatint, 8 ½ × 5 ⅞ in. Index/Bridgeman Art Library. **69** "They say 'yes' and give their hand to the first comer," plate 2 of *Los Caprichos*, Francisco José de Goya y Lucientes (1746–1828). Etching, 8 ½ × 5 ⅞ in. Index/Bridgeman Art Library. **72** "Young Woman Holding up her Dying Lover," preliminary drawing of plate 10 of *Los Caprichos* (page 35, recto, of double-sided drawing from the Madrid Sketchbook Journal-Album B). Francisco José de Goya y Lucientes (1746–1828). Brush and gray wash, touched with iron gall ink faded to brown on laid paper. Sheet: 9 ⁵⁄₁₆ × 5 ¹¹⁄₁₆ in. Photo © 2004 Museum of Fine Arts, Boston, gift of Frederick J. Kennedy Memorial Foundation, 1973 (700a). **72** "Love and death," plate 10 of *Los Caprichos*, Francisco José de Goya y Lucientes (1746–1828). Etching, 8 ½ × 6 in. Index/Bridgeman Art Library. **76** "All will fall," plate 19 of *Los Caprichos*, Francisco José de Goya y Lucientes (1746–1828). Etching, 8 ½ × 5 ⅞ in. Index/Bridgeman Art Library. **76** "There they go, plucked," plate 20 of *Los Caprichos*, Francisco José de Goya y Lucientes (1746–1828). Etching, 8 ½ × 6 in. Index/Bridgeman Art Library. **76** "How they pluck her!," plate 21 of *Los Caprichos*, Francisco José de Goya y Lucientes (1746–1828). Etching, 8 ½ × 5 ¾ in. Index/Bridgeman Art Library. **78** *Self-Portrait*, Francisco José de Goya y Lucientes (1746–1828). Brush and gray wash on paper, 6 × 3 ⁹⁄₁₆ in. The Metropolitan Museum of Art, Harris Brisbane Dick Fund, 1935 (35.103.1). Photo © 1988 The Metropolitan Museum of Art, New York. **82** "He puts her down as a hermaphrodite," preliminary drawing for plate 57 of *Los Caprichos*, Francisco José de Goya y Lucientes (1746–1828). India ink wash, 8 ⅕ × 4 ⅞ in. Réunion des Musées Nationaux/Art Resource, New York. Louvre, Paris, France. **82** "Masquerade of Caricatures," preliminary drawing for plate 57 of *Los Caprichos*, Francisco José de Goya y Lucientes (1746–1828). Pen and sepia ink, 11 ⅖ × 7 ⅕ in. Derechos Reservados © Museo Nacional del Prado, Madrid, Spain. **82** "The Lineage," preliminary drawing for plate 57 of *Los Caprichos*, Francisco

José de Goya y Lucientes (1746–1828). Red ink wash, 7 ½ × 4 ⅞ in. Derechos Reservados © Museo Nacional del Prado, Madrid, Spain. **82** "The Filiation," plate 57 of *Los Caprichos*, Francisco José de Goya y Lucientes (1746–1828). Etching, 8 ½ × 5 ⅞ in. Index/Bridgeman Art Library. **86** "Blow," plate 69 of Los Caprichos, Francisco José de Goya y Lucientes (1746–1828). Etching, 8 ¼ × 5 ⅞ in. Index/Bridgeman Art Library. **88** "Blasts of wind," plate 48 of *Los Caprichos*, Francisco José de Goya y Lucientes (1746–1828). Etching, 8 × 5 ⅞ in. Index/Bridgeman Art Library. **89** "The devout profession," plate 70 of *Los Caprichos*, Francisco José de Goya y Lucientes (1746–1828). Etching, 8 ¼ × 5 ⅞ in. Index/Bridgeman Art Library. **90** "Bon voyage," plate 64 of *Los Caprichos*, Francisco José de Goya y Lucientes (1746–1828). Etching, 8 ½ × 5 ⅞ in. Index/Bridgeman Art Library.

MORE GOYA: "THERE ARE NO RULES IN PAINTING"
95 *Execution of the Defenders of Madrid, 3rd May, 1808*, Francisco José de Goya y Lucientes (1746–1828). Oil on canvas, 105 ½ × 136 ⅝ in. Museo Nacional del Prado, Madrid, Spain/ Bridgeman Art Library. **98** *Jean Paul Marat, politician and publicist, dead in his bathtub, assassinated by Charlotte Corday in 1793*, Jacques-Louis David (1748–1825). Oil on canvas, 64 ⅓ × 50 in. Erich Lessing/Art Resource, New York. Louvre, Paris, France. **108** (Detail of *3rd May*, from **95**) **110** *Self-Portrait with Dr. Arrieta*, Francisco José de Goya y Lucientes (1746–1828). Oil on canvas, 45 ⅛ × 30 ⅛ in. The Minneapolis Institute of Arts, The Ethel Morrison Van Derlip Fund. **114** *The Procession of San Isidro*, Francisco José de Goya y Lucientes (1746–1828). Oil on plaster, transferred to canvas, 55 ⅛ × 172 ½ in. SCALA/Art Resource, New York. Museo del Prado, Madrid, Spain. **117** *Capricho with Five Heads*, Francisco José de Goya y Lucientes (1746–1828). Oil on canvas, 44 × 26 ½ in. Collection of Stanley Moss.

GIORGIO MORANDI: NOT JUST BOTTLES
124 *Still Life*, 1916, Giorgio Morandi (1890–1964). Oil on canvas, 32 ½ × 22 ⅝ in. © Artists Rights Society (ARS), New York/SIAE, Rome. Digital Image © The Museum of Modern Art/SCALA/Art Resource, New York. The Museum of Modern Art, New York, acquired through the Lillie P. Bliss Bequest (286.1949). **124** *Still Life*, 1952, Giorgio Morandi (1890–1964). Oil on canvas, 16 ¾ × 21 ⅞ in. © Artists Rights Society (ARS), New York/SIAE, Rome. Private collection/Bridgeman Art Library. **129** *Still Life with Yellow Cloth*, 1952, Giorgio Morandi (1890–1964). Oil on canvas, 16 × 17 in. © Artists Rights Society (ARS), New York/SIAE, Rome. SCALA/Art Resource, New York. Private collection, Milan, Italy.

JOAN MITCHELL: REMEMBERING IN COLOR
142 *Calvi*, Joan Mitchell (1926–1992). Oil on canvas, 96 × 64 in. Private collection. **142** *Mooring*, Joan Mitchell (1926–1992). Oil on canvas, 95 × 71 in. Permission granted from the Estate of Joan Mitchell. Museum of Art, Rhode Island School of Design, gift of Mrs. Harriet Ewing. Photo by Cathy Carver. **144** *Clearing*, Joan Mitchell (1926–1992). Oil on canvas, overall 110 ¼ × 236 in. Whitney Museum of American Art, New York, purchase, with funds from Susan Morse Hilles in honor of John I. H. Baur (74.72). **146** *Untitled*, Joan Mitchell (1926–1992). Oil on canvas, diptych, 110 ¼ × 141 ¾ in. Private collection.

152 *Uncle Rudi*, Gerhard Richter (b. 1932). Oil on canvas, 34 ¼ × 19 ¹¹⁄₁₆ in. © and permission granted from the artist. **159** *Confrontation 2 (Gegenüberstellung 2)*, Gerhard Richter (b. 1932). From the series *October 18, 1977*. Oil on canvas, 44 × 40 ¼ in. © and permission granted from the artist. Digital Image © The Museum of Modern Art/Licensed by SCALA/Art Resource, New York. The Museum of Modern Art, New York, purchase (169.1995.e). **159** *Confrontation 3 (Gegenüberstellung 3)*, Gerhard Richter (b. 1932). From the series *October 18, 1977*. Oil on canvas, 44 × 40 ¼ in. © and permission granted from the artist. Digital Image © The Museum of Modern Art/Licensed by SCALA/Art Resource, New York. The Museum of Modern Art, New York, The Sidney and Harriet Janis Collecion, gift of Philip Johnson, and acquired through the Lillie P. Bliss Bequest (all by exchange); Enid A. Haupt Fund; Nina and Gordon Bunshaft Bequest Fund; and gift of Emily Rauh Pulitzer (169.1995.a). **159** *Hanged (Erhängte)*, Gerhard Richter (b. 1932). From the series *October 18, 1977*. Oil on canvas, 79 × 55 in. Purchase (169.1995.l). © and permission granted from the artist. Digital Image © The Museum of Modern Art/ Licensed by SCALA/Art Resource, New York. The Museum of Modern Art, New York. **161** *Youth Portrait (Jugendbildnis)*, Gerhard Richter (b. 1932). From the series *October 18, 1977*. Oil on canvas, 28 ½ × 24 ½ in. © and permission granted from the artist. Digital Image © The Museum of Modern Art/Licensed by SCALA/Art Resource, New York. The Museum of Modern Art, New York, The Sidney and Harriet Janis Collecion, gift of Philip Johnson, and acquired through the Lillie P. Bliss Bequest (all by exchange); Enid A. Haupt Fund; Nina and Gordon Bunshaft Bequest Fund; and gift of Emily Rauh Pulitzer (169.1995.a). **162** *Dead (Tote) 1*, Gerhard Richter (b. 1932). From the series *October 18, 1977*. Oil on canvas, 24 ½ × 28 ¾ in. © and permission granted from the artist. Digital Image © The Museum of Modern Art/Licensed by SCALA/Art Resource, New York. The Museum of Modern Art, New York, The Sidney and Harriet Janis Collection, gift of Philip Johnson, and acquired through the Lillie P. Bliss Bequest (all by exchange); Enid A. Haupt Fund; Nina and Gordon Bunshaft Bequest Fund; and gift of Emily Rauh Pulitzer (169.1995.i). **163** *Dead (Tote) 2*, Gerhard Richter (b. 1932). From the series *October 18, 1977*. Oil on canvas, 24 ½ × 24 ½ in. © and permission granted from the artist. Digital Image © The Museum of Modern Art/Licensed by SCALA/Art Resource, New York. The Museum of Modern Art, New York, The Sidney and Harriet Janis Collection, gift of Philip Johnson, and acquired through the Lillie P. Bliss Bequest (all by exchange); Enid A. Haupt Fund; Nina and Gordon Bunshaft Bequest Fund; and gift of Emily Rauh Pulitzer (169.1995.j). **163** *Dead (Tote) 3*, Gerhard Richter (b. 1932) From the series *October 18, 1977*. Oil on canvas, 13 ¾ × 15 ½ in. © and permission granted from the artist. Digital Image © The Museum of Modern Art/Licensed by SCALA/Art Resource, New York. The Museum of Modern Art, New York, The Sidney and Harriet Janis Collection, gift of Philip Johnson, and acquired through the Lillie P. Bliss Bequest (all by exchange); Enid A. Haupt Fund; Nina and Gordon Bunshaft Bequest Fund; and gift of Emily Rauh Pulitzer (169.1995.k). **164** *January (Januar)*, Gerhard Richter (b. 1932). Oil on canvas, left panel 126 × 78 ¾ in.; right panel 126 × 78 ¾ in. © and permission granted from the

artist. The Saint Louis Art Museum, funds given by Mr. and Mrs. James E. Schneithorst, Mrs. Henry L. Freund and the Henry L. and Natalie Edison Freund Charitable Trust; and Alice P. Francis by exchange. **167** *Reading* (*Lesende*), Gerhard Richter (b. 1932). Oil on linen; 28 ½ × 40 ⅛ in. © and permission granted from the artist. San Francisco Museum of Modern Art, purchased through the gifts of Mimi and Peter Haas and Helen and Charles Schwab, and the Accessions Committee Fund: Barbara and Gerson Bakar, Collectors Forum, Evelyn D. Haas, Elaine McKeon, Byron R. Meyer, Modern Art Council, Christine and Michael Murray, Nancy and Steven Oliver, Leanne B. Roberts, Madeleine H. Russell, Danielle and Brooks Walker, Jr., Phyllis Wattis, and Pat and Bill Wilson.

PUBLICATION CREDITS

"The Pleasures of Bewilderment" appeared in *The Yale Review* 91, no. 4 (October 2003); "Vermeer's Annunciation" in *Modern Painters*, Spring 1996; "The Man with the Red Crayon" in *Modern Painters*, Spring 2000; "Ghosts at the Table" in *Modern Painters*, Summer 1997; "More Goya: There are No Rules in Painting" was published as "Goya's Bodies: The Living, the Dead, and the Ghostly" in *The Yale Review* 93, no. 3 (July 2005); "Giorgio Morandi: Not Just Bottles" appeared in *Modern Painters*, Winter 1998; "Joan Mitchell: Remembering in Color" was published as "Remembering in Color" in *Modern Painters*, Autumn 2002; "Gerhard Richter: Why Paint?" was published as "Double Exposure" in *Modern Painters*, Summer 2002.

COLOPHON

Design and typography of this book are by William Drenttel and Don Whelan of Winterhouse Studio, Falls Village, Connecticut. This book is set in two Dutch typefaces: the text is composed in Swift, designed in 1985 by Gerard Unger; headings are set in Quadraat Sans, designed in 1998 by Fred Smeijers.